ARCHITECTURE OF THE WORLD

The Story of All of Us

With Embedded Manual

SECOND EDITION

Mark A. Comeau Professor & Architect

Kendall Hunt
publishing company

www.kendallhunt.com
Send all inquiries to:
4050 Westmark Drive
Dubuque, IA 52004-1840

Copyright © 2014, 2017 by Mark Comeau

ISBN 978-1-5249-4071-3

Foreword

To quote St. Augustine, "The World is a book, and those who do not travel read only one page".

It's a paradox that those who do not travel, can read those words and feel no emotion but on the other hand it can strike a chord so deep within those who do. And I never knew as a young man that I would become integral in the cultural experience of so many travelers, including the author Mark Comeau.

We all have a collection of indelible memories from our childhoods. They tie us to the place where we grew up, our families, the cultural society we lived in, and the celebrations of our heritage that mark the milestones we pass in life. And though ours' is unique to us and helped shape us into who we are, there comes a point (and we all remember it), when we go on vacation or travel to another place and we witness or experience something so different to us - their culture. That experience usually comes in the form of a celebration, a parade, or even a game of some kind. Sometimes we laugh at the event because we think it's silly (we don't understand its context); sometimes we find it so curious that we marvel at its pageantry; and sometimes it galvanizes us, we make that connection between what we're watching and the "story" (if you will), that gives it meaning, and it has an emotive effect on us.

In Florence, we celebrate *La Festa di San Giovanni*, "the feast of St. John" on June 24th. St. John is the Patron Saint of Florence. Generally, businesses are closed and there are parades in the City center with celebrators wearing regalia cut in traditions of color and pattern. It's common that families observe the celebration while enjoying gelato. Symbolisms depicted often include the camel-skin robe of St. John, the cross, and the lamb. To the unknowing onlooker, scenes of the parade would appear entertaining but purposeful while the local participant is moved by the acting out of the mission of St. John through baptism rituals and as the baptizer of Christ. It's important. It's important to us Tuscans.

I was born in the Bronx, New York to first-generation Italian-American parents who met there after immigrating from Sicily. We moved to Italy as a family to a small town not far from Pisa in the 1980's and my early years were spent back and forth between these two places so rich in traditional and culture. After graduating high school in New York, I completed undergraduate work at Westchester Community College and eventually my Masters Degree at SUNY Stony Brook in Italian Renaissance Art History and Languages.

Following graduation, I taught Italian and Spanish in the Harrison County School District in Westchester County, NY and it was then that I first took my own students abroad to Italy so that I may tie together the language and culture into the curriculum. That connection had a profound effect on me but I soon (like many) became disillusioned with what the profession of teaching had become at that level (the shift from academic to administrative tasks and the erosion of pedagogy in favor of parental involvement). Soon after in 2002, I found the best of both worlds; I made Italy my home and worked for an intercultural tour company leading groups who were thirsty for the historic knowledge, culture, and language I was eager to dispense.

Enter Professor Mark Comeau. Leading his annual entourage of around fifty students, Mark's group was in awe of where they were; they wanted to see the architecture, learn the history, taste the foods, and experience all aspects of cultural immersion. Mark and I quickly recognized how we complimented one another and built upon our mutual respect as our friendship grew quickly and soon, I was leading his tours when they included Italy.

A decade later, after honing my skills in organization, logistics, leadership, communicating "stories" and engaging an audience, I knew that I had found my calling and I started my own company as a professional Tour Guide of Tuscany (www.tuscantourguide.com).

One can not state with enough emphasis, the power of inspiration, intellect, ingenuity and originality felt when viewing or standing under the domes of the Pantheon in Rome or Brunelleschi's Duomo at Santa Maria del Fiore in Florence. Though built over fourteen hundred years apart, the former inspired and informed the latter and yet, when Brunelleschi's Duomo was being constructed it was so anticipated that it appeared in frescoes in the cloisters of Santa Maria Novella in Florence even before it was completed. The great Michelangelo would draw upon both domes in his design of the great dome of St. Peter's Basilica but it was Brunelleschi's Duomo near his home that would serve as his beacon, his compass, and one of his many works that served as the muse for his poetry.

I'm forever inspired by the connection Florentine-Italian (and European for that matter), architecture has between simple function and rustic yet, graceful form. The loggia (atrium) for instance; a colonnaded courtyard, provides inward focus of space, efficient circulation, and organization all while providing shade and comfort - all responses to a lifestyle in harmony with a particular environment. This is difficult to convey by describing or even showing pictures. Leading tours, I witness that moment when the concept is understood and appreciated - the success of the loggia's design is experienced with all spaces in full view and comprehension, defined by the columns as a light breeze goes by.

Just as I love what I do, it is true of Professor Comeau. Like music, architecture is something that all cultures have in common and one that often remains to tell us about a culture gone-by. Architecture for Comeau is not *a* source of evidence but *the* source of evidence for the myriad of visions, reactions and efforts that make us who we are and this book serves as a comprehensive and linear "story" that makes it exciting and understandable at the same time as seen through his countless photographs and informative narratives.

Happy reading but more importantly, happy looking!

Paul Costa

Resident and Tour Guide, Tuscany, Italy

Paul Costa (left) and Mark Comeau (right) on tour in 2006 en route from Italy to Greece.

About This Book

It is intended that this book be para-conventional.

Just as the design of architecture can be avant-garde while at the same time being reflective, the format contained herein offers a pictorially centric layout while containing related briefs. As a text book that accompanies the lecture portion of a traditional "ground" course, the details are delivered in the classroom and they come in the form of a semester-long story. To see the figures, hear the stories, and "jot down" notes and highlights, is to retain; retain a visual memory of architecture and correlate the application it has to its cause to be built.

The author has taught Architecture of the World for almost two decades. Though several books are suggested as recommended readings, there has never been an assigned text book as no one book has been found to deliver the content in a way that parallels the author's "contagious enthusiasm" for teaching history through stories and experiences.

The content of this book represents an ongoing accumulation of the author's experiences, photographs, research, and of course — stories, as lived through travel study around the world that he has led more than a thousand learners on. It is meant to be more of an album, a record, that along with the live lectures results in a semester-long story of the history of all of us!

Course Description:

The course offers a global perspective of buildings, their settings, and the dissemination of ideas about architecture from the late Neolithic period to the present. Particular attention is given to the relationships of architectural expression, meaning, and building technology and to issues arising when architectural traditions of one culture are imposed upon or otherwise adapted by another. Students will explore the impact of climate, economy, philosophy, social structure, and technology on architecture by becoming familiar with some of the world's major monuments in architectural history. The course also integrates the visual arts that paralleled each era, exploring the fundamental elements of each "movement" as illustrated through aesthetic expression.

Educational Outcomes:

- ◆ Improve cultural appreciation and tolerance through discovery and reflection of the influence and effects of human interface throughout time;
- ◆ Understand the inventory of important built forms (landmarks), created through time that result from the impacts of climate, geography, religion, and other influential cultural elements;
- ◆ Acquire an understanding of aesthetic principles, i.e., scale, proportion, order, etc., and draw defendable criticism through the use of appropriate words (lexicon within the vernacular).

Educational Objectives:

- ◆ Establish chronological and thematic frameworks for the study of the world's history through its architecture;
- ◆ Create understanding and appreciation for cultures' architecture from traditionalism to modernity;
- ◆ Develop skills of description of formal and historical analysis and aesthetic evaluation.

Introduction

Architecture of the World is an informative and intense course. Considerable content will be conveyed to the student while building a logical basis for understanding the design philosophies and conditions which shaped architecture from prehistory to the present.

The course is divided into four-week sections:

The first section examines the origins of ancient-world architecture with specific focus on the cultures of Egypt, Mesopotamia, and the Aegean. Differences in climate, geography, materials, philosophy, social structure, and technology will be explored to discover how these are reflected in the architecture of each culture.
This section will also explore the classical architecture of Ancient Greece and Rome, as students are introduced to the principles of the Architectural Orders and the elements of which they are composed, detailing, engineering advances, proportion, and planning theories.
Christian Architecture will be traced from its origins in Rome through the synthesis of form, function, philosophy, and structure in the Gothic Cathedrals.

The second section examines the origins of the Renaissance in Italy and the development of the various Renaissance styles from Early Renaissance through the Baroque Period. The economic, political, social, and technical influences which shaped this movement will be explored to provide a better understanding of the meaning of the forms used.
This section will also explore the spread of Renaissance ideas and designs throughout Europe, the Americas and the East. Particular attention will be placed on the development of Renaissance design in France and England.
The development of architecture in America will be traced from the Colonial Period through the Gothic Revival. Students will explore the relationship of American architecture to cultural developments in Europe as well as the search for an appropriate American style.

The third section examines how society in general and architecture in particular, reacted to the changes and technology brought about by the Industrial Revolution. Students will explore initial reactions as they found their expressions in architecture, a period covering the years roughly between 1850 and 1900.
This section will also examine the period covering 1900 to World War I as architectural response was refined in a search to express the new century. The period covering World War I to World War II is the final portion of this section to be explored as students discover how the war graphically demonstrated the immense power of technology for both construction and destruction, thus, causing a general reassessment of values in society, architecture, and design.

The fourth and final section examines the period from World War II to the present day. Students will discover how America emerged as a world power and leader in technology and architectural expression. Architectural periods covered which illustrate this include those such as the race of the skyscraper, the Modern Movement, the Chicago School, the Shingle Style, Post Modernism and more. This section will also explore the current period of architecture in practice today as well as provoke discussions concerning the civic and social responsibilities of architecture of the past and how it may influence that of the future.

Table of Contents

Table of Contents

Architecture: Ancient and Pre-Classical
- Architecture is a product of time and space — of circumstance.
- It is born from man, religion, politics, art, technology, aspirations, landscape, geology, climate.
- One *must* address these circumstances to understand architecture.
- Prehistoric man was spread widely — thin on the ground but "there." The object was survival and through necessity, many things were invented (spears, hooks, basket, etc.)
- While man was still not settled, he was "nomadic" — not civilized and therefore there were no *towns*.

Origins of Civilization
- Civilized settlements first occurred in river deltas where alluvial soil was organic and fertile: Nile in Egypt; Tigris and Euphrates in Mesopotamia; and the Yangtze in China.
- A common link among them was the mastery of irrigation.
- By controlling water one could do the work of many, freeing many people up thus mind sharpens upon mind advancing thoughts, ideas, and inventions.
- Refinement of techniques and ideas led settlements to develop leaders, priests, kings, lawyers, merchants; and thus cities, architecture, and ultimately civilization.

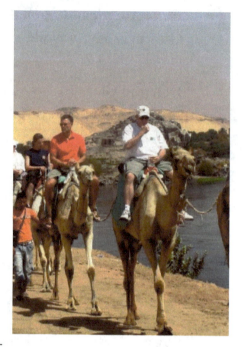

Egyptian Culture
- The Nile — source for all life.
- The mysteries of the sun, the moon, the stars, futility and grave, led to a complex hierarchy of gods.
- Egyptian service to religion advanced their art and architecture.

Egyptian Religion
- Survival after death depended upon preservation of the body.
- At the day of resurrection, "Ka" entered the dead (embalmed) body again.
- "The good burial" became an obsession and mummification became an art.

Egyptian Burial
- The impregnable tomb became the basis for Egyptian architecture.
- Within the tomb, the mummified was buried with possessions that would be necessary in the afterworld.
- Tombs were to be and "look" durable, monolithic, and impregnable.

OLD KINGDOM

1. Mastabas
2. Stepped Pyramid of Zoser
 at Saqqara by Imhotep
3. Great Pyramids
 at Giza Cheops (Khufu)
 Chephren (Khafra)
 Mykerinus (Menkaura)

MIDDLE KINGDOM

4. Rock Cut Tombs
 at Beni Hasan

NEW KINGDOM

5. Mortuary Temple of Queen Hatshepsut
 at Deir el-Bahari by Senmut
6. Temple of Amen-Mut-Khonsu
 at Luxor
7. Temple of Amun
 at Karnak
8. Temple of Ramses II
 at Abu Simbel
9. Mortuary Complex of Ramses III
 at Medinet Habu
10. Temple of Horus
 at Edfu
11. Kom Ombo
 at Kom Ombo (Near Aswan)

3200 – 2258 BC

2650 BC

2575 BC
2530 BC
2500 BC

2134 – 1570 BC

1975 – 1800 BC

1570 – 1085 BC
1500 BC

1390 – 1260 BC

1314 – 1200 BC

1257 BC

1198 – 1166 BC

322 BC

180 BC

1. Mastaba elevation:
 - First Egyptian tombs, I–III Dynasties of Archaic Period (3200–2700 BC) located in Memphis, south of Cairo
 - Made of mud and brick, with rooms and chambers leading to tomb
 - Faced with limestone blocks brought down by the Nile during floods
2. Mastaba plan:
 - Embryo of pyramids — fine stone cutting common thread of European architecture
 - Involved tools, mathematics, transport and organized labor
3. Stepped Pyramid Zoser:
 - 200 feet high — tomb of Pharaoh Zoser of III Dynasty
 - Layout, plan, vista, setting, painting and sculpture — architecture
4. Pyramid of Zoser:
 - Double throne symbolized Zoser's rule of upper and lower Egypt
 - Imhotep (architect) was high priest of "Re"(Sun God)
5. Papyrus columns at Zoser:
 - Symbolic of lower Egypt, columns "engaged" — not free standing, expressing a vertical element over a very horizontal wall
6. Complex at Giza:
 - Pyramids at Giza mark the end of "Old Kingdom", built during IV Dynasty were Khufu, Khafra and Menkaure
7. Pyramid of Khufu:
 - Largest of the pyramids, 2575 BC, 6 ¼ million tons of stone, 480 feet high before apex stone, 760 feet square base with math error of 0.03%, stone joints 1/15 inches — jeweler's work only repeated later at the Parthenon.
8. Pyramid of Giza (Sphinx):
 - Ally of sphinx guided the burial procession
 - Herodotus wrote it took 100,000 men 20 years fed on onions, to build pyramids
 - No pulleys, carts, cranes, wheels, some stones 20' x 6' x 6'
9. Trabeated column A Giza:
 - Trabeated columns at Khafra mortuary temple
10. Rock Cut Tombs:
 - Many of the recovered tombs found here
11. Temple, Queen Hatshepsut:
 - Typical processional avenue, forecourt, columns, inner shrine
 - Avenue of sphinxes lead from Nile to temple ramping
 - Noted for it linear horizontal contrast against verticality of cliffs
12. Colonnade, Hatshepsut:
 - Early use of obelisk/point marker as planning marker

13. Temple of Amun at Karnak:
 – Karnak one of the largest master planning efforts in history
14. Plan of Karnak:
 – Developed over many years and generations
15. Avenue of sphinxes/Karnak:
 – A smaller version of that at Giza
16. Column at Karnak:
 – A conscious use of relief — hieroglyphic — used to visually "lighten" the load on the columns
17. Ramses II Abu Simbel:
 – These statues recently moved upgrade to be saved, note the large scale
18. Ramses II Plan:
 – Illustrates typical Egyptian temple with entry pylons, processional allies, and mortuary temple
19. Ramses III at Habu:
 – Continuation of the Ramses Dynasty
20. Ramses III Plan:
 – Note planning concepts and integration of culture, religion, and symbolisms
21. Temple of Horus at Edfu:
 – Large entry pylons showing hieroglyphic — law of frontality (to be seen from the front)

1. Capitol:
 – The upper-most mouldings or carvings of a column, usually defining their "type".
2. Civilization:
 – As related to this unit, the social and cultural evolutions that result from the end of nomadic behavior.
3. Clerestory:
 – Overhead apertures that allow light to enter lower spaces.
4. Column:
 – A vertical architectural structural member that supports transferred building loads.
5. Hieroglyph:
 – A carved communication consisting of pictogram characters.
6. Hypostyle hall:
 – A higher clerestoried hall entering into the mortuary complex.
7. Law of Frontality:
 – The concept of being principally concerned about the 'front' details of something.
8. Mastaba:
 – The stone rectangular burial form constructed during the early dynastic Egyptian period.
9. Obelisk:
 – A vertically pyramidal monolith often carved with hieroglyph and used as a spatial marker.
10. Peristyle hall:
 – A columned hall usually forming a court.
11. Processional:
 – The sequential movement and events conducted during the burial of a Pharaoh.
12. Pylon:
 – A tapered wall structure serving as an entrance gate to New Kingdom burial complexes.
13. Rock-cut Tomb:
 – Middle Kingdom burial complexes cut into the stone cliffs.

▶ 28 Dynasties over three Kingdoms (Old, Middle, New)
 ▶ Old: Pyramids
 ▶ Middle: Rock-cut Tombs
 ▶ New: Pylon Complexes

▶ Influenced by: Weather, Landscape, Religion, Irrigation

▶ First burial form was the Mastaba

▶ Great architects included Imhotep and Senmut

▶ Pyramids: Geometrically perfect, platonic, made of limestone, related to various constellations

Ancient Egypt Timeline

The mastaba was an early burial form developed in the Old Kingdom of Egypt. Consisting of a burial shaft that led to an offering chamber and "Serdab" (cellar tomb) or burial chamber, the mastaba was built of stone and was a simple rectangular structure.

Ancient Egypt

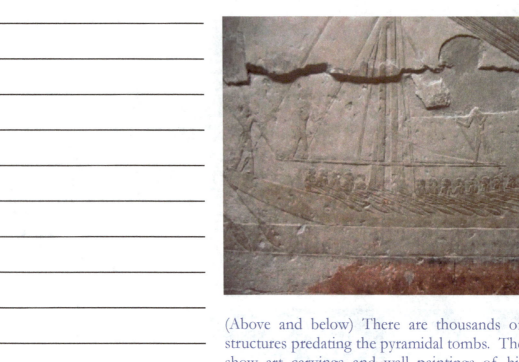

(Above and below) There are thousands of mastaba structures predating the pyramidal tombs. These images show art carvings and wall paintings of high artistic value because mastaba scenes depicted everyday life, whereas pyramidal and subsequent scenes often depicted life in the court of the Pharaoh.

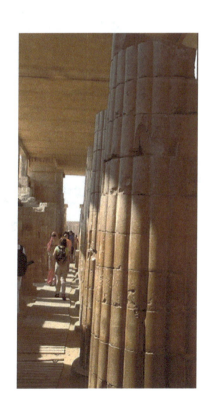

Ancient Egypt

When building Zoser's burial complex, Imhotep responded to political, religious, and environmental elements while reflecting cultural ones (the papyrus carvings on the column capitols are symbolic of Zoser's unification of upper and lower Egypt).

12

(Above) Pyramid began under Huni and finished under Sneferu. The structure collapsed in ancient times. Burial complex lies to the left of the Pyramid.

(Below) Bent Pyramid at Dahshur. Built for Sneferu. A Small Pyramid for the Queen of Sneferu lies to the right of the Pyramid.

Ancient Egypt

The Pyramid complex at Giza was a culmination of the effort to construct the platonic pyramidal form (Chefren shown below).

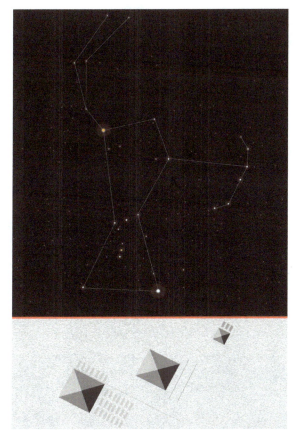

Central to current discussions surrounding the Pyramids is the Orion correlation theory by Robert Bauval, associating the Giza complex with the constellation and its relationship with Osiris, the sun god of rebirth and afterlife.
The Pyramid complex at Giza (the city of Cairo is in the distance).

Cheops Chefren Mycerinus

Ancient Egypt

——————————————
——————————————
——————————————
——————————————
——————————————

The "Great Pyramid" Cheops (Khufu). Built with jeweler's precision (paper cannot be fit between the stone joints), its base measured 756 feet square and it stood 481 feet high to its apex. Usually seen with its lower -angled edges (resulting from two triangular inclined planes intersecting, e.g. Chefren's below), its true surface slope is revealed when standing closer to its inclined side (above).

Cheops

Chefren

Mycerinus

Cheops' tomb

Ancient Egypt

The "Great Sphinx" stands in front of the pyramid of Chefren (Khafra).

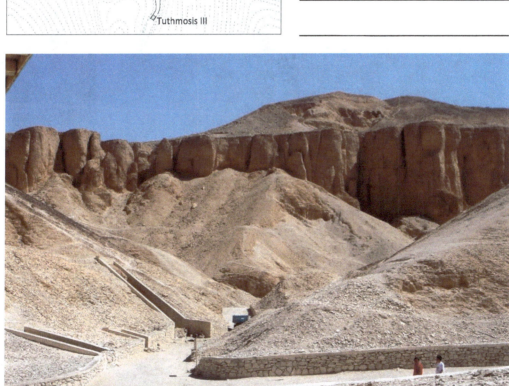

Valley of the Kings

Ancient Egypt

(Opposite) Map diagramming tomb locations. Tombs were cut into the stone (rock-cut) and were meant to provide better concealment of the burial chambers.

(Above left) Photo shows typical gallery leading into the tombs.

(Above) Acrylic model of the Valley showing locations of rock-cut tombs.

(Left) Underside of model showing configuration and proximities of various rock-cut tombs.

Mortuary Temple of Queen Hatshepsut (Deir el Bahari)
1500 BC by Senmut

(Left) Stone carving of Queen Hatshepsut. The Queen assumed power when her father died (Pharaoh Thutmose I), and she wore his regalia to appease the people.

(Below) The Queen's Chancellor and Architect Senemut designed her mortuary complex, juxtaposing the shadows of negative space with the columns — both driving dramatic horizontal lines against the background vertical cliffs.

Ancient Egypt

Viewing these photos from top-left to lower-right, these photos are taken from vantage points that both revealed and then concealed the long ramps, creating rhythms in both space and time.

Hypostyle hall at Chephren (note the relatively smaller scale of the columns and their close spacing).

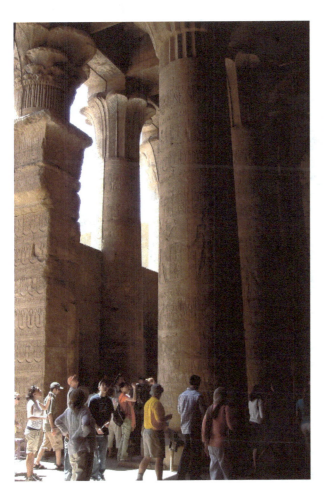

Hypostyle halls at Luxor and Karnak respectively, showing monumental scale increases.

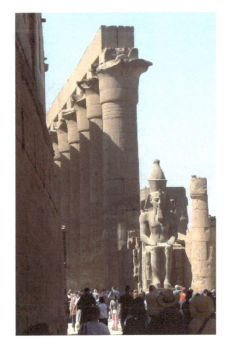

Ancient Egypt

Alley of Sphinxes, leading to the Temple of Amon-Ra (Luxor), is built of "Nubian" sandstone from the Gebel el-Silsila area.

24

The opposing obelisk to the one shown is now located in Paris at the Place de la Concorde.

Ancient Egypt

Colossus of Ramesses II (son of Seti I) as seen at Luxor. The dual statues "stand guard" of the avenue that once stretched for a mile and a half.

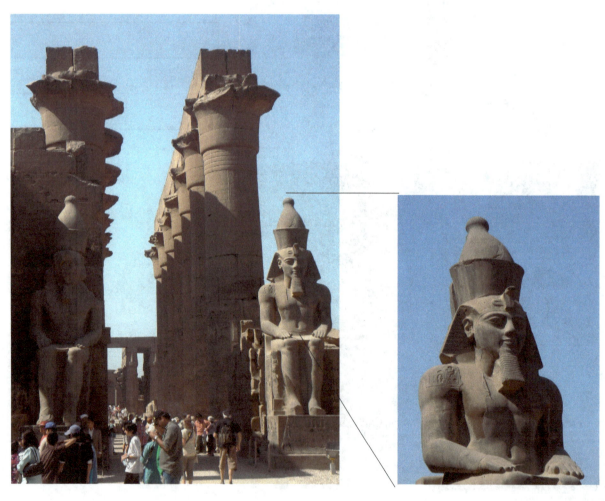

(Below and Opposite) Map diagramming the Temple of Karnak. The Temple was constructed over a period of two thousand years, stretching from the Middle Kingdom into the Ptolemaic period.

(Note the marking of the vantage point for the photograph opposite.)

The obelisk of Hatshepsut at the Temple of Karnak (its location shown in the accompanying diagram).

The monolith measures 97 feet tall and weighs an estimated 400 tons. Inscriptions at its base indicate it took seven months to quarry.

Ancient Egypt

The temples of Ramesses II and his queen Nefertari, are rock-cut structures that were originally located on Lake Nasser (near Aswan). They were moved in their entirety in 1968 to Abu Simbel to avoid damage from the construction of the Aswan High Dam.

An example of the rock-cut tomb, the Temple of Ramesses II consisted of a carved cliff-entrance that led through a series of halls, ending with the burial chamber.

Ancient Egypt

The rock-cut tomb of Ramesses II's queen, Nefertari, was constructed adjacent to his to commemorate victory at the Battle of Kadesh.

Built during the Greek-influenced Ptolemaic period, the Temple of Horus (falcon god) reflects the prosperity of this period through its enormous scale.

Ancient Egypt

(Left) Carving of Horus; often the face would be removed, rendering it ineffective by successors.
(Below) The walls of the temple complex covered in carvings.

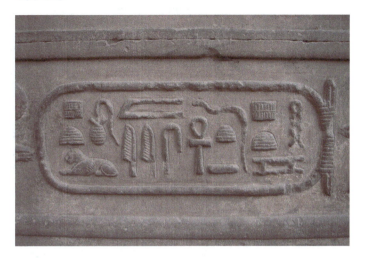

(Above and across) Examples of "positive" relief hieroglyph and "negative" relief.
(Below) Kom Ombo was the unification of two temples; one built to Sobek (the crocodile) and the other to Horus (the falcon).

Ancient Egypt

Kom Ombo Temple reveals an entablature that reflects Greco-Roman influence at various times during the temple's construction. Once covered by sand, the stone remains in very good condition.

The Aegean
- Minoan culture flourished before Greece around the Aegean
- This civilization is known as Mycenaean
- Bronze Age 3000 BC — 1100 BC
- Period for the basis of the Iliad (Ilios) and the Odyssey (Homer's epic Aegean accounts)

Mesopotamia
- Located in the Iraqi desert prophesized by Jeremiah (Jer. 51.43), "Her cities are desolate, dry land."
- Maybe first civilization before 3000 BC and Egypt
- "cradle of civilization" — the invention of writing (Sumerian literature)
- The land between the Tigris and Euphrates rivers (alluvial plain where they empty into Persian Gulf)
- Kingdom of Babylon — Ishtar Gate (gateway of the gods)
- Tower of Babel dedicated to God Marduk 300 feet high

Mycenaean
- Walls of Mycenae built in 1250 BC, entrance through iconic Lion Gate
- Mycenae last phase of Helladic culture ran from 1600 — 1100 BC
- Home of many of Homers characters (Ithaca — Odysseus) (Pylos — Nestor)
- Home of Atreus (Mycenaean King)
- Legend of Troy, Agamemnon from Mycenae, Nestor from Pylos, Odysseus from Ithaca
- Trojan War 1200 BC first damage to Mycenae

Knossos (Palace of Minos + Phaistos - Minoan)
- Knossos was built around a central court
- The dead were buried in round stone structures
- The stone throne room of Minos had colorful walls and frescoes
- Use of plumbing gutters — storm drains, handling of domestic waste in terra-cotta
- Palace of Phaistos — Queen of South, had impressive entrance
 a. 45 feet wide, twice destroyed by earthquake and rebuilt
 b. Steps corrected perspective illusions

1. Ishtar Gate and Babylon: the gateway at Babylonia built as gateway of the gods.
2. Lion Gate: protective entrance to the city, now missing the lion's faces (masks) with golden hair. The placement of this stone in the negative-load space above the lintel illustrates the architect's knowledge of load manipulation.
3. Citadel of Mycenae: Menelaus, son of Atreus, led his men from Mycenae to war in Sparta. The "House of Atreus," in other words — the lineage of the royal family of Atreus, buried at the Circle Grave site.
4. Treasury of Atreus: early use of "corbelled dome" and an introduction to the arch concept.
5. Palace of Minos: its brightly painted columns are precursors to the Doric order.

Major Works

1. Ishtar Gate and Babylon at Mesopotamia	600 BC
2. Lion Gate at Mycenae	1250 BC
3. Citadel of Mycenae at Mycenae	2000 – 1400 BC
4. Treasury of Atreus at Mycenae	1400 BC
5. Palace of Minos at Knossos	1300 BC

1. Babylon:
 - An ancient Mesopotamian city of biblical importance located in modern-day Iraq
 - Location of the palace of Nebuchadnezzar
 - Mythical location of the Tower of Babylon
2. Ishtar Gate:
 - Gateway of God into Babylon
 - Now in the Pergamon Museum in Berlin, it's inscribed with Nebuchadnezzar II's cuniform
 - Also depicts animal kingdom through textured tiles
3. Mycenaean Village:
 - Typical walled-in fortification of the period
 - Entered through decorated post and lintel openings, and the Lion Gate
4. Lion Gate:
 - Depicts two lionesses facing each other divided by a column
 - The triangular lion-plaque illustrates load displacement over a trabeated opening
5. Treasury of Atreus:
 - Known for its "beehive" vaulting, accomplished through circular rows of corbels
 - Entrance shows tapering retaining walls leading to trabeated entrance
6. Palace of Minos at Knossos:
 - The citadel arranged around a central court
 - Its reverse-tapered columns, early templates for classical columns to come
 - The palace decorated with bold frescoes, bright sea depictions of dolphins, and geometric patterns of design

Mycenae and the Aegean

1. Corbel:
 – A structural member (usually a masonic unit) that protrudes from the surface engaging it, to laterally displace support and move it to another plane.
2. Cyclopean:
 – Wall units of large stone, deriving the name from the mythical giant "Cyclops" from Homer's epic Odyssey.
3. Language:
 – In the architectural discussion, the coding, symbols, and sequences that have evolved to represent the spoken word in written form so that it might be reproduced. Valuable record has often been incorporated into built architecture.
4. Structural Forces:
 – The transfer of loads through structures to the earth or base that bear them.

▶ Architectural Column Derivatives
 ▶ Base: Where the column bears (rests)
 ▶ Shaft: The majority "cylinder" of the column
 ▶ Capitol: Decorative top to the column

▶ Architecture of the "Fertile Crescent"

▶ Real structures built in a land of mythical recordings

▶ The Aegean has valuable impact on Classical development

Aegean Sea Timeline

Mycenae and the Aegean

Ishtar Gate, constructed by Nebuchadnezzar II, is said to be the "Gate to God" and was lined with the processional of lions and the Gods Adad and Marduk.

(Opposite) Lion Gate, the tomb-portal built into the Bronze Age Mycenaean cyclopean walls. It expresses the very essence of trabeated post and lintel architecture, with symbolic metaphor of the lionesses facing the earthly Minoan column.

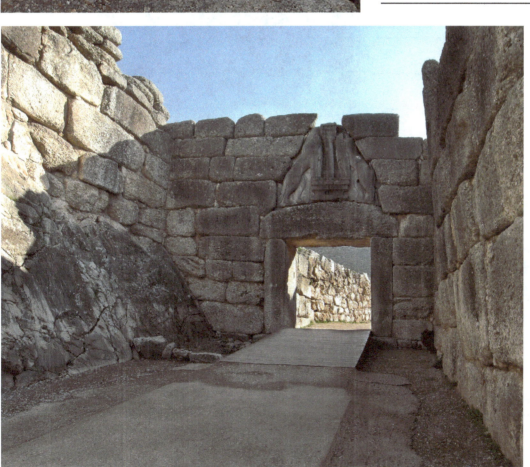

Mycenae and the Aegean

The treasury, another example of cyclopean masonry, creates a beehive-shaped structure through its corbelled coursing of stone. Also, one can notice repeated use of the trabeated opening.

Palace of Knossos

(Above) Plan of the Palace at Knossos.

(Right) The Royal Avenue led to a court, which also served as an event gathering "theater."

A complex ensemble of roughly a thousand rooms (possibly deriving the myth of the labyrinth), the palace of Minos served as a religious and administrative center and consisted of studios, theaters, work and processing rooms, storage, and other uses that served the people.

Mycenae and the Aegean

Discovered in the late nineteenth century, much of what is known about the palace comes from Roman coins found, wall murals, and decorated pottery.

The palace is partially reconstructed and its size and complexity far exceeded the initial notions of its discoverer, Minos Kalokairinos.

Though steeped in Classical myth (the Minotaur and the labyrinth), its architectural importance lies in its columns. Unlike Greek columns of stone, the Minoan column was made from the trunk of an inverted cypress tree. It is unclear whether the inversion was functional or aesthetic. Archeological evidence suggests the columns were painted a muted red hue, made from red ochre. Murals depicted scenes from the sea and geometric designs.

Mycenae and the Aegean

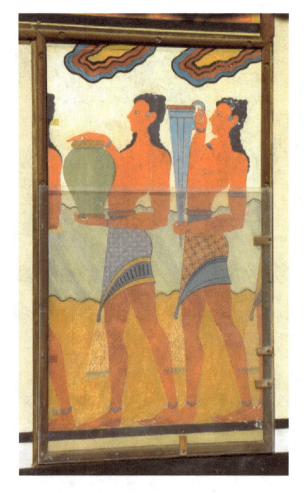

Wall murals aid in the understanding of climate, regalia, design, and other important aspects of Minoan life.

Vessels (called pithoi and as seen in both wall murals and physically in store rooms) were used to store and transport wet and dry consumables including wine, oils, fish, grains, and other items of importance.

Mycenae and the Aegean

The city of Epidaurus was an important local center in the Saronic Gulf in the Argolid due to its fertile land and positioning within the Aegean near Corinth, Athens, and Aegina.

The Asklepieion of Epidaurus (named for the god Asklepios), became a sacred center for healing and is considered the cradle of the art of medicine. Born to Apollo and Koronis, Asklepios (meaning "to cut open"), was cut from the womb by Apollo as Koronis died in childbirth. He was raised by the centaur Chiron who instructed him in the art of medicine.

Below is the Theater of Epidaurus. It's conical volume is an intricate mathematical exercise in the Fibonacci sequence, resulting in exemplary acoustics that allow the orator to speak from a focal point to a capacity crowd of 14,000 in just a normal voice. The lower register has 34 rows and the upper 21.

As a rule of thumb, Greek theaters had a capacity of 1/10th of the city's population thus Epidaurus is believed to have had a population of approximately 140,000 people during its zenith.

Mycenae and the Aegean

With its comfortable seating, the Theater of Epidaurus displayed beautiful natural vistas to its spectators. These vistas along with optimal geological site conditions, were a prerequisite for locating an ancient Greek settlement. The theater served the ancients for centuries, having been restored by the Romans for continued use.

Egypt

Culture:
- Nile, source of all life and central to Egypt's growth
- 28 Dynasties over three Kingdoms (Old, Middle & New)
- Complex religious system involving:
- The "good burial" was played out by the "processional"
- Resurrection day when "Ka" ascends the body spirit
- The burial tombs were "durable" to protect afterlife
 - Life was lived on the east bank, death played out on the west
 - The mystery of the sun, moon & stars served their religion
 - Two significant Gods were Amen and Amun

Architecture:
- Architecture is "trabeated", meaning "post and lintel"
- Burial tombs were (by kingdom), platonic (pyramids), rock-cut tombs & pylon hypostyle-hall complexes
- Artwork bound by the limits of the law of "frontality"
- The mastaba was the first burial entombment
- Imhotep built the Stepped Pyramid for Zoser
 - Papyrus-capitol columns symbolized Zoser's two thrones—the unification of upper and lower Egypt, and expressed knowledge of reinforcing long enclosure wall
- Snefru constructed his two bent pyramids
- Cheops (Snefru's son) built his pyramid at Giza
 - Celestial alignment to Orion's belt
 - Three great pyramids are Cheops, Chephren, Mykerinus
 - Great Sphinx aligned with Chephren
- Queen Hatshepsut's was the most dramatic Rock-cut Tomb, designed by Senmut, it contrasts the vertical cliffs with strong horizontal lines and deep vertical shadows
- Temples at Luxor and Karnak were two of the World's most complex master planning efforts using Pylon walls, hypo-style halls and were developed over many succeeding generations

Detail:
- Rosetta Stone basis for Linguistic knowledge
- Hieroglyphs were negative (carved in) or positive (excess-relieved)
- Bodies were mummified and buried in a sarcophagus
- First paper was a method using papyrus reeds
- Theories of "slave-labor" debunked by modern discoveries proving workers were well fed and cared for
- Discovering irrigation was a catalyst for civilizing Egypt

Aegean: Mesopotamia & Mycenae

Culture:
- Mesopotamia forms in the delta's of the Tigris & Euphrates rivers
- Sumerian language (1st written) developed
- Biblical civilization of Babylonia develops
- Minoan culture of Mycenae develops during the Bronze Age 3000 BC
- Mycenaean period is datum for many of Homer's stories, fables and characters
- Built fortified walled-in villages on rugged highlands
- Artwork, pottery, architecture unique to this period

Architecture:
- The Babylonians developed glazed textile walls that depicted many animals of the world realm
- These walls led to "God's Gateway" into Babylon, through the large "Ishtar Gate"
- Mycenaean's built "cyclopean" walls to surround and fortify their villages
- "Lion Gates" led through the walls, two confronted lionesses with a column in between them that represents a deity
- Minoan palaces of Minos and Phaistos at Knossos, exhibit evidence of mathematical prescription and are likely the predecessor to the Doric column order
- Treasury of Atreus was a "beehive" dome of corbelled stones, the entrance having an empty triangle over it, illustrating their knowledge of "relieving forces" to the post-stones

Detail:
- The languages developed were "cuneiform"
- This period was influenced by relations with the Asia Minor and Phoenician territories
- Some elements of Egyptian architecture refined for use
- Skill and craft of work was part reaction to the common seismic activity of the region

The Land, The Sea, and the People

- Greece is a peninsula of ragged bays cutting deep into the mainland and separated by mountains. Its people become sailors — traveling by sea. Climate and geography produced athletic men, the marble an invitation to carve them as if gods.
- The Greeks traded little — only as east as Spain — west to Euxine. They looked only upward to Hellas, rather than out upon the world. They could never have organized an empire like the Romans. When threatened, the cities would band together as in the wars with Persia.
- Ancient Greeks were of two races: the Dorians were a tribe of northern shepherds; The Ionians came over from the sea from Asia Minor and were Oriental (sensuous and effeminate). Athens, Sparta, and Corinth were cities of patriotism and effort.
- Here too, the theatre is born. Custom becomes law, ritual and myth become drama. The priest becomes the original actor. As with sculpture and theatre, so it is with thought. Plato laid down the condition for government; that a philosopher be King and a King a philosopher, this had been fulfilled under Solomon just as custom is replaced by law and order. Nature and Society were now understood.
- Greek maxims: "know thyself," and to the balanced mind "nothing to excess."
- Greek democracy was really the vote of a few thousand Greek-born males. Violence, homosexuality, slavery, and the stunted role of women existed. They were aloof and saw the world beyond the Aegean as barbaric.
- Greek wisdom was based upon their attitude to human mind and body. They rejected the Egyptian gods and the monotheism of the Jews. They conceive the Gods of Olympus — anatomically perfect yet possessing human frailty. They built statues for gods, shrines for statues (the temples). They enshrined Olympus in poetry, myth, drama, and architecture.

The Making of an Age

- Egyptian craftsmen carved the same hierarchic figures, the same eye, nose, torso, etc. The Greek sculptor is observing and analyzing — even the archaic statue by Pygmalion is "about to breathe" because of instinct with life.
- The Classical Age consisted of two Athenian generations and can be compared to a comet. This was fifth century BC under the rule of Pericles. It's the beginning of modern man and though civilization began centuries earlier, the Periclean Age brings intellect and the rule of law.
- Hellenism — the beautiful manifestation of the human spirit defined the Greek civilization, developed through many centuries in small city states and the territories invaded by Alexander the Great throughout Magna Graecia. Also referred to as the "Golden Age."

The Architecture

- As their rule was to be perfect, so was it with architecture — absolute perfection sought. The Greeks had no engineers and though they knew the arch, they never exploited it — the architecture remained trabeated. Obsessed with mathematics and their adoration for the human body, sculpture was elevated to a status of dominant art.
- The architecture was civic, not national. The work of Athens — not Greece — was where the Periclean Age expanded its genius.
- Greek towns were a collection of white-walled houses with flat-tiled roofs, looking inward to an inner court. Politics were an affair of the market place (the agora); drama, an affair of the amphitheater (open air). This left the temple as the medium for great architecture, reflecting the attributes of the human body, (proportion, balance, grace, precision, subtlety, and sculptural beauty).
- Architectural origins are uncertain and drawn from many sources. The basic concept of the columned temple probably came from the Mycenaean Palace of Minos.

The Orders

- The basic temple forms were rectangular with low-pitched roofs and surrounding "peristyle" colonnade." The Acropolis, having the most famous collection of buildings, is of the Doric and Ionic order. The term order refers to the whole "unit."

 > Doric — plain with simple moulded capitol and no base (Romans added base later)
 > Ionic — capitol of two connected volutes — a more slender column and added base
 > Corinthian — leafed capitol of acanthus leaves — used more by the Romans than Greeks
- Vitruvius minutely prescribed the details and proportions of the Orders in the first century AD in his four books of classical architecture. Architects today still adhere to the laws of the Orders.
- The Acropolis had its sides built up and top flattened and was a deliberate separation from the town. The Acropolis buildings were actually skillfully placed when seeming haphazard at first, no symmetry but spatial "balance."
- As beheld from the entrance (Propylaea), the simple mass of the Parthenon to right is balanced by the smaller but more complex Erechtheum to left. The composition was resolved by a large statue of Athena holding a shining spear and helmet visible to sailors out on the Aegean. The Parthenon was placed so it could never be seen except against the "Aegean Blue" sky, space planning to be copied forever. The Temples could never be seen at once, only when one had passed through the Propylaea.
- The Greek temple "reads" well from afar. Ornamentation was meant to be seen from close-up and abided by the "law of frontality."

ARCHAIC

1. The Basilica (Temple of Hera I) 550 BC
 at Paestum, Italy
2. Temple of Poseidon 460 BC
 at Paestum, Italy
3. Temple of Aphia 510 BC
 at Aegina, Greece
4. Temple of Zeus 460 BC
 at Olympia, Greece
5. Temple of Apollo and Complex Fourth Century BC
 at Delphi

THE ACROPOLIS

6. Propylaea 437 – 432 BC
 at Athens, Greece by Mnesikles
7. Parthenon 447 – 432 BC
 at Athens, Greece by Iktinus and Kallikrates
8. Temple of Nike Apteros (Athena Nike) 427 – 424 BC
 at Athens Greece
9. Erechtheum 421 – 405 BC
 at Athens, Greece

THEATRES

10. Theatre at Delphi, Greece Second Century BC

11. Theatre at Epidauros, Greece 330 BC
 by Polykleitos

OTHER

12. Choragic Monument of Lysicrates, Athens, Greece 334 BC

13. Stoa of Attalos, Athens, Greece 140 BC

14. City Plan at Priene, Greece Late Fourth Century BC

15. Alter of Zeus at Pergamon, Turkey

1. The Orders:
– A set of mathematical units that described a particular temple front
 Doric — simple molded capitol on a stout shaft with no molded base
 Ionic — connected volute capitol on a slender shaft with molded base
 Corinthian — acanthus — leaf capitol on a tall shaft with molded base
2. Refinements:
– The series of temple adjustments that took place over centuries, culminating at the Acropolis.
3. Temple Plan:
– The horizontal spatial layout of a temple consisting of
 Pronaos — the entrance portal
 Naos — the inner most chamber of a temple plan
 Cella — the smaller chamber adjacent to the naos containing the effigy and storage of offerings

4. Moldings:
– The decorative and symbolic carvings that adorned sections of the architectural design.
 Egg and dart — egg-like shapes forming a row with sharp darts separating them
 Bead and reel — appearing like beads strung together
 Lotus bud — strings of lotus flower connected laterally

▶ The Greek Orders
 ▶ Doric
 ▶ Ionic
 ▶ Corinthian

▶ Ancient Greece was inward looking, seeing the world beyond their borders barbaric

▶ Strive toward perfection reflected in all aspects of Greek life

▶ Rules of Beauty
 ▶ Proportion (Golden Ratio 1:1.618)
 ▶ Scale
 ▶ Order

▶ The Acropolis was the manifestation of the "Golden Age."

1. Basilica at Paestum:
- (550 BC) columns have exaggerated taper — early use of entasis

2. Temple of Poseidon:
- Horizontals slightly curved, plaster hides flaws in local travertine

3. Temple of Aphia:
- Exemplifies typical Greek temple, copied often

4. Bronze of Zeus:
- Bulky depiction, lacking detail seen in renaissance sculpture

5. Temple of Zeus
- Massive expression related to Minos Temple

6. Plan of Acropolis:
- No symmetry, yet balanced
- Composition of large Parthenon and small Erechtheum resolved by the 30 feet statue of Athena visible by sea
- Parthenon placed so it is only seen with blue sky as backdrop
- Buildings only be seen all at once when passing through Propylaea

7. Model of Acropolis:
- Note the site was retained and filled

8. The Propylaea:
- Gateway building (not a temple), strategically placed, view/vista

9. Parthenon:
- 228' x 101', peristyle of 56 Doric columns, contained 40 feet statue of Athena
- 8 end columns (unusual) leaves center space denoting "entrance," 17 side columns "closed"
- 63' x 44' cella in addition to naos called Parthenon room and tended by virgin maidens who tended the temple.
- How was the temple lit? hyperthral theory
- 1. Rectangualr hole in roof above shrine (but no drainage)
- 2. East doors left open for light (good only for morning light)
- 3. Roof timbers clad with alabaster (good theory and supported)
- Use of circle, ellipse and parabola, rectangular yet no right angles
- Every horizontal line has a 2 mile radius, barely perceptible
- Columns taper to a point 1 mile high, end columns closer together
- No two stones alike but each side mirrored the other and opposite stones were carved by the same person
- Pediments are birth of Athena and contest with Poseidon for Attica (high)
- Metopes show battle of centaurs and lapiths (read from Propylaea)
- Frieze shows panathenaic procession (prancing cavalry) could only be read from door passage

10. Plan of Parthenon:

 – Illustrates column locations and illusionary corrections

11. Parthenon Interior:

 – Athena covered in gold must have been impressive

12. Parthenon Peristyle:

 – Example of Doric columns

13. Temple of Athena Nike:

 – Gem of Ionic order, 13 feet long "foil" to the Parthenon

14. Erechtheum:

 – Curious form by Mnesicles, separate shrines for Athena and Poseidon

15. Erechtheum porch:

 – Caryatids express "easy load," temple never finished

16. Theatre/Delphi:

 – The priest was the first stage actor, stage design for production

17. Theatre/Epidaurus:

 – Seated over 30,000, meant to be open air within Greek structure

18. Stoa of Attalos:

 – Important civic space, place of commerce and politics

19. Plan of Agora:

 – Typifies open air marketplace of ancient Greece

20. Greek Orders:

 – Doric, Ionic, and Corinthian

21. Choragic monument:

 – Relief shows Lysicrates victories

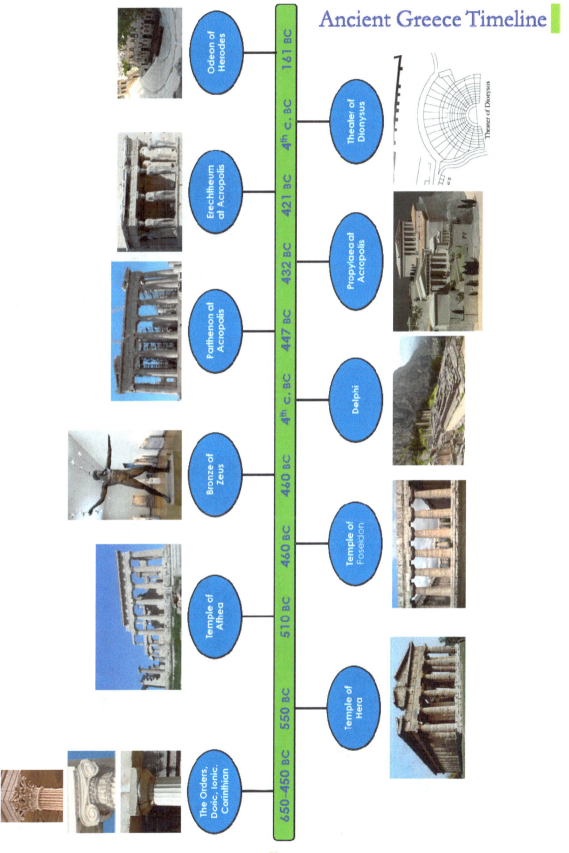

Ancient Greece Timeline

161 BC — Odeon of Herodes

4th c. BC — Theater of Dionysus

Theater of Dionysos

421 BC — Erechtheum at Acropolis

432 BC — Propylaea at Acropolis

447 BC — Parthenon at Acropolis

4th c. BC — Delphi

460 BC — Bronze of Zeus

460 BC — Temple of Poseidon

510 BC — Temple of Aftea

550 BC — Temple of Hera

650-450 BC — The Orders, Doric, Ionic, Corinthian

Ancient Greece

The Greek diet has long been a model for eating healthy — books have even been written. For centuries, this diet has been rich in greens, olive oil, red wine, lamb and other meats, olives, fish, honey, and other foods that naturally contain antioxidants, essential fatty-acids, minerals, and vitamins.

Pictured from Left to Right, Greek salad, red wine, souvlaki, olives, baklava, and a gyro made with lamb, greens, tomato and tzatziki.

60

Shown top-left to lower-right:
Doric Order
Ionic Order
Corinthian Order (below Ionic)

Ancient Greece

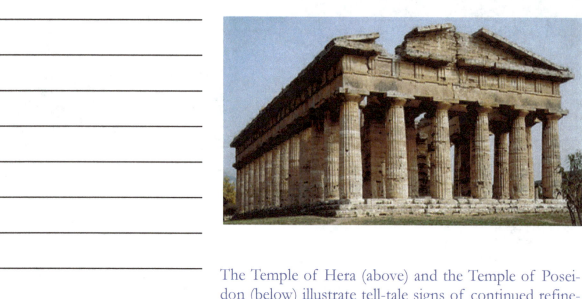

The Temple of Hera (above) and the Temple of Poseidon (below) illustrate tell-tale signs of continued refinement of the Doric Order. Columns of Hera have a more "flared" capitol, wider necking and are proportionally more stout. Columns of Poseidon have a more rounded capitol, thinner necking and are more slender.

Found at Cape Artemision and housed in the National Archaeological Museum in Athens, the Bronze of Zeus (throwing a lightning bolt), showing Zeus "stopped" in the moment before dispensing his wrath.

Doric Order at the Temple of Afhea, showing further refinement of the Order.

Ancient Greece

Delphi was a period — important mountainous settlement hosted by Apollo and where Greeks would travel to consult the Oracle. Legend accounts that Zeus released two eagles to fly around the Universe and where they met was the "omphalos" (navel) of the Earth. The stone in the photo above marks this spot.

The Temple of Apollo (shown below) in the context of its mystical perch. Note the people left of the columns (for scale).

Model recreation of Delphi (model located in
the Delphi Archaeological Museum).

(Below) The Temple of Apollo. The divine oracle would retreat
to a lower chamber (said to emit methane gas), and emerge in a
transcendental state in which riddled comments were uttered.

Ancient Greece

The Delphi amphitheater (shown below), its spacious view as a backdrop. Note the proximity of the Temple of Apollo just beyond.

(Opposite page) Exposed foundation of the Temple of Apollo. (Above) Showing inscription on the stones, providing evidence that the labor force was skilled and valued (not slaves).

Athenian Treasury (rendered recreation on mural at archaeological site).

Athenian Treasury (as reconstructed at archaeological site).

Ancient Greece

———————————————————

———————————————————

———————————————————

———————————————————

———————————————————

———————————————————

———————————————————

———————————————————

———————————————————

———————————————————

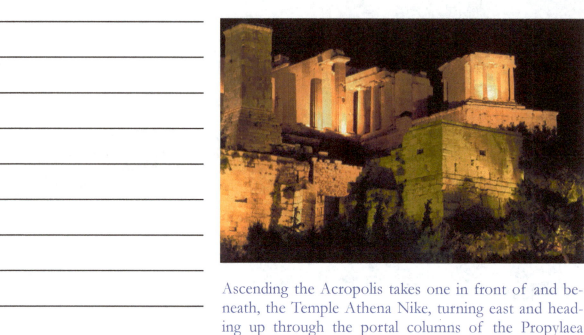

Ascending the Acropolis takes one in front of and beneath, the Temple Athena Nike, turning east and heading up through the portal columns of the Propylaea "gate" structure.

As seen from the northeast perch of the Chapel of St. George Lycabettus, the Acropolis rises up above Athens' modern city (note the Port of Piraeus in the background). The master planners and architects of the Acropolis and Parthenon were Ictinus and Callicrates.

(Above) Scaled model recreation of the Acropolis in the Royal Ontario Museum. The model illustrates a processional through the Propylaea and the Parthenon and Erechtheum in the background.

(Below) Plan of the Acropolis. Note the circuitous ascension through the Propylaea, revealing the juxtaposition of the Parthenon and Erechtheum.

Plan of the Acropolis

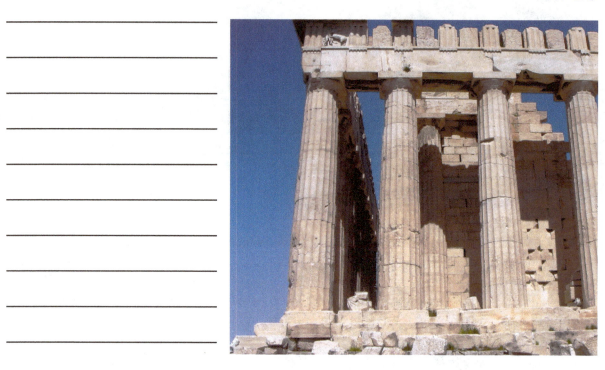

(Above) Viewing the southwest corner of the Parthenon, one can notice the closer spacing of the corner columns. This was done to correct the illusion that they would be further apart as the corners were seen with the light of the sky between them. Not evident to the eye but making profound impressions on the Parthenon's aesthetics are the many adjustments: all columns tilt inwards; horizontal lines form sweeping arcs; and it is a structure of apparent straight lines yet with few.

Plan: 1. Pronaos, 2. Cella, 3. Opisthodomos, 4. Opistho-naos. The Parthenon is a peripteral octostyle temple of the Doric Order. On a three-step stylobate, the Temple has eight columns supporting its pediment ends and seventeen columns on the sides. (See slide notes for more details on perspective-correcting mathematics.)

Parthenon

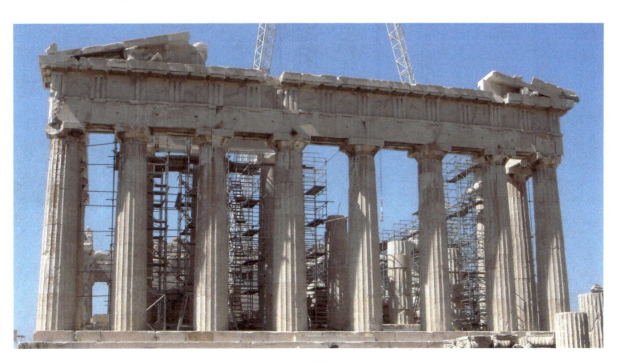

Ancient Greece

The master sculptor Phidias was responsible for the Parthenon's pediment and frieze carvings which depict the birth of Athena, Athena's victory over Poseidon for Attica, and scenes from the Panathanaic Procession.

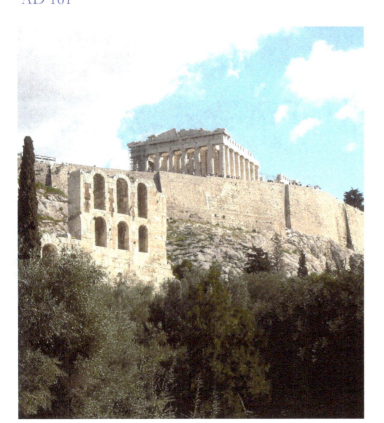

(Left) View from the Acropolis base looking up at the Parthenon (walls of Odeon of Herodes in foreground).
Note the people along the wall in front of the Parthenon.

(Right) The Odeon of Herodes as viewed from the Acropolis (vantage point in front of the southwest corner of the Parthenon).

Designed by Mnesikles, the Erechtheum is a unique asymmetrical temple, having the famous South Porch whose roof is supported by the iconic Caryatid statues. Detailing on the Ionic Order is ornate; shown are carvings that include egg and dart, and bead and reel.

The Erechtheum as seen from a vantage point just through the Propylaea and before the Parthenon, looking northeast.

(Above) The Caryatids as displayed in the Acropolis Museum. (Below) Copies of the Caryatids now support the Erechtheum's South Porch.

The statues seemingly support the load of the roof with ease; their knees gently bent, the posture of repose reflects their acceptance of this duty. As their necks alone would not have supported the weight, Phidias engages braids of hair past the shoulders to add mass.

The Making of an Empire

- It is somewhat unknown what it was that caused a small Latin tribe to conquer the world and build that empire from which we are all come; our laws, learning, religion, roads, agriculture, infrastructure, and of course — architecture.
- By mythical beginnings, Romulus and Remus were abandoned infant twins who were discovered and suckled to health by a she-wolf while being fed by a woodpecker (a lasting symbol of Rome). They were found by a shepherd and raised to adulthood. The boys proved to be natural leaders and when quarrelling over where to seat a new city (on the Palatine or Aventine hills), Romulus kills Remus and found "Rome."
- Rome at its height in third century AD stretched from Hadrian's wall in Scotland to the Persian Gulf, embracing Arabia and North Africa.
- Seneca said, "The Roman—came into the world with a sword in one hand and a spade in the other." The Romans succeeded where the Greeks didn't and vice versa. The Greek was inward looking while the Roman looked outward to the world.
- Romans despised Greeks as effeminate and tricky, yet all Roman intellectual life from nursery to university was saturated with Greek thought.
- Rome became a mix of cultures, customs, and languages. Though tolerant and even embracing of such diversity, they extinguished what they perceived as threats with alacrity.

Construction

- The arch and its use, though found in Mesopotmia, was not exacerbated until the Roman Empire. Seeking to express power through architecture, emperors were able to construct large and efficient structures that used arches, vaults, and domes, all based upon the premise of using stone in a state it performed best in — compression.
- A most lasting construction element out of many created by the Empire, was concrete. Owning to the discovery of Pozzolanic ash, the Romans modified and validated refinements of their concrete until arriving at a universal mix that could be used everywhere due the abundance of locally found materials, and the use of relatively unskilled labor required for its placement.
- The styles of Roman walls developed are the very reason their structures are even around for us to learn from today. They continue to teach us just as they taught the young Brunelleschi fifteen hundred years after their construction (see the Principle Terms and Renaissance chapter).
- Aspects of Rome's infrastructural inventions impact the modern world even today:
 - "paved" roads
 - Aqueducts
 - Fountains and water systems
 - Cisterns and drainage collection
 - Sewers
 - Ventilated exterior and interior spaces

The Architecture

- Greek architecture (and its artisan) as seen and perceived, was columns, pediments and cornice; shrines and temples; and steeped in religion.
- Roman architecture (and its engineer) was primarily structure, absorbed in the enclosure of space; of large floor areas by vaults, domes; and engineering in brick, stone, and concrete.
- Rome's utilitarian structures, bridges, roads, and aqueducts, are some of the Empire's finest qualities.
- Planning: the Greek temple was a shrine — aloof and isolated. The Roman temple was a feature in the street, an urban monument which represented the craft of the empire (not civic — of one town as in Greece). Thus, the Romans see town planning as a conscious and monumental art.
- The "grand manner," formal axis, triumphal arch, avenue, fountains, and all symmetrical attributes culminate in Vienna, Paris, and Washington, DC and owe to Rome.
- The failures of Rome (vulgarism, slums, crime) were also a product of their urban creations.
- Rome is a piecemeal city, with each emperor planning his own pretentious addition. Much of Rome's ruins were used later as quarries for stone, leaving us only that which we have today yet, we can still trace back the layouts and outlines.
- The Romans liked massive buildings of stone, brick, and cement and were fortunate to have Pozzolana Cement — the best in the world. It's by mistake that it was discovered. Rome progressed from the trabeation, to the round arch, tunnel vault, groin vault (intersecting tunnel vaults), and successions of groin vaults when buttressed.
- Modern cities owe their network of urban nodes and links to Rome. The public square (piazza) was an organic occurrence in the Roman environment. Open spaces connected by streets were the public markets and gathering spaces. The markets were located closest to relevant sources and channels of transportation (rivers and main streets).

ETRUSCAN

1. Temple of Jupiter Capitolinus 509 BC
 at Rome, Italy (from Vitruvius)
2. Tomb of the Reliefs Third Century BC
 at Cerveteri, Italy
3. Arch Third Century BC
 at Feleree Novi
4. Porta Maggiore AD 52 (Reconstructed Third Century AD)
 at Rome, Italy

ROMAN — MONUMENTAL WORKS

5. Arch of Titus AD 82
 at Rome, Italy
6. Arch of Constantine AD 315
 at Rome, Italy

TEMPLES

7. Temple of Portunus 80 BC
 at Forum Boarium (Rome), Italy
8. Maison Caree 16 BC
 at Nimes, France
9. Temple of Hercules First Century BC
 at Forum Boarium (Rome), Italy
10. Temple of Vesta First Century AD
 at Rome, Italy
11. Temple of Vesta in Forum Boarium AD 64 and 191
 at Rome Italy
12. Pantheon AD 120
 at Rome, Italy by Hadrian

FORUMS

13. Forum of Trajan AD 112
 at Rome, Italy by Apollodorus of Damascus
14. Basilica Ulpia
15. Trajan's Column

OTHER

16. Colosseum AD 70 – 82
 at Rome, Italy by Vespasian
17. Baths of Caracalla AD 211 – 217
 at Rome, Italy
18. Basilica of Constantine (Maxentius) AD 310 – 320

LATER AND EASTERN VARIATIONS

19. Temple of Baachus Second Century AD
 at Baalbek, Lebanon
20. Market Gate AD 160
 at Miletus, Turkey
21. Temple of Venus Second and Third Century AD
 at Baalbek, Lebanon

ENGINEERING WORKS

22. Aqua Claudia
 at Rome, Italy
23. Pont du Gard AD 14
 at Nimes, France
24. Via Appia Begun AD 312
 Begins at Rome

RESIDENTIAL

25. House of the Silver Wedding First Century AD
 at Pompeii, Italy
26. House of the Mysteries First Century AD
 at Pompeii, Italy
27. House of the Vettii First century AD
 at Pompeii, Italy
28. Insula of Diana AD 150
 at Ostia, Italy
29. Hadrian's Villa AD 118 — 139
 at Tivoli, Italy

1. The Composite Order:
 – Enjoying the detail and beauty of the Ionic Order combined with the scale and majesty of the Corinthian, the Romans employed the Composite Order, overlaying both capitols:

> Acanthus leaves adorn the capitol
> Volutes cap the column, though slightly turned out
> The shaft is fluted with a molded base

2. Arch:
 – Departing their vertical support at the "spring line," "voussoir" stones arc their way toward the center "key stone." Loads from above are transferred to the arches supporting columns or sides through these permanently compressed arch members.

3. Arcade:
 – A linear series of arches. The first support is called the abutment and the interior supports are called the piers.

4. Vault:
 – An "extruded" arch that forms a sort of tunneled ceiling.

5. Engaged Pilaster:
 – A column portion attached to a wall (giving visual and aesthetic support to an entablature above it).

6. Atrium House:
 – Typical of residential Roman form, an atrium house was organized around an open-air interior court.

- The Romans were outward-looking, curious of the world beyond and interested in conquering the parts they needed or liked.

- The Romans created the Composite Order, combining the Ionic and Corinthian capitol.

- Concrete as a reproducible construction material and method was invented by the Romans.

- Roman architects and engineers developed the basis for which most roads, buildings, and infrastructure are built today.

- Unlike the Greeks whose temples were aloof and built above and out of the city, the Romans made their temples a part of the urban environment, placing them in the streetscape.

- The Greek-god system was adopted by the Romans but given different names.

- The arch was refined and its use crucial to the building of Rome.

- At its extents, the Roman Empire consisted of most of Europe and Northern Africa.

The Roman Empire

1. Temple of Jupiter:
- Composite columns, higher proportions, breakaway order

2. Maison Caree:
- Engaged columns, prototype for Jefferson's First Virginia Bank

3. Arch of Titus:
- Roman Forum, columns on plinths, monumental architectural prototype

4. Temple of Fortuna:
- Columns on plinths, note fluting

5. Plan of Forum:
- Note "Imperial Planning," brings the temple to the streetscape

6. Pictorial of Forum:
- Note the bringing monumentality of temple to civic space, frontality

7. Pantheon Elevation:
- Sheathed in marble, gilded tile once covered dome exterior

8. Pantheon Interior:
- 142.5-feet sphere fits perfectly in the dome, tangent to the floor, dedicated to the deities of seven planets

9. Pantheon Section:
- Sphere derived from cosmos, note oculus "sun" walls were 20-feet thick

10. Forum of Trajan:
- Reference for Hadrian, adjacent to the ancient Forum

11. Trajan's Column:
- A Roman interpretation of the Egyptian obelisk

12. Colosseum Elevation:
- Note the stacking of the three Orders, groin vaulted

13. Colosseum Model:
- Finished by Domitian, it's a 620' x 513' ellipse that seated 50,000, could empty in five minutes

14. Colosseum Interior:
- Seating was broken into four "classes," the arena measured 287' x 180' with store rooms below

15. Colosseum Valarium:
- Roman sailors manned riggings that controlled canvas masts that shaded the seating

16. Baths of Carracala:
- Essential to Roman life, use was similar to today's community center/locker room

17. Basilica of Constantine:
- Similar to the Baths

18. Temple of Baachus:
- Use of temple motif in other applications

19. Temple of Venus:
- Similar to Greek temples

20. Aqua Claudia:
- Arcuated colonnade with water channel above, the first public waterway

21. Pont du Gard:
- 900-feet long and 180-feet above Gard River, utilitarian corbels/design

22. Via Appia:
- "all roads lead to Rome," the first and most enduring road system

23. House of Mysteries:
- Istacidi family, most complete example of suburb living, excavated in 1909

24. House of Vettii:
- Exemplifies atrium/court layout which was a reaction to climate

25. Hadrian's Villa:
- Home of Emperor Hadrian (builder of the Pantheon), philosopher

26. Hadrian's Villa:
- Contained a court, the piazzo d'oro, libraries, naval theatre, philosopher's hall, a stadium, baths, and storerooms

27. Temple of Jupiter:
- The colossal temple of the Forum

28. Arch of Titus:
- Early "victory" arch, commemorates heroic feats

29. Arch of Constantine:
- Commemorates victory over Maxentius at Ponte Miluro

Roman Empire Timeline

Timeline labels: Mythical Founding of Rome · Roman Forum in Boarium · Pont du Gard Aqueduct · Roman (Trajan's) Column · Pompeii · Baths of Caracalla · Piazza Venezia · Ostia Antica · Roman (Caesar's) Forum · Maison Caree · Roman Colloseum · Pantheon · Piazza Navona · Spanish Steps

Dates: 750 BC · 3rd c. BC · 1st c. BC · 1st c. AD · 14 BC · 16 AD · 113 AD · 70 AD · 79 AD · 120 AD · 212 AD · Piazzas Various Dates

The iconic Italian "Vespa," lining the streets of Rome on any given day.

Shown below are four stone plaques that depict the growth of the Roman Empire (any white represents Rome). The are lined up on a wall along the "Imperial Way," which connects the Colosseum to Piazza Venezia as one passes by the ancient Forum.

The Roman Empire

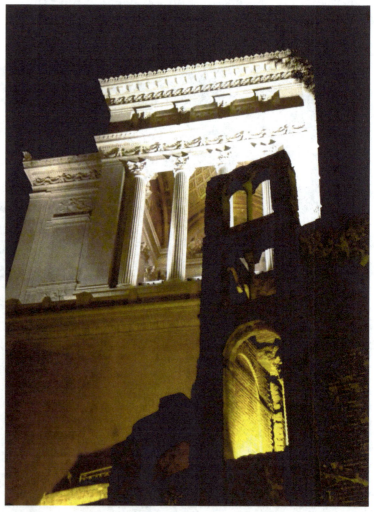

———————————————————

———————————————————

———————————————————

———————————————————

———————————————————

———————————————————

———————————————————

———————————————————

———————————————————

———————————————————

(Above) Italy's fertile volcanic soil and abundant sunshine result in organic produce that is wildly fragrant and bursting with flavors.

(Left) Rome spills with scenes of contemporary architecture juxtaposed against antiquity.

(Above) Housed in the Capitoline Museum in Rome the Capitoline she-wolf (*lupa*), was said to have suckled Romulus and Remus to health.

After Romulus founded Rome, the City's population grows rapidly, mostly of unmarried men, refugees, and rural farmers. To ensure the proliferation of Rome, Romulus led the abduction of Sabine women. Pictured (left), Giambologna's "Rape of the Sabine Women" (*raptae — to take*), as seen in Florence's Loggia dei Lanzi.

The Roman Empire

A founding city of the Empire, Ostia is located at the mouth of the Tiber River west of modern-day Rome.

(Left) Relieving-arch in the wall distributes forces.
(Below) The theater at Ostia.
(Bottom) Keyed map depicting Ostia Antica at around AD 80.

Streets running in cardinal directions illustrate early Roman planning techniques, the intersection of which (the main streets) create a forum.

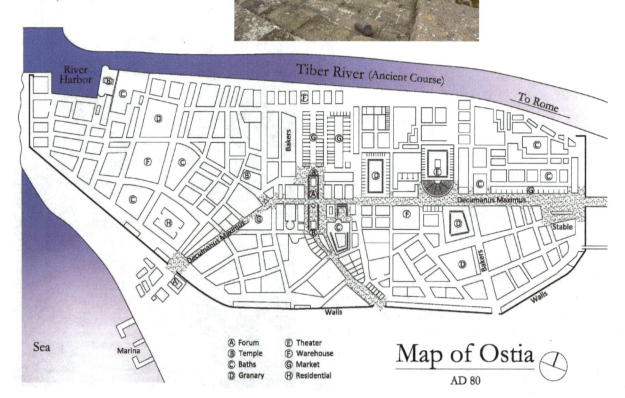

A Forum E Theater
B Temple F Warehouse
C Baths G Market
D Granary H Residential

Map of Ostia
AD 80

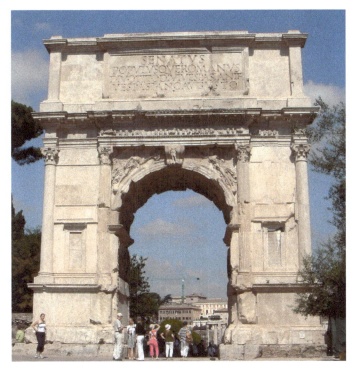

(Above and left) The Arch of Titus on Via Sacra was the template for the triumphal arch (image on the left showing Titus' spoils of Jerusalem).

(Below left and right) The Temples of Portunus and Hercules respectively. Portunus showing the engaged column technique, and Hercules showing Roman flexibility of form, both brought to the streetscape.

The Roman Empire

(Above) The Arch of Septimius anchors the northwest end of the Roman Forum (it commemorates the Emperor's Parthian victories over his sons Caracalla and Geta).
(Below) A view from within the Roman Forum.

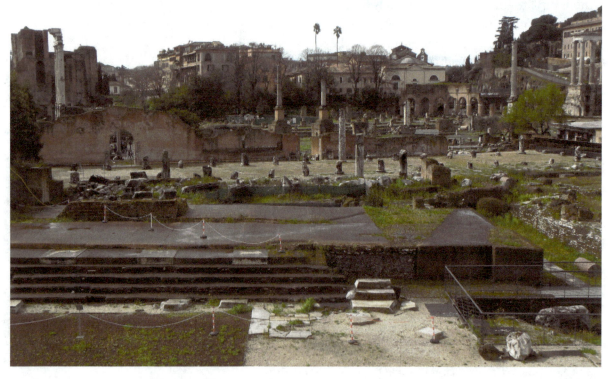

The Slides: The Forums
Caesar's Forum
First Centuries BC and AD

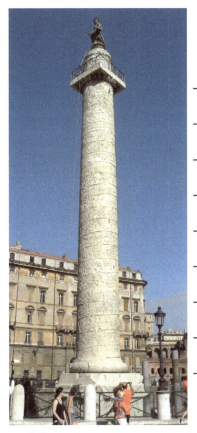

(Below left and right) The Temples of Mars, in the Forum of Augustus, and Saturn, in the Forum Romanum, respectively.

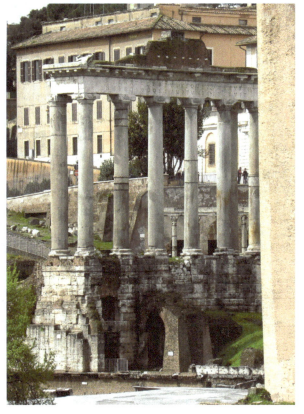

The Roman Empire

(Opposite page and left) The Column of Trajan in Trajan's Forum (shown below). The column, Trajan's interpretation of the Egyptian obelisk, shows his victories in the Dacian Wars.

(Below) Trajan's Forum, constructed along with markets and the renovation of Caesar's Forum. The design is attributed to the architect Apollodorus of Damascus.

(Below and right) One of the best preserved Roman temples is the Maison Caree. A "Vitruvian" temple by mathematics, it illustrates the engaged column and served as a template for structures to come, including the Pantheon.

The Roman Empire

Bocca della Verita "the Mouth of Truth" was placed in the portico of Santa Maria Cosmedin in Forum Boarium and is thought to be part of a first-century fountain. "Bocca" refers to the ancient god of the Tiber River. It was believed in the Middle Ages that if a lie was told while one's hand was in the mouth, it would be bitten off.

A sewer channel shown right, discovered during a new construction project in Vienna, Austria. The method of construction (arched capping) is an example of infrastructural durability, an enduring quality of Roman building.

The Romans developed various wall construction types, owing their integrity to Pozzolano concrete and varying bonds and coursing. Shown are:
(Top right) Wall of Opus Incertum
(Middle) Wall of Reticulatum
(Bottom left) Wall of Opus Listatum

The Roman Empire

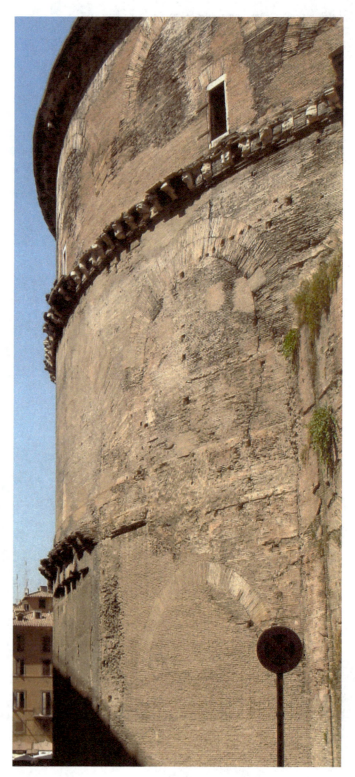

Shown left is the rear wall of the Pantheon (AD 126). Note the use of relieving arches built into the wall. They were use to distribute loads from above efficiently and also served as a planer interlock.

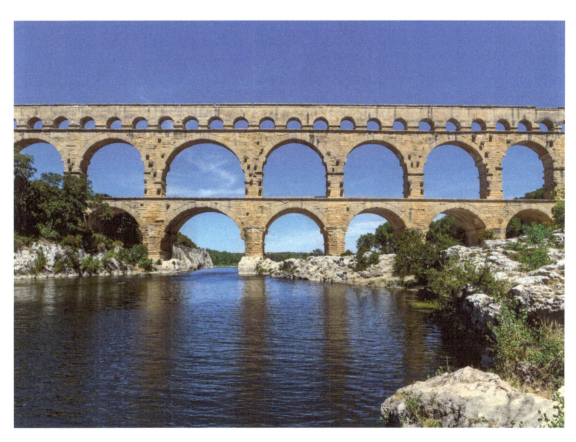

Meaning "guard bridge" and spanning the Gardon River, this — the highest of Rome's aqueducts rises 160-feet above. The aqueduct's descending displacement is 56-feet (to facilitate flow via gravity) but the bridge portion descends on 0.98 inches, a ratio of 1:3000.

The Roman Empire

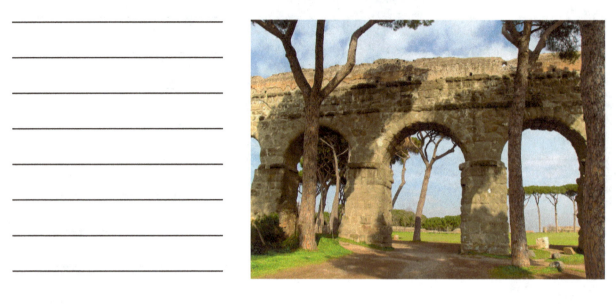

(Above) Parco degli Acquedotto (Aqueduct park), located along the Via Appia.
(Below right) Aqua Claudia (also shown above in Aqueduct Park), was completed by Caligula in AD 38. Providing abundant water was crucial to the Empire's cities and considered a compulsory task for Rome's leadership.

The Slides: Entertainment
The Colloseum, Rome
AD 70

Known as the Favian Theater, the Roman Colloseum was started by Vespasian, completed by his successor Titus, and modified under the reign of Domitian, the three known as the Flavian Dynasty after their family name.

Constructed of concrete and stone, it was an arcuated ellipse in shape (an improvement upon the Greek theater) and stacked the three Greek Orders as shown below.

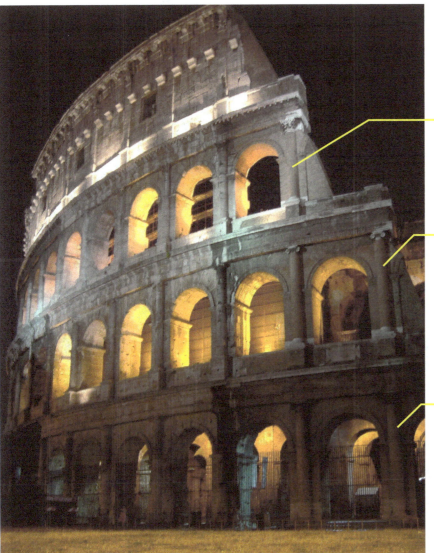

Corinthian Order

Ionic Order

Doric Order

The Roman Empire

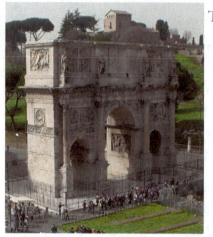

The Slides: Entertainment
The Colloseum, Rome
AD 70

(Right) The Arch of Constantine as seen from the Mezzanine level of the Colloseum.

Entertainment programs for the Colloseum included gladiatorial contests, animal hunts, sea battles, theatrical shows, and public events. Beyond the partially reconstructed deck shown below, one can see the lower chambers where animals and prisoners were kept.

Holding over 50,000 spectators, it could be emptied in ten minutes due to the efficient design of portals passages.

Built by Apollodorus for the Emperor Hadrian, the Pantheon was constructed on the site of a previous structure built by Agrippa. The inscription still legible in the frieze reads, "Marcus Agrippa, son of Lucius, three times consul, made this building."

The Roman Empire

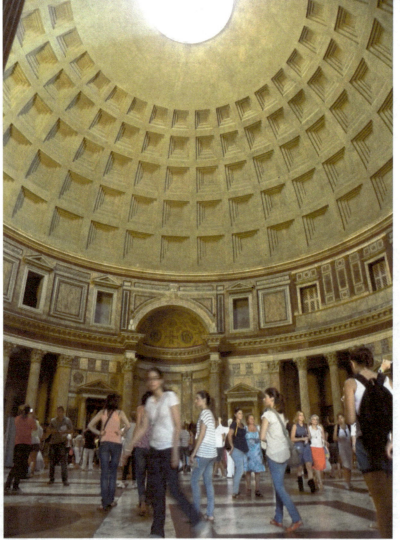

Said to be a Pantheon to "all gods," it may be presumed that forming the design around a 142.5-feet diameter sphere related the building to the cosmos. The concrete dome's coffers lead the eye up to the almost 30-feet diameter open-oculus in the roof.

The image above illustrates the moving-spotlight on interior statue niches created by the Sun's path.

Viewing the coffers right, note the eccentric receding squares; this was done to reverse the illusion that they would be eccentric when viewed from below (opposite).

The coffers also created vertical ribs and displaced mass, therefore lightening the weight of the roof.

Though having experienced several renovations, this temple, located in the serene streetscape of Assisi still maintains its First-Century-AD Corinthian Order temple-front.
(Above) The Temple's interior shows its Sixteenth-Century interior of Santa Maria Sopra Minerva.

The Roman Empire

(Left) A caldarium (hot room) at the baths at Pompeii. Note ceiling ribs which were used to channel condensation down to the decorated pilaster and frieze to prevent dripping.

(Below) Ruins of the Baths of Caracalla, likely built to gain political favor with Roman citizens. Lavish yet functional, the baths served as a sort of community center, having pools, saunas, gymnasiums, and even libraries.

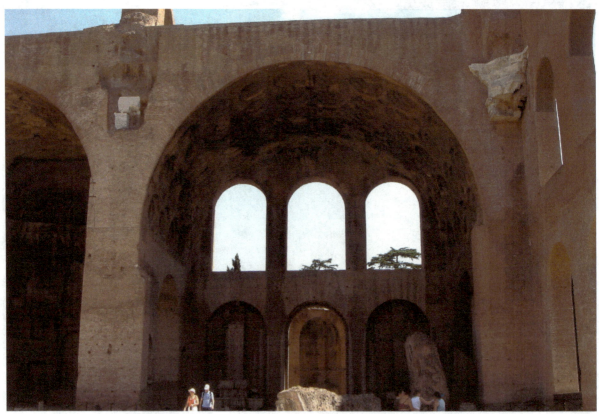

Founded by the Osci around the Sixth Century BC and conquered by the Romans in 80 BC, Pompeii was an important harbor-city brisk with trade and commerce from all around the Mediterranean.

(Below) The Forum stands before Mt. Vesuvius (background), which erupted in AD 79, covering the City in approx. 20 feet of pumice and ash. Near modern-day Naples, excavations of Pompeii continue even today.

The Roman Empire

Images shown illustrate Roman mastery of urban infrastructure. Brought into the City via aqueducts, water was distributed through fountains that provided a potable supply while overflowing into the streets, flushing runoff and waste. Note the basalt tablets that serve as stepping stones for pedestrians. Close inspection also reveals wear, both on the street from chariot wheels and on the fountain from drinkers placing their hands for support.

(Above right) The quadriporticus as seen behind the Theater of Pompeii. Also shown below and to the right, this portal-gate into the City was re-built following damage from an earthquake in AD 62 and transformed into barracks for gladiator training.

(Top) The *mensa ponderaria* (public weights and measures table).

(Above) Piping, likely made of lead, showing a seam-hem along the top and curb-joint made of a metallic "butterfly."

(Below right and left) A mosaic from the entry to the House of the Tragic Poet reads *cave canem*, "beware of the dog." Pompeian sidewalks were lined with "cats eyes," white marble mosaics inlayed into the walk surface that reflected in the evening by moonlight or the light of burning oil sconces lining the streets, guiding pedestrians.

On August 24, AD 79, Mt. Vesuvius experienced a "pyroclastic" explosion (which is different from a volcanic kettle-eruption). Following the main explosion, hot pumice (tephra) and air-surges reaching over 400°F brought certain death to all in the City. Excavations reveal cavities with skeletal remains; plaster was pumped into the cavity, assuming the configuration of the body and encapsulating the bones. Shown above is a man trying to cover his face, and a dog contorted on its back. Shown below is a man, likely a slave as there appears to be a belt shackled to his waist. Note the remains of his skull somewhat intact on the underside.

The Roman Empire

The baths were a part of every major Roman City, Pompeii included. Shown left is the *frigidarium*, "cold room," of the Pompeian Baths. Shown below-center are niches separated by small statues. It is believed that these were served as lockers where garments and sandals would be stored during the bath.

(Below) Typical street-bar showing vessels for keeping wine and consumables cool. Note the grooves in the curbing which were for sliding doors.

(Far left) A basalt pestle for grinding grain into flour and a typical Pompeian oven for baking.

To appreciate Pompeii's fresco-erotica is to understand the mores of the Romans; that while liberal, must be seen in the context of an era where fertility gods were imperative.

Called the "*Lupanar*" (wolf den), brothels were a fact of Roman life. The name derives from women who would howl like a wolf to indicate their availability. Pompeii was a sea-faring commercial center and as such, men arriving from sea could find the brothels by following the direction of the phallus symbols carved into the street stones.

Shown below, frescoes in the brothels served as "menus" therefore, mitigating the need for translation of languages.

The Roman Empire

The images below are from various Pompeian residences and illustrate the "atrium style" design that used an open-air atrium to facilitate ventilation and allow rain water to be captured below in a foot-pool called the "impluvian". Beyond the impluvian was the *tablinum* (reception) which opened to the peristyle, an open atrium about which the rooms were organized.

Colorful scenes in fresco often decorated the walls.

(Above) The ever-popular Piazza Navona was built upon the site of the Stadium of Domitian, known as *"Circus Agonalas"* (arena of the games). At it's center stands Bernini's famous *"Fontana dei Quattro Fuimi"* (fountain of the four river gods).

(Left and below) Piazza del Popolo (people's square). Located near the north gate of the Aurelian Walls, the piazza was once the place for public executions until 1826. The Egyptian-style lion below stands guard near the obelisk (left) from the period of Seti I and erected here in 1589 by Sixtus V.

The Roman Empire

Meaning "largest circus," Circus Maximus was Rome's largest chariot racing stadium and sporting arena. Measuring approximately 2,037 feet long (more than one-third of a mile) and 387 feet wide, it held roughly 150,000 spectators and was situated in a valley between the Aventine and Palatine Hills.

Now a public park located a short walk from the Colloseum, it served as the template for most of the Empire's circuses.

Seen beyond the Circus, are the massive ruins of the Baths of Caracalla.

At the intersection of Via del Corso and Via dei Fori Imperiali, Piazza Venezia was named for Pope Paul II (Pietro Barba) from Venice. Flanked by two Venetian style palazzo's, the square lies between the Colosseum, Piazza del Popolo, and Stazione Termini (by way of Via Nationale). The image below was taken from the steps of the Monument to Vittorio Emanuele II (first king of Italy), seen above.

The Roman Empire

The Spanish Steps (often called the "living room" of Rome), ascend from Piazza di Spagna at the bottom, to Trinita de Monti, the Church at the top.

(Above) Built in the Roman Baroque Style, the steps provide a dynamic experience as one climbs the 135 steps (often weaving through the bustle of those seeking the same view).

(Below) A view from the top reveals Pietro Bernini's "Fontana della Barcaccia," (fountain of the sunken boat), at the beginning of Via Condotti. The fountain was built to commemorate flooding in the Square from the Tiber River.

116

With over four hundred fountains in Rome, cataloguing them by theme, period, or size would be a book in itself. At one time, eleven aqueducts brought water to the city and the fountains were an important aspect in delivering it, along with providing a mechanism for cooling public squares.

(Above) The Fountain of Neptune (AD 1565) at the north end of Piazza Navona was built during the restoration of the aqueduct Aqua Virgo, bringing water to Campo Marzio.

(Below) The popular "*Fontana di Trevi*" (Trevi Fountain, AD 1762), derives its name from the convergence of three roads (*tre vie*) at the termination of the aqueducts Vergine, Virgo, and a First-Century-BC Roman aqueduct. Legend is the basis for the fountain's scene, that a virgin girl led Romans to the water's source.

The Roman Empire

———————————————
———————————————
———————————————
———————————————
———————————————
———————————————
———————————————
———————————————
———————————————

Called "the City of domes," a view of Rome's skyline appears like a painting from any vantage point. Its mix of periods, styles, materials, and colors, reflect the "Eternal" city's evolution over the centuries.
In the image below, how many domes do you see?

Ancient Greece

Culture:
- The "Classical Age" was this Athenian generation, 5th Century BC
- Greek culture manifested itself in:
 - Art & architecture
 - Customs and laws
 - God-system, theatre, literature and Myth
- Greeks, obsessed with beauty as defined through
 - Scale, proportion, balance, color
 - Mathematics, rules and function
- Axioms: "Know thyself", and "nothing in excess"

Architecture:
- The Greek Orders were developed, an order meaning a building's base, column style and diameter, entablature and pediment (roof)
- The Orders include:
- Doric, Ionic & Corinthian
- Delphi was host to the God Apollo and the Oracle, getting its name from the dolphin Apollo transformed into to save the people at sea
- Architectural refinement manifested itself on the Acropolis where they built the Parthenon, Erechtheum, and Propylaea
- Pericles was the elected leader of Greece during this period, called the golden or "Hellenistic" age
- Parthenon (Doric) was a web of mathematical optical corrections named for Athena Parthenos, who fought Poseidon for Athens
- Erechtheum was a smaller, detailed Ionic temple that used "Caryatid" columns (women in repose) to hold the south porch roof
- The primary architects were Ictinus, Callicrates and Mnesicles, while Phidias was the master sculptor in charge of art program

Detail:
- Greek Mythology and Gods underpin all architectural development
- The Greeks were inward-looking people who saw the rest of the world as barbaric
- Ancient Greece was a maritime, sea-faring culture that was a collection of city-states unified for the greater purpose
- Skill and craft of work was a reaction to their quest for beauty and perfection
- The architecture was actually very colorful, the entablature and pediments often painted with primary colors

Roman Empire

Culture:
- Much of Rome's culture had its origins in Ancient Greece
- Rome adopted the orders and added the Composite (larger, combining the Ionic & Corinthian)
- The Romans were outward-looking seeking to conquer the World
- Mythically, Ramos and Romulus were saved by a she-wolf and founded Rome

Architecture:
- Roman architecture advanced engineering, (e.g. sewers, fountains, aqueducts, etc.)
- Scale and large spatial enclosure showed Roman power
- The Romans built their temples right in the streetscape (not on hills like the Greeks)
- Concrete was an invention of the Roman Empire
- Roman architecture developed the "engaged column"
- Emperors constructed "triumphal arches"
- Hadrian built the Pantheon (later copied by Jefferson at UVA)
- The Coliseum held over 50,000 spectators and could be flooded
- Aqueducts included Aqua Claudia & Pont du Gard
- Fountains provided water and cooled the public piazzas
- Roman baths were gifts to the community
- Rome exacerbated the use of the arch and dome

Detail:
- The Roman Empire consisted of most Europe and northern Africa
- A Roman city was based on cardinally-directed main roads at the intersection of which was a Forum
- The main road was called the Apian Way

After the Fall of Rome

- July 25, AD 306 — Constantine acclaimed emperor of world and seven years later gives freedom to Christian church.
- He is baptized on his death bed and self declared the 13th Apostle, believing he would be absorbed into Holy Trinity at death. This choice of deity secured him loyalty of the army and people.
- With Rome in peril, he moves capitol of the Empire in AD 334 to Byzantium (Istanbul), renaming it Constantinople. This Hellenistic location dominated by Greek culture was a strategic location, making Venice to Kiev close and Peking within knowledge.
- It remained Christian until it fell to the Turks in AD 1453 — what some called the end of the world.
- Byzantium married the art of the Greeks and the engineering of Romans as exemplified in the architecture of church.

A Juxtaposition: Byzantium and Gothic

- The best way to analyze them is to oppose them. They are a contrast in structure, plan, and decoration.
- Hadrian's Pantheon was liked by Constantine.
- Byzantine architecture involves solutions to problems inherent in the construction of domed buildings, discovery of decoration for these buildings, and the integration of plan and liturgical "function."
- As in the Pantheon — the circle is the most inflexible form and most difficult to expand on. This era sees the circle built over the square — each with its own dome allowing the connection of many squares.
- A circle drawn in a square leaves four triangular areas; this is the concept of the pendentive — base of a dome.
- Medieval architecture was European but emanated mostly from France after the twelfth century, it has come to be called Gothic.
- Brittany was on the fringe of Celtic world; Normandy, Burgundy, Aquitaine, and Provence were represented in the Roman Senate.
- Central realm of ile de France Capetian monarchy dating back to the days of Charlemagne. Hugh Capet in the tenth century called "August King of France and Aquataine."
- Normandy, Burgundy, etc., slowly came under rule of Royal Scepter.

BASILICA CHURCHES

1. Old ST. Peter's Basilica begun AD 324
 at Rome, Italy
2. St. Paul's (Outside the Walls), Secolo IV AD 380
 Via Ostiense, Rome
3. S. Apollinaire in Classe AD 549
 at Ravena, Italy

CENTRAL CHURCHES

4. San Vitale AD 547
 at Ravena, Italy
5. Hagia Sophia AD 532 – 537
 at Istanbul, Turkey Anthemius and Isidorus
6. Charlemagne's Chapelle AD 800
 at Aix-La-Chapelle (French), Aachen

ROMANESQUE ("Roman-like," the year 1000 AD brings a rash of church building)

7. Cathedral at Pisa AD 1063 – 1118
 at Pisa, Italy, Boschetto
8. Sant'Ambrogio begun AD 1080
 at Milan, Italy
9. St. Mark's AD 1063
 at Venice, Italy
10. St. Etienne AD 1050
 at Vignory, France
11. Abby Church AD 1095
 at Cluny, France
12. Santiago de Compostella Cathedral begun AD 1077
 at Santiago de Compostella, Spain
13. Ste. Foy AD 1050 – 1130
 at Conques, France
14. St. Gilles du Gard begun AD 1116
 at St. Gilles, France
15. Durham Cathedral AD 1093 – 1133
 at Durham, England
16. St. Etienne AD 1066 – 1115
 at Caen, France, for William the Conqueror

1. Church Plan Form:
- Byzantine churches were usually laid out in a "Greek" cross shape, having centrality while the parts of the church splayed away equally. Gothic cathedrals were usually laid out in a "Latin" cross, having the transept cross the nave two-thirds of the distance to the altar:
 Greek Cross, equal arms
 Latin cross, high cross-arm

2. Church Anatomy:
- Whether Byzantine or Gothic, both forms share similar parts (listed from front to back):
 Narthex — the entry space into the church
 Nave — the space where congregants collect (often called the sanctuary today)
 Transept — the chapels that cross through the nave
 Crossing — the place where the nave and transept intersect
 Choir — the space after the crossing
 Apse — the chapel(s) that terminate the progression, often housing the altar

3. Pendentive:
- The triangular form resulting from a circle inscribed in a square. In three dimensions, this forms a complex curved triangle, the underside is called the "squinch" (this was decorated)

4. Vault:
- An "extruded" arch that forms a sort of tunneled ceiling

5. Mosaic:
- A pictorial image made by the ensemble of marble or glass pieces — mosaics decorated the interior of the Byzantine basilica as a way of explaining biblical stories

► The fall of Rome saw Constantine move the seat of the Empire to Istanbul (he renames Constantinople), where Justinian I builds Hagia Sophia meaning "holy wisdom."

► The Byzantine church form is Romanesque and can be described as masculine in form.

► The Byzantine church's mass and forms are its decoration (compared to the carving of Gothic).

► Most Byzantine basilicas are centrally planned, based on the Greek cross, and have a dome over the crossing.

► Mosaics were used to explain biblical stories and decorated the massive architectural shapes within the church.

► Often, the church's exterior was plain and of local stone while the interior was colorfully decorated.

1. Old St. Peter's Basilica:
- Originally constructed of wood trussing, illustrates lack of wealth

2. St. Paul's "Outside the Walls":
- Fourth century AD, 132 meters long, built on burial place of the Apostle of the Gentiles

3. St. Apollinaire in Classe:
- Justinian recaptures Ravena from Goth barbarian Kings, lack of transept, lamb mosaic represents Apostles coming from Bethlehem

4. San Vitale at Ravena:
- Emperor had just established new Roman capitol in Raven, Italy. Sister church of Saint Apollinaire in Classe. Follows eastern church, foot print, octagon, dome constructed of much lighter material — reducing outward forces — which reduce buttressing. Exterior wall a little hefty however. Towers flanking entrance show it was a "Royal" church to "emperor" (Justinian). "Squinches" cut and bridge corners and also add simplicity to seat dome, shift from square to octagon then to 16-sided form. Double stilt block columns — classicals thrown out of picture now. Very decorative interior — marble, colors, and mosaics. Drillwork of capitols substitutes carving of Corinthian columns. The concave triangular surfaces supporting the dome (pendentives) are decorated by colorful mosaics. Towers flanking entry show royal church to emperor Justinian.

5. San Vitale Plan:
- Eastern — octagon footprint—light material reduces outward forces

6. San Vitale Interior:
- Interior decorative with marbles, mosaics, colors, drillwork capitols

7. Hagia Sophia:
- Anthemius' son finishes after dome collapsed, 40 windows, 40 ribs

8. Hagia Sophia Section:
- Dome floor 107' X 250', Junstinian camped at site to urge construction.

9. Hagia Sophia Plan:
- Meaning "divine wisdom," displays impressive elegance, minarets added later

10. St. Ambrogio at Milan:
- Four-part-rib vaulting in nave (note atrium), tie-rods, triforium gallery

11. Cathedral at Pisa:
- Designed by Boschetto, cathedral not well know, early Romanesque example

12. Tower at Pisa:
- Failed due to soils, Bonano knew about leaning at third floor, Galileo's experiments

13. St. Mark's Venice:

– Most of façade was added in the Gothic period. Essentially a centrally planned church. Relates with eastern churches. Famous set of horses above entrance were looted from invasion of Constantinople and shows Venetian superiority. Interior utilizes domes on pendentives.

14. St. Etienne at Caen:

– Built for William the Conqueror, Romanesque to spires, sailing buttress

15. Abby Church, Cluny France:

– Most involved monastery, double transept (more chapels)

16. Santiago de Compostella:

– Holds remains of St. James (apostle), pilgrim church of nine spires

17. Ste. Foy at Conques:

– High tunnel vaulted nave with high crossing topped with lantern

18. St. Giles du Gard:

– Note Romanesque — receding arches

19. Durham Cathedral:

– First church to use ribbed vaulting, also fortress against Scotts, masonry

20. Rheims Cathedral:

– Rheims — breakdown of solid surfaces, columns to colonettes, clerestory development.

Byzantine Timeline

Founded by Constantine and consecrated in the fourth century AD, this papal basilica was believed to have been built over the burial place of St. Paul. Behind the nineteenth century portico lies the Holy Doors from Constantinople, opened only during the Jubilees. The interior shows typical early basilican arcuated colonnades and a decorated coffered ceiling.

———————————————

———————————————

———————————————

———————————————

———————————————

———————————————

———————————————

The Church's nave is center-aisled flanked by side aisles leading to a typical early basili-can polygonal apse, the alter of which is said to be over the burial place of Saint Apolli-naris' martyrdom. The marble columns are capped with typical Byzantine "wind-blown leaves" capitols, created by a carve and drill technique. The abundance of light is com-plimented by the use of light shades of mosaic color that gives a glittering effect.

San Vitale is one of the most important basilican churches, noted for its vast interior area of colorful mosaics, it remains one of the best preserved churches from the period of Justinian I. The Church combines Roman and Byzantine elements as seen in its use of geometric shapes and its expression of massing.

Byzantine

Central to the themes of mosaics in San Vitale is the desired authority of Justinian. It can be interpreted to represent his desire to reign as a traditional emperor while simultaneously reigning as the defender of faith as the Christian emperor. The image above is a part of a large program of mosaics in the chancel.

The image to the left depicts the typical carved and drilled Byzantine column capitol, below is the dome.

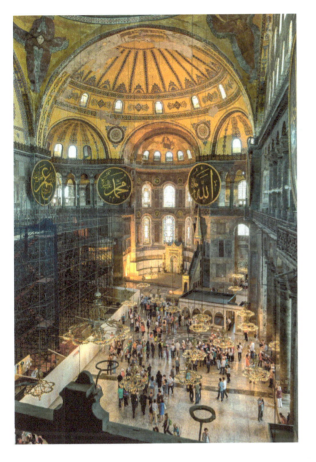

Hagia Sophia is known as the first masterpiece of the Byzantine period. The lasting structure of Justinian is the last of a series of constructions: the first church by Constantius II; the second by Theodosius II; and the third (present-day) structure by Justinian I. Though an entirely new building, it was not without its failures. Built by Isidore and Anthemeus, there were tell-tale signs that the dome was not stable after earthquakes in AD 553, 557, and 558.

Somewhat flat, the dome was brought down by shear forces from the piers. Isidorus (the younger) who was the nephew of Isidore, redesigned and built the dome we see today. It rests between two half domes, has a 102.5-foot diameter and measures 182.5-feet tall. Its weight is distributed by pendentives to the supporting walls.

Byzantine

Built as an early Byzantine Christian church, Hagia Sophia became seat of the Eastern Orthodox Church, then was converted to a mosque thus it shares both Christian and Muslim decoration inside. Its structural massing is traditionally Byzantine, incorporating classic carved and drilled columns. Interior and mosaics and decorations are some of the period's most valuable and elaborate, causing Justinian to proclaim, "Solomon, I have outdone thee."

Located in Pisa's *"Piazza di Miracoli"* (square of the miracles), the cathedral, along with its majestic baptistery and fabled belfry, stands as testament to eleventh-century faith. Grey marble with arcuation topped by pointed arches, make the exterior distinctively Romanesque while mosaics and gilding show the interior's Byzantine influence. The large multilevel baptistery allowed numerous attendants (see image opposite). The baptismal font (above), was carved by Nicola Pisano and became an inspiration for sculptors for years to come (his son Giovanni carved the Cathedral's pulpit).

Byzantine

The Cathedral's campanile (known as the "leaning tower" and shown opposite), was begun in 1173 and was built over three separate phases. Its unintended lean was due to unsuitable bearing conditions and begun during construction. Design assignment has been circumspect at best, owing its beauty to either Bonanno Pisano or Tomasso di Andrea Pisano. Galileo's secretary recorded that he dropped cannon balls of differing mass and swung pendulums from the tower.

The design is quintessential basilica, with its frontal atrium, clerestory-lit nave, flanking side aisles and apse. Constructed of bricks from various periods, two bell towers flank the narthex; the right tower called "*dei Monaci*" (of the Monks) and the left tower built over different period. The interior expresses Romanesque description by use of stone, brick and plaster, delineating the arcuations.

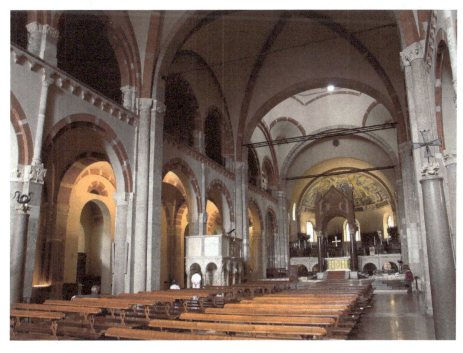

Byzantine

Venice, a collection of over one hundred small islands, was founded in the marshy lagoons between the Po and Piave Rivers. Now the capitol of the Veneto region, it was named for its original ancient inhabitants — the Veneti, and was a prosperous maritime community during the Middle Ages and Renaissance. Its network of canals, marriage of Eastern and Western influences, and adaptability to its environment make Venice one the most unique and beautiful cities.

(Above) St. Mark's Square, flanked by the Campanile and the Doge Palace.
(Below) A view down the Grande Canal taken from the Rialto Bridge.

St. Mark's, seen looming behind the Campanile from across Piazza San Marco below, derives its layout and form from Constantine's Church of the Holy Apostles (no longer existing) and Hagia Sophia, including its plan based on the Greek cross, crossing dome, and subordinate domes over its out-stretched arms. Enveloping the west end, the narthex creates the architectural canvas on which the façade tympana decorate. The square has been referred to as, "the drawing room of Europe." Its shape trapezoidal, it directs focus onto the composition of St. Mark's, the Campanile, and the Doge Palace.

Byzantine

The façade transitions from the lower register of portals and columns, to the upper register of mosaic-decorated lunettes, to the domes. Lower register mosaics describe the life of Christ. Upper register mosaics describe the relics of St. Mark.

(Left top) The Doge and people of Venice receive the body of St. Mark above St. Peter's Gate.

(Left middle) Last Judgment.

(Left bottom) Venetian merchants smuggling St. Mark's body out of Alexandria, Egypt. To get past the Muslim guards, they covered his body in layers of pork (the fellow in blue is holding his nose).

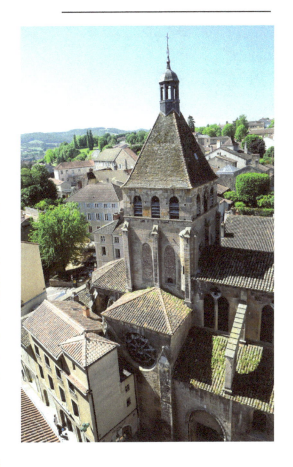

(Above) Local stone, more simplified detailing, and a more vertical expression is typical for this period of Romanesque basilica design.

(Left) Note that Abbey Church is more woven into the fabric of Cluny's village, complimenting the settlement's landscape yet providing a visual and spiritual anchoring point. Conforming to the Rules of St. Benedict, the Abbey owes its form to its Order's edicts, prohibiting the ownership of land by way of feudal service, and the liturgy was its main form of work.

Byzantine

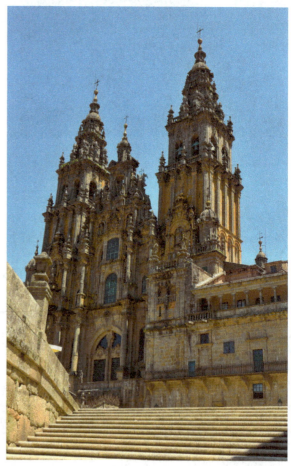

Said to be the burial place of St. James the Great. This basilica's Baroque façades provide dynamic backdrops for their adjoining piazzas, creating a unique urban environment.

The *"Portico de Gloria"* (portico of glory), has three-arched tympanum, the center of which depicts St. James.

The Romanesque barrel vaulted nave, seen above, is flanked by side aisles — each with eleven bays and it is intersected by a large transept of six bays.

Additionally, a pulley device is anchored in the dome above the crossing, and swings the Botafumeiro, which emits clouds of incense.

St. Foy, nestled into its valley village, has retained its original Romanesque form and sense of retreat since its medieval founders. The tympanum shown left, is typical for this period in southern France, depicting the Last Judgment through its numerous angels and demons. As seen above, the nave, though short, expresses great height. This was accomplished by extending the pilasters engaged to the columns, up to the vaults.

St. Gilles Romanesque style is plainly expressed by the three-arched portals and Corinthian columns. They include scenes and figures from the Old and New Testaments, the Adoration of the Magi, and the Crucifixion of Jesus.

The crypt shown above, houses the tomb of St. Giles, whom legend says founded the church in the Seventh Century on land given to him after he was mistakenly injured by a Visigoth King (Wamba) during a hunt.

The Slides: Romanesque Churches
Durham Cathedral, Durham England
AD 1093

Durham could be considered a "transition" basilica, though Romanesque, as it features many elements that are later found in Gothic architecture (pointed arches and mullions). Its interior hints at the approaching Gothic period too, its ceiling decorated with ribbed vaults, pointed arches, and somewhat slender columns.

Popularity has come recently to Durham Cathedral, having been represented as Hogwarts School in the Harry Potter films, a spire having been digitally added to its exterior.

Byzantine

Also know as *"Abbaye aux Hommes"* (mens, abbey), St. Etienne (Stephen) was in the Romanesque style but has had numerous Gothic renovations and additions. Also considered transitional (between Romanesque and Gothic), it is the burial place of William the Conqueror and served as a place of refuge for the inhabitants of Normandy during the Landings of WWII.

A Juxtaposition: Byzantium and Gothic
- The social system has great impacts on Gothic architecture.
- Trade routes, abbeys, and monasteries lose power as a gathering place. Now the "city" becomes the central gathering place for trade, etc.
- Cities more or less compete for tallest and best cathedrals.
- A rash of building is seen in this period — early evidence of building from plans. Spiritual matters take precedence over scientific discoveries. Realities are lost in the beliefs of the church (i.e., Copernicus and Galileo).
- Gothic cathedrals viewed from the interior appear to be supported by faith, the structural systems "hidden" yet acknowledgeable from outside cathedral.
- Important aspects of Gothic cathedrals: the pointed arch, the flying buttress, and stained glass.
- Space enclosed within the cathedral is the most important aspect, not the exterior shapes and forms.
- Sculptural programs given great respect, some portions of programs are even surprising. Structural systems and pointed arches transfer forces directly to piers and one can adjust the heights of the arches and control of forces with buttresses. Striving for height is the imperative element (real and apparent).

Gothic Elements
- Medieval architecture was European but emanated mostly from France after the twelfth century and came to be called "Gothic."
- Brittany was on the fringe of the Celtic world; Normandy, Burgundy, Aquitaine, and Provence were represented in the Roman Senate.
- Central realm of ile de France Capetian monarchy dated back to the days of Charlemagne. Hugh Capet in the tenth century was called "August King of France and Aquataine."
- Normandy, Burgundy, etc., slowly came under rule of the Royal Scepter.
- Gothic architecture must be seen by a Gothic Europe:
 - a. A product of caste — each man had his specific place.
 - b. The church or monastic orders built churches, cathedrals, abbeys
 - c. The aristocracy built manors and castles
 - d. The merchants and burghers built towns
 - e. Fine building a function of church and worldly success
- Roofs were of stone (so to be fireproof) where outward thrusts were resisted by buttressing, not thick walls as in Romanesque.
- Glass was subdivided by mullions and adorned with stain and tracery.
- Gothic was "carved masonic architecture," every stone, molding, and mullion was carved for a particular place in building and key features included:
 - a. The pointed arch
 - b. The flying buttress
 - c. The vaulting rib
 - d. Elaborate molding designs

FRANCE

1. St. Denis 1140 – 1144
 at Paris, France Under Abbot Sugar
2. Chartres Cathedral 1144
 at Chartres, France rebuilt 1194 – 1260
3. Notre Dame 1163 – 1250
 at Paris, France Jehan de Chelles
4. Reims Cathedral 1211 – 1290
 at Reims, France
5. Amiens Cathedral 1225 – 1236
 at Amiens, France by Robert de Luzarches
6. Beauvais Cathedral 1225 – 1568
 at Beauvais, France
7. St. Chapelle 1243 – 1248
 at Paris, France

ENGLAND — EARLY GOTHIC

8. Lincoln Cathedral begun 1192
 at Lincoln, England
9. Salisbury Cathedral begun 1220
 at Salisbury, England

ENGLAND — LATE GOTHIC

10. Exeter Cathedral 1280 – 1370
 at Exeter, England
11. Westminster Abbey begun Eleventh Century, resumed 1245
 at London, England
12. King's College Chapel 1446 – 1515
 at Cambridge, England

OTHER LATE GOTHIC

13. St. Stephen's Cathedral begun 1160
 at Vienna, Austria
14. Milan Cathedral begun 1385
 at Milan, Italy
15. Rouen Cathedral Begun 1202
 at Rouen, France Completed 1880

1. Flying Buttress:
- Though the nave walls were masonic and of great mass, they were outward of the clerestory whose walls fell to the nave columns below. The clerestory walls could not have had enough mass to resist the outward thrust of the roof which was tiled in stone slates or terra-cotta thus the flying buttress "reached" up to accomplish that task. Its main parts are:

 Buttress — bearing on the ground, its mass is perpendicular to the wall

 Flying buttress — springs from the buttress and arches over the push back on the roof

2. Stained Glass:
- In churches, stained glass was used to pictorially depict biblical stories and is made of:

 Glass — a noncrystalline amorphous solid (used in windows)

 Color — metallic salts were used in the manufacture of the glass to create various colors

 Leading — lead strips used to divide the colored glass and create the images

3. Finial:
- A decorative element usually at the top of a gable, pinnacle or apex part of a building, generally in the form of an urn, fleur de lis, or flower

4. Spire:
- A tall, usually conical or pyramidal "pinnacle" on a church, often having a cross at its top

5. Rose Window:
- The main window rosette over the main narthex portal, often the stained glass scenes held pictures that pertained to the church's origins or founders

6. Fan (flechette) Vault:
- In cathedrals, pilasters often extended past the pier termination at the triforium and continued to the ceiling, fanning out with ribs that formed a flechette on the underside of the vaulting

7. Pointed Arch:
- Cathedral architects employed the use of the Gothic pointed arch because it translates loads down to the earth efficiently while reducing outward thrusting forces

Gothic

Flying
Buttress

Buttress

1. St. Denis:
 – Ribbed vaulting, the columns are still Romanesque, it's the royal necropolis for Frances monarchs

2. Chartres Cathedral:
 – Double spire (not symmetrical), typical "rose" window, early Gothic, pioneered use of the buttress

3. Chartres Cathedral:
 – Expression of verticality clear, columns-ribs-vaults, first use of the trebuchet as a construction crane

4. Notre Dame:
 – Founded by Mourice Sully (a bishop who revered the sciences). He took eminent domain over homes on the site and removed them for the cathedral. The cornerstone was laid by Pope Alexander III. Crossing is a very important and dramatic portion of the building. Nave height measures 115 feet in a 1:2.75 proportion and the Cathedral's length is 420 feet.

5. Reims Cathedral:
 – Break down of surfaces — not as solid. Note: move from column to colonnettes. Nave is 125 feet from floor to ceiling. The triforium gallery is shrinking and clerestory is getting taller.

6. Amiens Cathedral:
 – Considered to be the most stylistic of these cathedrals, it was built over a short period of time. Wall surface is almost completely broken up. Massive frontal buttresses. Nave is 140 feet from floor to ceiling, 1:30 proportion.

7. Beauvais Cathedral:
 – Appears to have no real front, collapsed twice because of soil conditions, construction started with the transept and choir, and never got the rest. Nave measures 157 feet, 1:3.4 proportion.

8. St. Chapelle:
 – Near-total "disintegration" of the walls, the wall becomes stained glass "curtain"

9. Salisbury Cathedral:
 – Best example of early English Gothic cathedral, houses the Magna Carta

10. Lincoln Cathedral:
 – Unusual expression of horizontality

11. Exeter Cathedral:
 – Additional ribs become decorative element, expressing the "flamboyant" Gothic style

12. West Minster Cathedral:
 – Perpendicular style of cathedrals, expressing flying vaults and is the cathedral for England's coronations

13. King's College Chapel:
 – Fan vaulting decoration known as "flechettes," and stained glass wall, renaissance suggestions

14. Milan Cathedral:
 – Note progression of cross (to center in plan)

15. Rouen Cathedral:
 – Not clear spire but example of laced surface — no solid

▶ Gothic Cathedrals were often built and organized around an important relic or founding legend used the pointed arch and expressed verticality. They were made of stone as fire was common in medieval village life.

▶ Cathedrals were carved of masonry, built by free-masons and had no concrete (were gravity-fit joints).

▶ The Gothic cathedral's carving and height are its decoration (compared to the mass and mosaics of Byzantine).

▶ Most Gothic cathedrals were based on the Latin cross, had a transept that occurred two-third of the way to the altar, and had spires often doubling as belfries.

▶ Stained glass was used to explain biblical stories and to beautifully light the interior.

▶ Often, the church's exterior was highly carved of local stone while the interior was simpler but with most visual lines leading the eyes up to the vaulting.

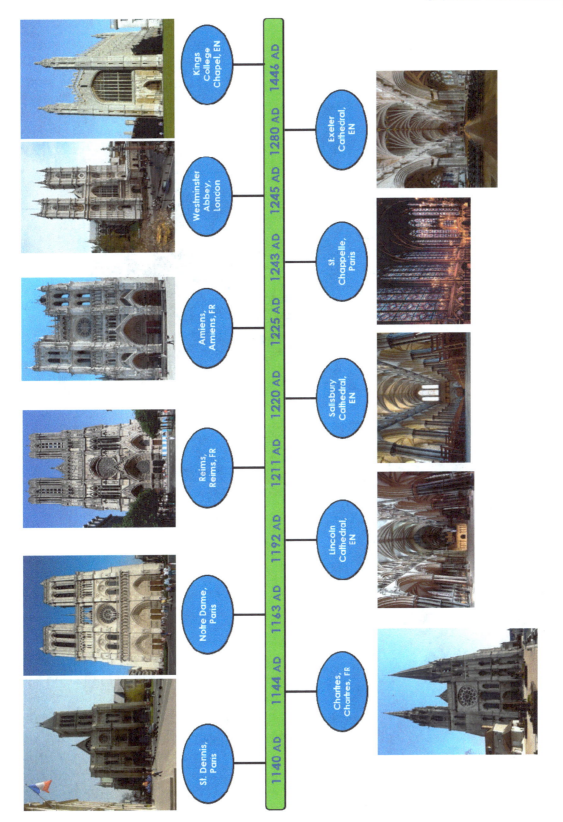

King's College Chapel, EN — 1446 AD

Exeter Cathedral, EN — 1280 AD

Westminster Abbey, London — 1245 AD

St. Chappelle, Paris — 1243 AD

Amiens, Amiens, FR — 1225 AD

Salisbury Cathedral, EN — 1220 AD

Reims, Reims, FR — 1211 AD

Lincoln Cathedral, EN — 1192 AD

Notre Dame, Paris — 1163 AD

Chartres, Chartres, FR — 1144 AD

St. Dennis, Paris — 1140 AD

Gothic

The burial place of France's Kings and Queens since Clovis in AD 496. It was saved and restored by the architect Viollet le Duc in 1825. St. Denis was the first Bishop of France and Patron Saint. The Narthex was built in the Gothic style in 1136 by Abbot Sugar. Its crypts were looted during the French Revolution and bodies dumped in a mass-grave "royal necropolis" but Louis XVI and Antoinette were moved back under order of the Bourbons when Napoleon was exiled to Elba.

The highest cathedral built at its time, it pioneered the "flying buttress" and was the first to use the trebuchet (a war catapult) as a construction crane. Most of the stained glass was removed during World War II for safety.

The "*Sancta Camisia*" (Virgin Mary's tunic) was said to have miraculously survived a fire which led to a pilgrimage and renewal of the waning construction effort. The fabric was proven to be Syrian and dates to first century AD.

Gothic

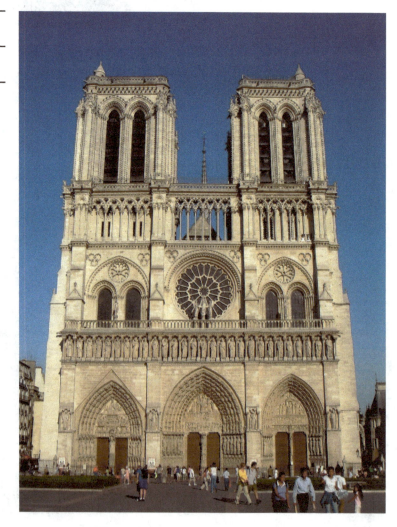

Three sculptured entrances are located in the west front. Above them lies a row of sculptures (28 generations of Kings of Judah), extending across the façade. . Over this, is the huge rose window that forms a "halo" around the head of the Virgin Mary who is flanked by two angels.

Summary Timeline

1160—Maurice de Sully (named Bishop of Paris), orders the original cathedral to be demolished.

1163—Cornerstone laid for Notre Dame de Paris, construction begins.

1182—Apse and choir completed.

1196—Nave completed. Bishop de Sully dies.

1200—Work begins on western façade.

1225—Western façade completed.

1250—Western towers and north rose window completed.

1250–1345—Remaining elements completed.

Composed of a central nave rising 110 feet high and flanked by double aisles that continue around the east end, the choir and nave (shown below right) were not originally designed to have buttresses but they became necessary during construction as stress fractures developed. Gargoyles reside on the Cathedral's façades, most of which serve as water scuppers.

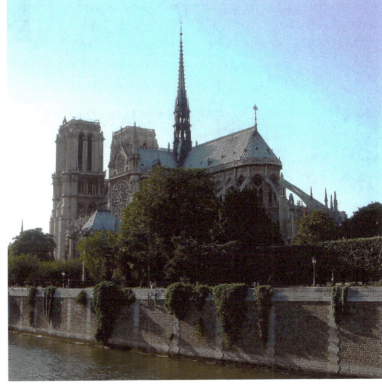

Gothic

Used for France's coronations, the nave of Reims was finished in the thirteenth century while the west front in the fourteenth. Its towers are 267 feet high, though designed to be 394 feet and contain a 11-ton bell. It was bombed and damaged in WW I and restoration was completed in 2010.

Saint Nicasius, founder of the Cathedral, forewarned the people of the invasions and is said to have been beheaded (and continued quoting psalm) by the Vandals who sacked the city. He is one of the *cephalophores*, or "head carriers" who like St. Denis, carried their head while talking.

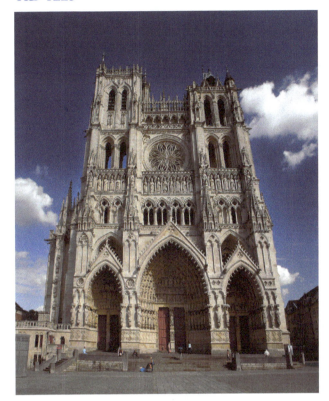

Maximized internal volume and the quest for height during this period was not without its challenges. Failing choir buttresses were saved by additions and a tensile iron bar-chain had to be installed around the triforium during the Middle Ages to reinforce the lower walls.

(Below) Sculpture depicting the life of St. Firmin whom died at Amiens.
(Right) The high nave, the floor of which is paved to form one of France's geometric labyrinths.

Gothic

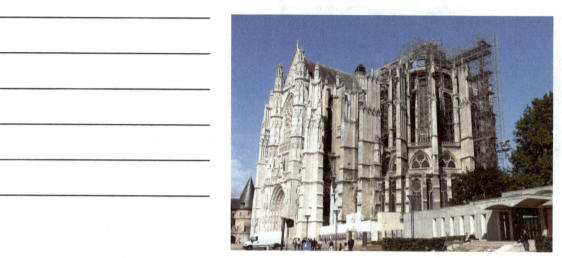

Beauvais, though daring in height and unique in that it does not have a traditional "front," remains incomplete and has historically been plagued with structural issues. Trading buttress mass for light, the choir vaulting and some buttresses collapsed in 1284, likely due to vibrations in the wind. The image below right, shows iron tie rods stabilizing the structure. Once removed in the 1960s, they were reinstalled through necessity.

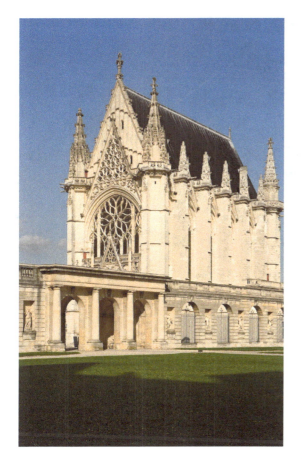

Built under King Louis IX, this royal chapel was constructed to house the King's Passion Relics, including the Crown of Thorns.

The exterior shows deepened buttresses capped by pinnacles, this is known as "Rayonette" architecture.

The interior, expressing verticality toward the heavens appears to create a curtain of stained glass. This is accomplished by highly colored colonnettes and mullions.

Gothic

Lincoln Cathedral was ordered built by William the Conqueror and was reputedly the first building to surpass the height of the Great Pyramid, Cheops, with its central tower that collapsed in 1549. Its heavily descriptive vaults were both creative and experimental for their period. The Cathedral's rosette windows are some of gothic England's best examples of tracery — curvilinear stone carving decorating the outside of the window. Its nave is an envelopment of space and light.

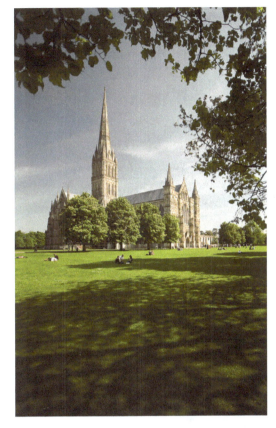

Owing to its relatively quick (38 years) construction period, Salisbury has a singular and consistent style, Early English Gothic. The spire, added later, could have experienced the same fate of other cathedrals of the time but buttressing and even tie beams added by Christopher Wren, proved to be sufficient reinforcing.

With the highest spire in the UK, the Cathedral is home to the best surviving copy of the Magna Carta and the world's oldest working clock.

Gothic

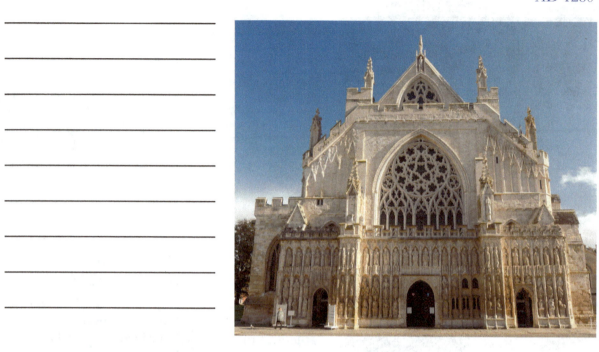

Differing from France's gothic cathedrals, England's (including Exeter), are generally village focal points surrounded by green space. Across Exeter's west front is its famously carved image screen, depicting the rulers Alfred, Athelstand, Canute, William the Conqueror, and Richard II, thus it is considered one of the finest examples of "Decorated Gothic."
The nave as seen below and measuring the length of a football field, is the world's longest continuous gothic ceiling.

Originally begun in the eleventh century, Westminster is a "Royal Peculiar" (meaning it's exempt from the jurisdiction of the diocese and falls under that of the monarch), and is best known as the burial place and church of coronations for England's royals.

Pointed arches, flying buttresses, rose window, and its 102-feet high nave are among the typical prescriptive gothic features that inspired the Abbey's numerous phases of construction, the present design of which was begun in 1245 and mostly completed under the reign of Richard II and master mason Henry Yevele.

The image right shows the remnants of the original eleventh-century structure and the typical English Gothic arch window, the inside of which reveals a typical rose window over rows of figures.

Gothic

This is the chapel to King's College at the University of Cambriadge and is considered an example of "Perpendicular Gothic English."

Most striking within the Chapel is the ornate rood screen and the vaulted ceiling, completely consumed by "flechettes," or ribbed fan vaulting.

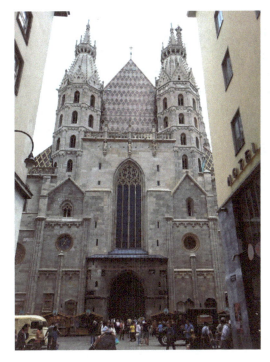

Like many cathedrals of the Late Gothic period, St. Stephens was built upon the Romanesque ramparts of its predecessor.

The cathedral is built of limestone and is also typical for its period in that its towers were intended to be identical but with the Gothic style losing popularity, the north tower was eventually completed with a Renaissance cap.

Unique to St. Stephens remains its tiled roof and color-washed nave, deriving its dancing hues upon the stone colonnettes from the simple geometrics of stained glass, replacements for the originals destroyed by fires during WW II.

Gothic

Built over many centuries, the Milan Cathedral appears like a city of spires emanating from a single façade detail. Its mix of Gothic, Neogothic, and even Classical details are evidence of its protracted construction.

A nave flanked by double-side aisles lend breadth to its plan thus broadening the façade, hierarchically ordered. Historians have been critical of the church's combined Flamboyant and Perpendicular styles.

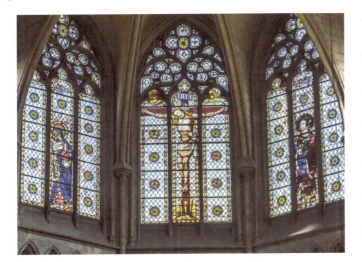

Fire afflicted Notre Dame of Rouen as it did many cathedrals of the period. Completed as an example of Flamboyant Gothic, a carving of Richard Lionheart remains on its tower and its façade was the subject of many of Claude Monet's paintings. Its tower inspired Raymond Hood's design for the Chicago Tribune Tower.

Byzantine

Culture:
- Byzantium saw the growth of Christianity
- The Empire rose as Rome fell
- The Basilica plan was based around liturgical operation
- The Church was the center of the Byzantine village
- Centered around modern-day Turkey, Byzantium spread West

Architecture:
- The Church was based on the Greek Cross (equal arms)
- Basilicas were centrally planned around a dome
- The Basilica was generally massive but expressed detail through expansive mosaic work
- The triangular form that resolves the dome over the square is called the pendentive
- Parts of the Church included the atrium-court, narthex, nave, side-aisles, dome crossing and apse
- The belfry was usually a separate structure
- The Baptistery was usually a separate structure
- Complex mosaics of beautiful marbles and gold decorated the Basilica interior

Detail:
- Many current-day Mosques were once Basilicas
- The Pope possessed power over the Holy Roman Emperor
- Most cities were found within old Roman walls
- Enclosure of large spaces was an architectural outcome

Gothic

Culture:
- Gothic advanced the state of Christianity
- Gothic Cathedrals:
 - Expressed verticality
 - Used the Gothic Arch
 - Were completely carved and used no concrete
- Cathedrals were based on the Latin Cross (high cross)
- This was a period of religious and scientific struggle

Architecture:
- Gothic cathedrals relied on the buttress and flying buttress to resist loads from the roof
- Cathedrals were made of stone to prevent burning down from fire
- Stained glass was utilized to express pictorially, the biblical stories and themes
- The Rosette window was a staple in Gothic architecture
- Parts of the Cathedral included the narthex, nave, side-aisles, transept, crossing, choir, apse
- The exterior was completely carved and the interior expressed verticality at every chance
- The vaulting in the roof produced barrel vaults, groin vaults, and flechettes

Detail:
- Most cathedrals were founded around a theme, artifact or faith story
- Free-masonry was practiced to keep worksites safe, organized and on schedule and to grow the talent pool of masons
- Many European cathedrals were heavily damages in WWI & WWII

The Birth of a New Era

– "Renaissance," meaning "rebirth," is the term by which fourteenth and fifteenth century Italy is referred, widely thought to reflect the Period's resurrection and refinement of Classical ideas. As the Middle Ages waned on, Italy coalesced into a collection of city states based largely upon geographic and cultural influences as well as emerging political structures that departed from Feudalism and aligned more with a social system based on merchants and commerce. These city states and territories included:

> The Kingdom of Naples;
> The Republic of Florence;
> The Papal States at the center;
> The Milanese and the Genoese;
> The Venetians to the east.

– Many of Italy's cities both large and small, owed their urban fabric to constructions either executed or inspired by the Roman Empire. With remaining infrastructure still operable, protective walls still in tact, and the forums becoming market squares, the Classical nature of the Renaissance seems an organic progression like honey bees adopting synthetic starter-combs placed in the hive.

– The classic "chicken and egg" debate has long been argued in the context of the Florentine Renaissance: i.e., was it mere chance that the great minds of Botticelli, da Vinci, and Michelangelo were all born in Tuscany?; or did the emerging political structure create the conditions by which Florence became the crucible for renaissance architecture, art, and sculpture?

– Either way, with an eye toward republicanism and away from monarchical hierarchies, conditions were set for the people to appreciate and cherish life, infuse the positive spirit of humanism into even the smallest of things, and to be governed by leadership that shared and promoted this vision with fairness, justice, and efficient administration.

– These notions of freedom were able to coexist with the absolutions of the Church and manifested themselves through paintings, sculpture, architecture, literature, etc., serving as moral and socio-political inspirations for anyone who desired such for themselves.

– Disease and plague laid whole villages ill and/or dead, resulting in faith-based art programs seeking to define and celebrate one's mortal life on Earth.

A Foundation for Change

– Central to the merchant and commercial aspects of Renaissance Italy was the formation "guilds." Formed from individuals sharing a particular expertise, skill, and mastery of their craft, guilds allowed for an assurance of quality as members were formally taught, trained, and apprenticed in their vocation.

– Like modern-day unions, as the guilds developed what amounted to proprietary knowledge and skill, they also gained political clout. This was evidenced by sponsorships of art and other projects that served to advance the guild by way of success, reputation or expression of power.

– With the emergence of printing (press), so too was the dissemination, distribution and preservation of "knowledge," leading to a literate society.

– *De Architectura*, known as Vitruvius' "Ten Books of Architecture," was the Latin and Ancient Greek treatise from the first century BC that guided architects and served to inspire early Renaissance artists and architects.

– As related to architecture, books emerging from Renaissance Italy included:
> – *De re Aedificatoria*, "On the Art of Building," Leon Battista Alberti, 1485
> – *I quattro libri dell'architettura*, "The Four Books of Architecture," Andrea Palladio, 1570

The Architecture

- The "rebirth" of this period was not just a cultural transcendence, it drilled down into the core of urban planning and building design.
- Early Renaissance architects were profoundly influenced by the aforementioned books (previous page) on architecture and building.
- Just as the Renaissance embodied the spirit of Classical Greek and Roman antiquity, so it was with the architecture.
- Planning: Cities bustled with a more secular-induced commercialism and busy traffic, a stark contrast to ecclesiastically-induced conformance and sense of "fright" in the Middle Ages. One can imagine the din of building projects, merchants selling their wares from shops and street stalls, and people milling around and discussing public art.
 - The apparent haphazard fabric of the Medieval village gave way to and order, reason, and a mathematical basis. Using linear perspective, Filippo Brunelleschi is widely thought to have understood the dynamics of space before it was built, through graphic representations (perspective drawings) that simulated three-dimensional perception in a two-dimensional medium.
- The Buildings: The centuries of refinement of the Classical Greek Orders, along with the aesthetic and engineering advances of the Romans, was not for naught. Renaissance architects sought not to simply copy Greco-Roman architectural form but to understand its intent, its structural "DNA" and to reflect its spirit in a refreshing and abstract manner.
- Common and lasting, and sometimes reinterpreted tenets of Renaissance architecture includes:
 - Expressing the structure as three stories (though they often exceeded 60 feet in height)
 - Strong horizontal banding at floor lines and the cornice
 - A "rusticated" stone lower level and material refinement from bottom to top
 - Romanesque expressions on the lower level and design refinement from bottom to top
- The architecture of the Renaissance is often delineated into three distinct phases; Renaissance, High Renaissance, and Mannerism.
- Mainly advanced by theoretician and architect Leon Battista Alberti, ecclesiastical forms were often webs of mathematical geometries expressing subtly, the Greek temple and the Roman triumphal arch.
- Renaissance architects also sought to reveal purity and truth. Just as something as simple as the post and beam system solves the problem of an opening simply, Renaissance architects sought to reveal purity and truth; clearly defined spatiality born of order, consisting of structure with a purpose, and ornament playing its rightful role.

EARLY RENAISSANCE

1. Florence Cathedral (Begun by Arnolfo di Cambio) 1296
 at Florence, Italy (Dome begun Filippo Brunelleschi) 1420
2. Foundling Hospital 1421 – 1445
 at Florence, Italy "Brunelleschi"
3. Basilica of Santa Croce (begun 1242) 1442
 at Florence Arnolfo di Cambio
3. Pazzi Chapel 1430 – 1433
 at Florence, Italy "Brunelleschi"
4. Palazzo Medici-Ricardi 1444 – 1459
 at Florence, Italy Michelozzo Michelozzi
5. Palazzo Rucellai 1446 – 1451
 at Florence, Italy Leon Battista Alberti
6. S. Francesco (Tempio Malatestiano) 1450 – 1468
 at Rimini, Italy "Alberti"
7. Sta. Maria Novella (completion of facade) 1456
 at Florence, Italy "Alberti"
8. Sant Andrea 1470
 at Mantua, Italy "Alberti"

MANNERISM

9. Bibliotec Laurenziana 1524 – 1557
 at Florence, Italy Michelangelo
10. Plan of the Capitol Museum 1538 – 1612
 at Rome, Italy Michelangelo
11. Palazzo Uffizi 1560
 at Florence, Italy Giorgio Vasari
12. Works by Andrea Palladio 1508 – 1580
 at Various Locations Andrea Palladio
13. *I Quattro Libri dell'Architecttura* "The Four Books of Architecture" 1570
 at Venice, Italy Andrea Palladio

BAROQUE

14. The Gesu 1580
 at Rome, Italy Giacomo della Porta
15. Santa Maria della Vittoria 1620
 at Rome, Italy Carlo Maderno
16. Santa Maria della Vittoria Cornaro Chapel 1645 – 1652
 at Rome, Italy Gian Lorenzo Bernini
17. Palazzo Barberini 1633
 at Rome, Italy Gian Lorenzo and Carlo Maderno
15. Scala Regia for Vatican 1663 – 1666
 at Rome, Italy Gian Lorenzo Bernini
16. Santa Maria della Salute 1681
 at Venice, Italy Baldassarre Longhena

HIGH RENAISSANCE

20. Designs for Centrally Planned Churches 1452 – 1519
 Leonardo da Vinci
21. Tempietto of S. Pietro in Montorio 1502
 at Rome, Italy Donato Bramante
22. St. Peter's Basilica Exterior 1506
 at Rome, Italy Bramante, Michelangelo, della Porta, Maderno, Bernini
23. St. Peter's Basilica Interior 1508
 at Rome, Italy
24. Palazzo Farnese 1517/1534
 at Rome, Italy Antonio da Sangallo (Younger), Michelangelo, Vignola, della Porta
25. St. Peter's Main Body & Dome 1547 – 1564
 at Rome, Italy Michelangelo Buonarroti

1. The Perspective Drawing:

– A two-dimensional medium that portrays a three-dimensional image. Perspectives express a photo-like quality of space and structures and mechanically consist of:

 Vanishing Points, two points that object lines converge to

 Horizon Line: the horizontal line that generally represents the viewer's eye at 5 feet above the ground

 True-length Line: A vertical line the drafter uses to plot scaled heights

2. Fresco:

– A painting technique applied to wet lime plaster (intonaco). Meaning "fresh," the intonaco is applied to a base surface (called the arriccio which is allowed to set for several days). Only as much intonaco is applied as can be painted before it sets (a *giornata*, or "day's work"). The pigments are applied to the wet plaster, no binder is needed as the pigments sink into the intonaco thus becoming the binder itself. Reacting with air, the fresco "sets," affixing the pigment in the plaster.

3. Humanism:

– Ushering in studies in the "humanities," humanism can be described more as a holistic approach to developing citizenry, than the vocational training of individuals.

4. Pietra Serena:

– Meaning "serene stone," this sandstone was particular to Renaissance Florence. Light to dark grey with hints of blue, it can sometimes be mottled with spots of mica. Pietra Serena was generally used for decorative architecture features such as columns, pilasters, entablatures or ribs.

5. Rustication:

– An architectural technique by which the mason leaves the surface of the stone rough while forming the block into rectangular "ashlars," sometimes edging the perimeter to accentuate the field.

Italian Renaissance

▶ Italy was the center of the Renaissance and Florence was its epicenter.

▶ A common secular Renaissance motif included:
- Three story articulation
- Strong horizontal banding
- Rustication and refinement vertically
- Design geometry refinement vertically

▶ A common ecclesiastical Renaissance motif included subtle design lines of a Greek temple over a Roman triumphal arch.

▶ The Italian Renaissance saw a "rebirth" of Classical ideas.

▶ The Italian Renaissance occurred generally in the mid-fourteenth to mid-sixteenth centuries.

▶ Technological impacts included advancements in printing and the perspective drawing.

▶ Scientific inquiry flourished during the Renaissance.

1. Florence Cathedral Baptistery:
- The competition for the door designs (Gates of Paradise) perhaps sparked the Renaissance

2. Florence Cathedral Dome:
- Use of tensile chain and herringbone brick pattern in dome base allowed for largest dome to date

3. Florence Cathedral Domes:
- Interior dome is a shell hung off the outer structural dome which is broken into eight ribs

4. Florence Cathedral Façade:
- Highly carved and decorated with red, green, and white stone

5. Foundling Hospital:
- Considered by many to be the first renaissance building, its arcuated composite columns slender

6. Santa Croce Basilica:
- It's now the burial place of many Renaissance masters including Michelangelo, Machiavelli, and Galileo

7. Tomb of Michelangelo:
- Designed by Vasari, the "angels of architecture, sculpture and painting" lament their loss

8. Pozzi Chapel:
- Façade elements give no reference to scale yet show thorough understanding, triumphal arch motif

9. Ponte Vecchio:
- Meaning "old bridge," it was spared bombing in World War II

10. Palazzo Medici-Ricardi:
- Exterior surface of rusticated stone refined vertically, horizontal banding, atrium court interior

11. Palazzo Rucellai:
- Stacked set of pilasters, carved grooves emulate masonry joints

12. Palazzo Stozzi:
- Another template for the tenets of Renaissance palazzo architecture

13. Sta. Maria Novella:
- Application of Roman orders, arches and geometry, Greek temple of Roman triumphal arch motif

14. Tempietto S. Pietro Montorio:
- Built over location where St. Peter is buried, strong use of symmetry

15. Sant Andrea:
- Classic example of temple front over triumphal arch

16. S. Francesco Tempo Malatestiano:
- Expression of Classic Roman triumphal arch

17. Palazzo Ufizzi:
- The south border of Piazza Signoria, it was the *Ufizzi*, "offices" of the Signoria (governing board)

18. Works by Andrea Palladio:
- Various works that express Palladio's architectural philosophies of Classical motif and local materials

19. The Gesu:
- By Giacomo della Porta, it is without a formal narthex, became a template of Jesuit churches

20. Sta. Maria della Salute:
- Built in response to prayers for protection from the plague that killed one-third of the population in 1629

21. Palazzo Barberini:
- Bernini applying complex geometries to accomplish false perspective

22. Sta. Maria della Vittoria:
- The Cornaro Chapel (Baroque) houses Bernini's Ecstasy of St. Theresa

23. St. Peter's Basilica Exterior:
- Remaining the largest church in the world, it is considered to be the center of Christendom

24. St. Peter's Basilica Interior:
- Begun by Bramante, it was continued by Michelangelo and completed by Maderno

25. St. Peter's Altar:
- Bernini's masterpiece "Baldaccino" made from the bronze, once gilding the Pantheon's dome

26. Scala Regia:
- Stair tapers while ascending, thus creating baroque perspective

27. Bibliotec Laurenziana:
- "Mannerist" in controlled movement of spaces

28. Piazza Compidoglio (Plan of Rome Capitol):
- Michelangelo bases the complex on an elliptical plan, creating dynamic movement

29. Palazzo Farnese:
- Designed by Michelangelo with Antonio de Sangallo, it is a fine example of High Renaissance

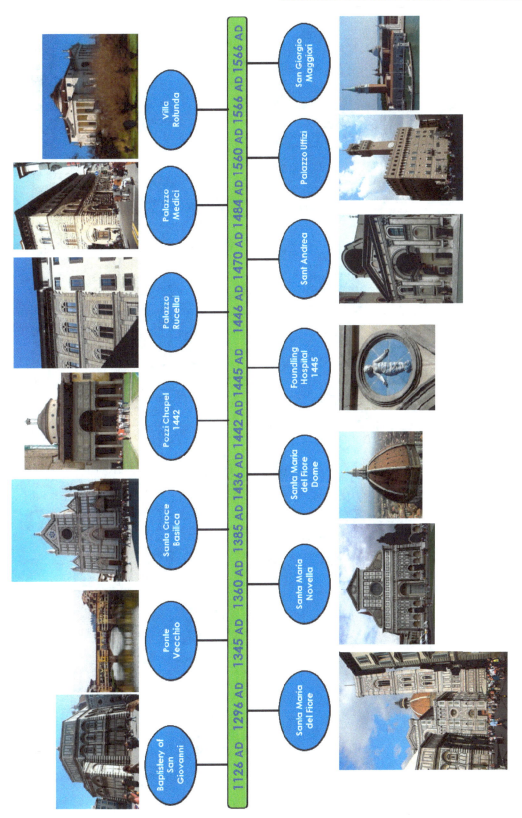

Italian Renaissance Timeline Cont'd

- 1506 AD
- 1534 AD — Palazzo Farnese
- 1538 AD
- 1562 AD — Villa Valmarana
- 1576 AD
- 1580 AD — Il Gesu
- 1620 AD
- 1633 AD — Palazzo Barberini
- 1633 AD
- 1667 AD — St. Peter's Square
- 1681 AD

- St. Peter's Basilica
- Piazza Compidoglio
- Il Rendentore
- Santa Maria della Vittoria
- Scala Regia
- Santa Maria della Salute

(Right) Paul Robert Walker's book, *The Feud That Sparked the Renaissance,* issues evidence that the competition for the bronze doors for the Baptistery (opposite), led to the frenzy for commissions of public art among artists.

Shown below is a panorama scene over Florence, taken from Piazza Michelangelo. Sweeping from the left, one catches a glimpse of the Ponte Vecchio, the campanile of the Ufizzi, Giotto's campanile complimenting Brunelleschi's dome of the Florence Cathedral (called "Duomo"), and finally the Basicila of Santa Croce. The only interruption of the quintessential terra-cotta tiled roofs is the Arno River as it winds its way through Florence.

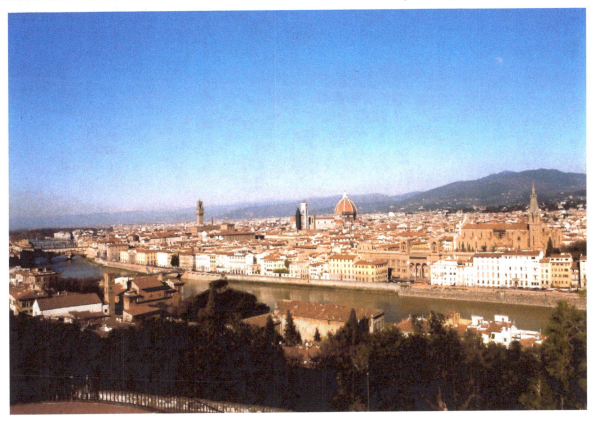

Italian Renaissance

1	2
3	4
5	6
7	8
9	10

(Left) "Gates of Paradise" doors by Lorenzo Ghiberti, keyed as:
1. Adam and Eve, 2. Cain and Abel, 3. Noah, 4. Abraham, 5. Isaac with Esau and Jacob, 6. Joseph, 7. Moses, 8. Joshua, 9. David, 10. Solomon and the Queen of Sheba. These are copies as Ghiberti's originals are in the Ufizzi Museum.

(Right) The Baptistery of St. John (at the Piazza del Duomo). Consecrated in AD 1059 and likely built on a Roman foundation, it was sized to accommodate large congregations as the administration of baptism only took place twice a year. The lower register consists of semipilasters supporting columns that lead to the arches in the upper. It was the *Calimala*, or guild of wool merchants who sponsored the competition of the Baptistery doors seen above.

Santa Maria del Fiore, "Saint Mary of the Flower," is the iconic symbol of Florence. Known as the *Duomo*, meaning "dome," together with its baptistery and Giotto's Bell Tower (1334), it forms one of the most explosive scenes of space, color, and scale in architecture. Spanning 140 years and built on the site of the previous Saint Reparata, construction progressed under di Cambio, Giotto, Andrea Pisano, Talenti, and finally Filippo Brunelleschi who completed the dome.

Planned as a basilica, the Church's form is driven by its geometries. The central nave flanked by side aisles, leads to the identically shaped polygonal chancel, transept, and chapels thus forming the octagonal base for the dome.

Italian Renaissance

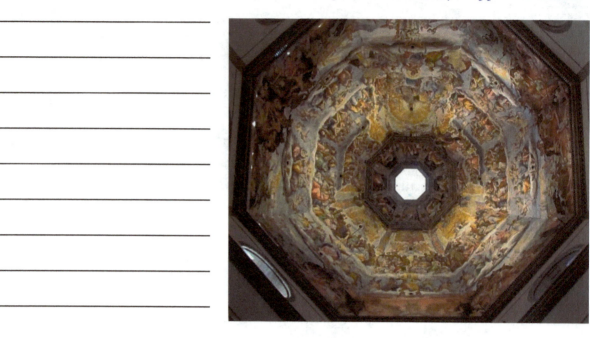

(Above) Frescoes within the Duomo depict the "Last Judgment" by Giorgio Vasari (though his student Frederico Zuccari is credited with much of the work).

(Below) With the help of Donatello, Brunelleschi produced a model to convince the Signoria of his ability to construct the dome. With four tensile stone and iron "chains" embedded in the dome, he combines a herringbone brick pattern to distribute weight to the supporting ribs and ultimately, the drum.

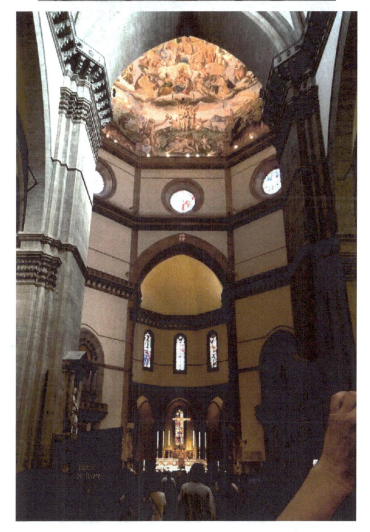

Upon entry through the bright marbles that ornament the front of the Cathedral, the column massing in the nave leads to the underside of the delicately frescoed dome lit by round portal windows in the drum. The light exterior marble reflects the hot Tuscan sun thus the Cathedral's interior is a cool reprise on hot summer days.

The stone floor pavers appear to form a vortex that leads to a focal point directly under the dome's lantern.

Italian Renaissance

(Above) A portal embedded in the ingenious herringbone brick pattern reveals the space between the inner and outer dome shells.

(Left) The stair that ascends to the lantern is lit by portals in the dome shells. Ascension to the lantern is a arduous task but the view over Florence that awaits is worth the effort.

One of the most important structures of the early Renaissance, Brunelleschi designed and managed the construction of this hospital which was said to have a place to leave unwanted babies after sunset hence, the bandage-swaddled babies in the spandrels between the arches.

Refining Roman Classical design lines, Brunelleschi created a delicate abstraction mathematically balanced that instigated an entirely new vocabulary for architecture of the Period.

Italian Renaissance

———————————————

———————————————

———————————————

———————————————

———————————————

———————————————

———————————————

———————————————

To visitors, Santa Croce's façade shares a likeliness with the Florence Cathdral due to its bright colored stone ornamentation.

The world's largest Franciscan church, Santa Croce today houses the tombs of many of the most important Renaissance greats including Michelangelo (shown right), Galileo, Machiavelli, Foscolo, and Rossini just to name a few.

Built as a chapter house for the Pozzi family (surpassed in wealth only by the Medici), the Chapel is a continuation of Brunelleschi's exploration with Roman forms but in a refined and abstract way. Note the imagery of a Roman triumphal arch captured in the façade concept.

Meaning "old bridge," the one existing today replaced the original bridge that was swept away in the floods of AD 1117. In 1564, the Medici had the "Vasari corridor" built to privately connect the Palazzo Uffizi with the Palazzo Pitti. Upon completion, butchers markets on the bridge were closed and the merchant space was given to the goldsmiths. Today, both sides of the Bridge's shops are lined with jewelry wares.

Another structure of lasting impression, the Palazzo Medici-Ricardi pioneered the template by which most Renaissance palazzos were built. Built for Cosimo Medici, the palazzo is one of the finest illustrations of four common design elements:

- Articulated as a three-story structure
- Strong horizontal banding
- Base-rustication and refinement of materials
- Design feature refinements over a Romanesque base

Italian Renaissance

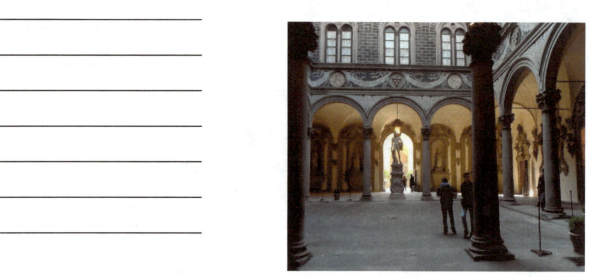

(Above) The "inner cloister" of the Palazzo references ancient Roman peristyles while allowing light into internal rooms.

(Below) The name "kneeling windows" was given to the method of bracketing under the window sills, transitioning human scale to the façade. The totality of design elements makes an otherwise tall urban façade, very human in scale.

The Slides: Renaissance
Palazzo Rucellai
Begun AD 1446 by Leon Battista Alberti

Alberti's mathematical command of architectural scale, balance, and rhythm are evidenced in this Palazzo's ruled registers of pilasters and entablatures. Like the Colesseum, the Orders are stacked (Tuscan, Ionic, then Corinthian).
The ground floor was the commercial space for the Rucellai, the second level (piano nobile) was for formal greeting, and the top floor was sleeping chambers.

Italian Renaissance

Depicting Renaissance features common to the Pallazo Medici-Ricardi, this palazzo differs in that it has streets on all four sides and is therefore freestanding. This presented challenges within the proportioning of internal spaces about two main axis instead of one.

Mullioned windows complimenting the rustication are capped by a strong bracketed cornice, details that would be copied for years to come.

192

Originally a Dominican Ordered church, the gothic-influenced lower level of the façade existed when Alberti was commissioned to complete the façade anew hence, "novella." He placed a Greek-style frieze and pediment over four columns, resolving the composition with his signature scrolls — another ensemble that would be copied for years to come.

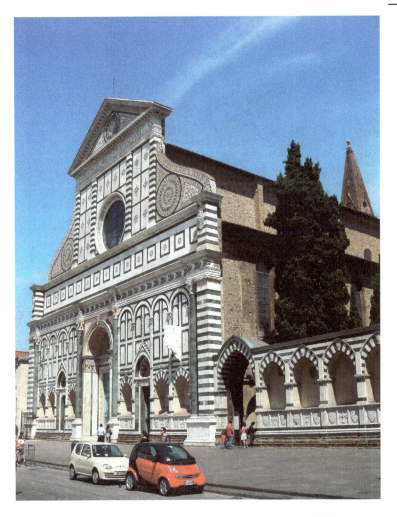

Italian Renaissance

The interior of Santa Maria Novella is known for the pulpit, designed by Brunelleschi, and the Tornabuoni Chapel with frescoes by Domenico Ghirlandaio and his workshop (studiolo) done between 1485–1490. Considering these dates, it has been thought that a very young Michelangelo, apprenticing for Ghirlandaio, learned the basics of fresco during this commission.

Commisioned by the Spanish monarchs Ferdinand and Isabella, Bramante shows his architectural command of creating dramatic space by using simple forms (a cylinder capped by a hemisphere). Built on the site of St. Peter's martyrdom, Tempietto appears like a subtle monument, owing its simplicity to the Doric Order.

Italian Renaissance

Built on the site of a Benedictine monastery (the belfry remains), Alberti once again calls on Roman form — borrowing from the Arch of Titus and superimposing a Greek temple front on the façade.

To show separation of the elements, the "temple's" supporting columns are raised on plinths and sent up to support the upper entablature (know as the giant order). This is a style Michelangelo would later employ in his architectural works.

The Slides: Renaissance
S. Francesco Tempio Maletestiano
AD 1450 by Leon Battista Alberti

Formerly a Franciscan Gothic church, Sigismondo Maletesta commissioned Alberti to alter the building to become his mausoleum. Maletesta's wealth declined and construction stalled. The building remains unfinished today, the east end never completed and an intended dome never built.

Italian Renaissance

The administrative offices *"Uffizi,"* were housed here but today it is known as the popular Uffizi Gallery, housing the finest collection of renaissance art and artifacts.

Designed by Vasari, perhaps this architect's "eye of a painter" is why the *cortile* (courtyard) creates one of Florences most dramatic perspectives, linking Piazza Signoria (seen below) to the Arno River.

198

Source: *Library of Congress*

Source: *Library of Congress*

(Above) Excerpts from Palladio's treatise The Four Books of Architecture (Dover Edition, 1965, Dover Publications, Inc.). First published in Venice in 1570, it is a requisite in the libraries of architects worldwide.

(Below) Villa Rotunda, is likely Andrea Palladio's most iconic design and was built in 1566 in Vicenza, Italy. It expresses the common tenets of Palladio's work; dramatic classical exterior forms, local and economical materials, and harmony and balance.

(Above) San Giorgio Maggiori, begun in 1566 by Palladio, provides a picturesque vista from any Venetian vantage point. The belfry is known for its nine bells in the note of C-major.

(Below) Il Rendentore Church (the redeemer), begun in 1576 as an offering church for the Venetian community having been spared from the plague outbreak of 1575. It also occupies a prominent venetian site, remarkably defining the maritime seascape vistas of Venice.

The Slides: Renaissance — Mannerism
Works by Andrea Palladio
(Various Dates)

Villas Emo and Valmarana (1558 in Treviso and 1562 in Vincenza respectively), illustrate that although their regulating lines are Classically driven, form remains a product of spatial needs, arrangement, and response to the site.

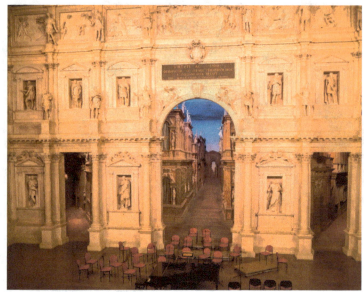

(Above) Teatro Olympico in Vicenza (1580), designed by Palladio was one of the first covered theatres built. Its classically detailed façade likens to those of backdrop walls of Greek amphitheaters.

(Below) Palazzo Capitiniato also in Vicenza, was built by Palladio in 1571 and fronts Piazza dei Signori in Vicenza.

Considered to be the first Baroque church façade, The Gesu is unique in that it is without a narthex. Entry is made directly into a single-aisle nave which explodes into dynamic movement of architectural detail and painting, the focus of which is the central fresco *Triumph of the Name of Jesus* by Gaulli.

Originally to be designed by Michelangelo, Pope Paul III's grandson Cardinal Farnese, commissioned della Porta and Vignola, architects for the Farnese family.

Italian Renaissance

Once again, with the Venetian "delivery" or, *salute* from the plague of 1630 which killed one-third of Venice's population of almost 100,000 people, the Church was offering of thanks for those spared.

Its octagonal base and drum support the large dome as large scrolls help buttress the dome's loads. Adding mass are the temple-front features.

It is approximated that the entire Church is built upon one million piles driven to refusal in the marshy lagoon of Venice.

Today, Santa Maria della Salute greets visitors who mostly arrive into the Grande Canal via water taxi.

Built by Maffeo Barberini (who would become Pope urban VIII), the palazzo was designed by Moderno with the help of his nephew Borromini. Moderno died shortly after starting and Bernini was assigned the project instead of Borromini, though they worked together for a short period. The Baroque façade is exemplary for its play on perspective as extra window depth in the upper register is accomplished by manipulating molding lines.

Italian Renaissance

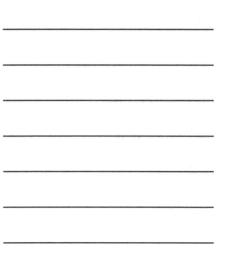

Standing as the only completed work by Moderno, this church is most noted for Bernini's masterpiece in the Cornaro Chapel, *The Ecstasy of St. Teresa.* Owing to an entry in St. Theresa of Avila's journal, the statue marks her vision of an angel piercing her heart with a golden line (of light or an arrow), causing her ecstasy.

St. Peter's, one of the most ambitious expressions of faith, visually stands guard over the Vatican and Rome, and serves as the center of the Christian faith.

Started by Donato Bramante (who died in 1514), construction of the Basilica resumed under several architects including Giuliano da Sangallo, Rafael, and Antonio Sangallo, Michelangelo, Vignola, Vasari, Giacomo della Porta, Carlo Moderno, and finally Bernini completing St. Peter's Square.

Credit is as follows: Bramante, basic plan; Sangallo's, piers and chapels; Michelangelo, correcting the piers and designing the dome; della Porta, continued Michelangelo's work and completed the dome; Moderno, expanding the narthex and completing the façade; Bernini, designing and completing Scala Regia and St. Peter's Square.

Italian Renaissance

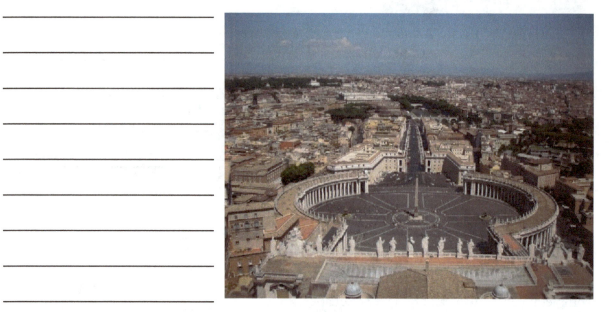

(Above) The view from the lantern atop St. Peter's dome provides a vista toward Castel Sant'Angelo via St. Peter's Square. The Tiber River can be seen winding southwest.

(Below) St. Peter's dome, attributed to Michelangelo, is built of similar construction to that of Brunelleschi's Duomo. The dome was brought to completion by Giacomo della Porta in 1590. Crepuscular rays of light (caused by light hitting particles in the air), can be seen coming through window portals in the dome's drum.

The Slides: High Renaissance
St. Peter's Basilica Nave
AD 1506 (Various Architects)

(Below) The nave of St. Peter's is a spectacle of scale (the letters visible in the frieze are over 6-feet tall).
The Church's length is 730 feet and its overall height is 452 feet. Covering roughly five soccer fields, its monumental scale overwhelms visitors regardless of faith.
The nave leads seemingly endlessly to the crossing where Bernini's Baldachin Canopy (shown opposite) marks the place of St. Peter's tomb below. Like a village main street, acoustic are swallowed by the shear volume of the space, revealing an even din that is never overbearing.

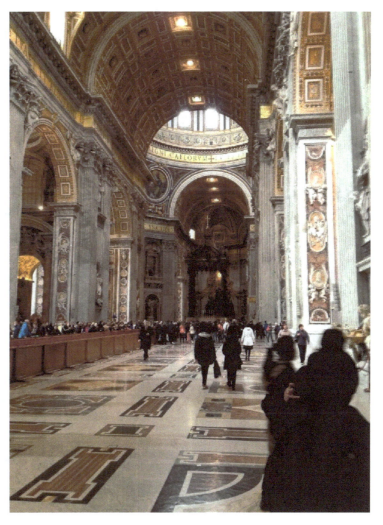

Italian Renaissance

The Baroque style crossing canopy called the Baldachin, provides a focal point beneath the dome and marks St. Peter's tomb below.

The design of the helical column design details reflect the Solomonic Columns said to have marked a screening in front of the altar in the original Old St. Peter's Basilica. Bronze bees swarm the columns, a reference to the Barberini family coat of arms. The source for the bronze has been debated but often attributed to bronze removed from the ceiling of the Pantheon.

The Slides: Renaissance—Mannersim
Piazza Compidoglio
AD 1538 by Michelangelo

Serving as City Hall today, the project at the Compido-glio was taken on by Michelangelo to revive the importance of the Capitoline Hill.

Realigning the tower toward the center and resolving the trapezoidal piazza with an ellipse, Michelangelo's plan would cement his authority as an architect and reshape urban planning. Michelangelo's geometric design of the piazza floor adds a dynamic element to the surrounding complex shapes, almost putting the space into motion.

The low roof, bold horizontal entablature, and giant column order are architectural signatures of Michelangelo.

Italian Renaissance

Designed over a series of architects that included Sangallo, Michelangelo, Vignola and della Porta, Michelangelo's designs stand out and further define his signature.

In keeping with the four aforementioned tenets of Renaissance palazzo design, quoined corners bookend the façade, the lower register of which shows kneeling windows, and a central rusticated portal.

The middle register (piano nobile) shows alternating triangular and elliptical pediments, the central window of which was modified by Michelangelo in 1541 to strengthen centrality.

The upper register is refined and capped by Michelangelo's typical low roof and entablature.

The Slides: Renaissance — Baroque
Scala Regia
AD 1633 by Gian Lorenzo Bernini

Meaning "royal staircase," the *Scala Regia* was initially built by Sangallo and refurbished by Bernini.

The Baroque elements of the vaulted colonnade help exaggerate and glorify the distance of the stair which terminates at an equestrian statue of Constantine, reminding those upon departure of his allegory of finding victory through the Church.

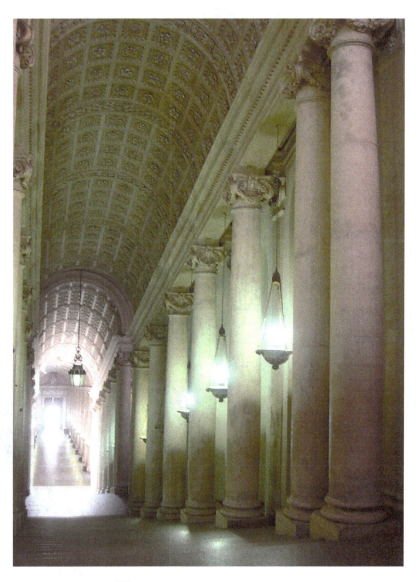

Italian Renaissance

Built by Bernini at the direction of Pope Alexander VII, it was intended to provide St. Peter's with a more suitable forecourt. In a stroke of genius, Bernini's elliptical colonnade provides a planned screening of the Vatican City acting as un unappealing distraction beyond. There are only two focal points from which the columns are in alignment.

(Right) Statue of
Dante in Verona,
where he spent
much time.

(Below right)
Illustration of the
Hell, scene from
Dante's Inferno.

(Left) Photo of some Italian calligraphy
from Dante's Inferno, the first part of the
Devine Comedy where as the narrator,
Dante experiences the nine circles of Hell
before Purgatory and eventually Paradise.
Considered one of the most important
world literary works, it allegorically repre-
sents the soul's journey to God.

(Left top) Statue of Donatello
(Top right) Statue in Florence of Judith and Holofernes by Donatello, symbolizing the Republic's freedom.

(Left) Pulpit in San Lorenzo.
Bertoldo, a pupil of Donatello's, completed the Work. Bertoldo, of whom Michelangelo was a pupil, connects the lineage of Florentine sculpture from Donatello, to Bertoldo, to Michelangelo.

The slides: Renaissance Art
Bertoldo di Giovanni
1435-1491 AD

Shown above (left and right respectively), "An Old Man and his Grandson" and "Portrait of Giovanna." Shown below is a wall mural from the bottega of Ghirlandaio.

Having been one of the individuals who spanned the early and later parts of the Florentine Renaissance, Ghirlandaio was an accomplished painter whose work includes wall scenes of the Sistine Chapel.

Later, impressed by the drawing ability of the young Michelangelo, Ghirlandaio accepted him into his studio and provided him with his earliest training in the art of fresco.

Renaissance Masters

(Above) Located in the left arch of the Loggia dei Lanzi, Perseus with the Head of Medusa depicts the Greek account of her decapitation. Her hair, said to be snakes, provided distraction but those whom looked her in the eye turned to stone. A small portrait blended into Perseus' hair is said to be Cellini himself.

(Right) Representing a chapter in Rome's founding, the statue depicts the story that early Roman men so outnumbered women that they acquired wives from the nearby Sabine families. The use of the word "rape" in this context (Latin from *raptio*), refers to an abduction and not a sexual violation.

The slides: Renaissance Art
Giambologna (Born Jean Boulogne)
1529-1608 AD

The Slides: Renaissance Art
Raffaello Sanzio da Urbino, "Rafael"
AD 1483–1520

(Left) Self portrait of Rafael.
(Below) The School of Athens
in the Rafael room at the Vatican. Considered his masterpiece, it represents philosophy
and depicts his contemporaries
as Greek philosophers. In the
center (left), da Vinci's face is
shown on Plato, Sangallo's on
Aristotle, Rafael's on Fornarini
(left in white), and Michelangelo's on Heraclitus (by himself
front-left).

Renaissance Masters

(Right) The original to this self portrait executed as red chalk on paper, is believed to be da Vinci. It has widely become known as the "Renaissance Man." (Below left) da Vinci's studies of mechanics, anatomy, and other scientific areas are unprecedented and likely not repeated until the likes of Thomas Jefferson.

(Right) Perhaps the most iconic painting of all time, the Mona Lisa remains enigmatic. This photo of the painting taken in the Louvre, is still able to convey the sublime features of the work, specifically the emotive expression, delicate insinuations, and masterful composition and arrangement.

Work of Michelangelo Timeline

1475 — Born March 6

1487 — Apprentice to Ghirlandaio

1488-92 — w/ Medici Apprenticed to Bertoldo

1493 — Explores Cadavers

1494 — In Bologna Gianfranco Aldrovani

1496-7 — Rome Cardinal Riario & Jean Bilheres

1501-4 — Florence David Cascina Tondo Doni

1505 — Rome & Carrara Tomb Julius II

1508-12 — Rome Sistine Chapel Ceiling

1515 — Florence Pope Leo X San Lorenzo

1520 — Florence Night/Day Dusk/Dawn

1534 — Rome Last Judgement Clement VII

1546 — Chief Architect of St. Peter's

1564 — Feb 8th Dies at 89

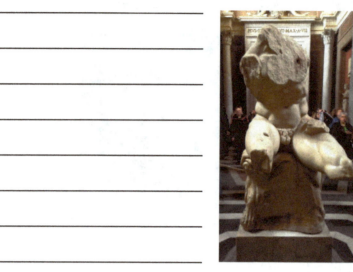

(Above) Called the "Belvedere Torso" (Vatican Museums) and credited to Apollonios, it is believed to have inspired Michelangelo.

(Right) "Dying Slave" (1513–1516) was to be paired with another sculpture "Rebellious Slave" on the tomb of Pope Julius II. Its unfinished quality is typical of Michelangelo's work as he sought only to free the object bound within the stone.

(Left) _Pieta_, "Pity" (1498–1499), completed when Michelangelo was only 24, cemented his genius and the investment the Medici made in the prodigy. Forming a pyramidal shape, the life-size form of Jesus appears naturally across the lap of Mary whose flowing drapery conceal her monumental scale. Being divine, Mary is depicted youthful, both faces resolved and accepted their fate.

David, referred to in its day as the "giant" and Michelangelo's masterpiece sculpted from the "Duccio" stone, symbolized the attitude of the Florentines just as David is represented at the moment he decides to engage Goliath but before the battle has started. Sling in his left hand, stone in his right, David's face expresses both fear and the confidence while the scene is played out in a form called *contrapposto*, suggesting motion. Having been marked by previous sculptors, geologists question how Michelangelo executed the work without a failure.

Renaissance Masters

The frescoes on the ceiling of the Sistine Chapel are the monumental painting task accomplished by Michelangelo for Pope Julius II between 1508–1512. Having devised a scaffolding with lifts and stairs and allowing for the roll of the vault, Michelangelo worked fervently until completed, upon which his neck was difficult to bend for months and his corneas were burned from paint drippings.

(Opposite) Though Michelangelo was assigned the task of painting the Apostles in the twelve pendentives, he demanded artistic control of the program.

In the center, nine scenes show God's creation of the World, God's relationship with Man, and Man's fall from God's grace. The surrounding pendentives and lunettes illustrate Prophets and Sibyls and the Ancestors of Christ.

(Right) Though previously featured, the dome of St. Peter's Basilica was an effort that Michelangelo had a special affinity for. Having studied Brunelleschi's dome and the Pantheon, his input and the drawings he left were crucial to ensuring the realization of this masterpiece.

<u>Political and Religious Change</u>
- As Europe took note of fervent changes emanating out of Florence, political and religious changes began taking place far and wide.
- Issues surrounding the League of Cognac (an alliance including the Pope, England, Florence, France, and Milan), lead to rifts between Holy Roman Emperor Charles V and Pope Clement VII.
- Pope Clement VII's alliance with France creates difficulties in Germany for Charles V and Habsburg dominions as the Holy Roman Emperor led the battle against the Reformation.
- Unpaid wages to Charles V's imperial troops led to the May 6, 1527 sack of Rome by Holy Roman Emperor Charles V.
- Using the underground passage between the Vatican and Castel Sant'Angelo known as the Passetto di Borgo, the Pope was escorted and defended by the Swiss Guard who lost almost 150 Guards in the skirmish.
- Henry II marries Catherine de' Medici and Henry IV marries Marie de' Medici, who ruled France as regent for Louis XIII.
- Louis XIV, "Sun King," had absolute power.
- In England, Henry VIII was granted an annulment from Catherine of Aragon, the Emperor's Aunt thus breaking with the Catholic Church and leading to the English Reformation.
- The great fire of London is 1667.
- The French treasury is very low after Louis XIV's expenditure at Versailles.
- 1789 sees the French Revolution and the Napoleonic Wars.
- England becomes a major power in manufacturing and shipping, has established her empire and has contacts with all parts of the world.
- A search for proper British style is on, Stuart and Revett publish *The Antiquities of Athens* in 1762. Pugin and Ruskin publish their writings.

<u>The Architecture</u>
- Though French Renaissance architecture abides mostly by the tenets of design for the Period, inflections of France's firm Gothic tradition remain.
- Palladio is translated in 1650 and the Academy of Architecture is established in 1671.
- Inigo Jones travels to Italy and Sir Christopher Wren is surveyor of the King's Works.
- France and England both put their touch on Renaissance designs; the French employing use of the Mansart roof with rhythmic dormers, and the English employing use of the balustrade-cornice and wider expanses of fenestration (windows).
- Classical ideals and design, reborn during the Period, spread beyond Europe.

1. Mansart Roof:
 - A two-part roof of gambrel form, the spring slope being so steep as to practically form a wall (usually pierced with dormer windows), and the upper slope almost flat. Though not invented by Francois Mansart, the design bears his name as his designs used it often.
2. Double Spiral (helix) Stair:
 - Popular during the Late Renaissance, the two helixes ascend to three floors without meeting at any one landing.
3. Balustrade:
 - A rail system of foot-cleat with heavy turned balusters capped by a molded rail, often seen during this Period at the roof cornice.
4. Palladian:
 - Architectural style deriving from the name of Andrea Palladio and incorporating the architectural design motifs and elements that adorn his work.

► Emanating from Italy, the spirit of the Renaissance in all of its forms spreads to Europe and then beyond.

► Creativity with the architectural elements of the Period finds its way into both secular and ecclesiastical works.

► France and England both derive unique stylistic architectural expressions.

► French and English influences spread to the territories they controlled, reinforcing their affiliated domains.

FRANCE TO 1700

1. Chateau de Chenonceaux		1514 AD
at France Loir Valley		
2. Chateau at Chambord		1519 AD
at France Loir Valley		
3. Chateau at Blois		1498–1638 AD
at France	Louis XII Wing	1498–1503 AD
	Frances I Wing	1515–1525 AD
	Orleans Wing	1635–1638 AD
4. The Louvre		1510–1670 AD
at France:	Court by Pierre L'Escot	1510–1578 AD
	East Front by C. Perrault	1667–1670 AD
5. Luxembourg Palace		1615–1624 AD
at France	Salomon de Brosse	
6. St. Louis des Invalides		1675–1706 AD
at Paris, France	J.H. Mansart	
7. Vaux le Vicomte		1657 AD
at France	LeVau	
8. Palace at Versailles		1669–1685 AD
at Versailles, France	LeVau and Mansart, Gardens by Le Notre	

ENGLAND TO 1700 AD

9. Longleat		1568–1597 AD
at Wiltshire, England	Robert Smythson	
10. Wollaton Hall		1580–1588 AD
at Nottinghamshire, England	"Smythson"	
11. Hardwick Hall		1590–1597 AD
at Derbyshire, England	"Smythson"	
12. Queen's House		1616–1635 AD
at Greenwich, England	Inigo Jones	
13. Banqueting House		1619–1622 AD
at London, England	"Jones"	
14. St. Paul's Cathedral		1675–1711 AD
at London, England	Sir Christopher Wren	

BAROQUE IN EUROPE

15. Transparente (Toledo Cathedral)		1732 AD
at Toledo, Spain	Narciso Tome	
16. Granada Charterhouse		1727–1764 AD
at Granada, Spain	Arevald and Vasquez	
17. Vierzehnheiligen Pilgrimage Church		1743–1772 AD
at Franconia, Germany	Neumann	
18. Karlskircke		1715 AD
at Vienna, Austria	Fisher von Erlach	

FRANCE and ENGLAND TO 1850 AD

19. Le Petite Trianon		1762–1768 AD
at Versailles, France	Gabriel	
20. Place de la Concord		1763 AD
at Paris, France	Gabriel	
21. Pantheon		1755–1792 AD
at Paris, France	Soufflot	
22. Arch de Triumph		1806 AD
at Paris, France	Chalgrin	
23. Paris Opera		1861–1874 AD
at Paris, France	Garnier	
24. Blenheim Palace		1705–1724 AD
at Oxfordshire, England	John Vanbrugh	
25. Christ Church Spitalfields		1723–1739 AD
at London, England	Hawksmoor	
26. Chiswick House		1725 AD
at Chiswick, England	Lord Burlington	
27. The Royal Crescent		1767–1775 AD
at Bath, England	John Wood the Younger	
28. Royal Pavilion		1815–1818 AD
at Brighton, England	John Nash	
29. Strawberry Hill		1748–1777 AD
at Twickenham, England	Horace Walpole	
30. House of Parliament		1840–1865 AD
at London, England	Barry and Pugin	

Late Renaissance

1. Chateau de Chenonceaux:
 - Protected planning, gothic elements in turret and pointed arches, broken segmented pediment, and horizontal banding
2. Chateau de Chambord:
 - Symmetry, rhythmic window pattern, horizontal banding, gothic cornice, and double spire stair celebrates da Vinci mannerist influence
3. Chateau at Blois-Orleans:
 - The quoined corners date the Louis XII gothic wing, there were three major winds built
4. Chateau at Blois-Francois:
 - Order of column-stacking differs from those on the Colleseum
5. Court of the Louvre:
 - Italian motifs — recessed windows, pavilion pulled out for five-part façade
6. East Front of Louvre:
 - Residence of King Louis XIV, he expanded the Louvre to stay in Paris
7. Luxembourg Palace:
 - Baroque use of rustication, mannerist detailing and five-part façade
8. St. Louis des Invalids:
 - Double temple front over triumphal arch, renaissance centrally planned space
9. Vaux le Vicomte:
 - Seven-part façade, refined rustication and temple front baroque
10. Palace at Versailles:
 - Cost at the time ran to the equivalent of $65M, quarter mile long, façades are in 3:5 rhythm, hunting lodge for Louis XIV. Architect Leveau stretches out the wings and pulls out the ends and center pavilions, elements appear to be same length, perspective of 3:5. Its plan is the epitome of French baroque, employing the use of point markers, avenues, vistas, and landscape themes
11. Hall of Versailles:
 - Gallery de glass (mirrors), mostly governmental activities went on here
12. Longleat Palace:
 - Medieval elements, use of horizontal string course, introduction of the "long hall"
13. Wollaton Hall:
 - Flemish elements in curved pediment, strapwork and chimney, Italian balustrade
14. Hardwick Hall:
 - Corner towers are pulled in and doubled, use of bay windows but many details are not renaissance
15. Hardwick Hall:
 - Many elements smoothed over and refined here
16. The Queen's House:
 - Inigo Jones references Palladio's "villa" to get strong central theme

17. Banqueting House:
– Central pavilion with flat roof behind balustrade, expresses two-story height but is one
18. Double Cube Room:
– At Wilton House, Palladian proportions 1:1:2, highly decorated
19. St. Paul's Cathedral:
– Plan based on Latin cross, dome features are similar to St. Peter's, Wren's math knowledge conquers a difficult site, column-buttresses
20. Transparente:
– Uses light and false perspective on unique sculptures
21. Granada Charter House:
– Rococo—creates surface movement through shades and shadows
22. Vierzehnheiligen:
– Combines five interlocking ovals, results in turning dynamic walls
23. Karleskircke:
– Pioneers eclecticism, Roman front, column spires, Flemish gables
24. Le Petite Trianon:
– Later the model for Newport's Marblehouse, built for the King's mistresses
25. Arch de Triumph:
– Built during Napoleon's reign, "monumental" scale, commemorates French revolution
26. Paris Opera House :
– Attempt to revise baroque (stairs), end pavilions pulled out, giant order
27. Blenheim Palace:
– Developed English garden, not as rigid as French or Italian, more natural
28. Church at Spitalfields:
– "brutal", weighty baroque, Palladian motif, modified Doric columns
29. Chiswick House:
– Modeled after Palladio's villas and said to be inspiration for Jefferson's Monticello
30. Royal Crescent:
– Form makes commanding statement, rhythms set up well
31. Royal Pavilion:
– Most progressive use of iron in dome and structure
32. Strawberry Hill:
– Exemplifies the English renaissance manor and grounds

French Renaissance Timeline

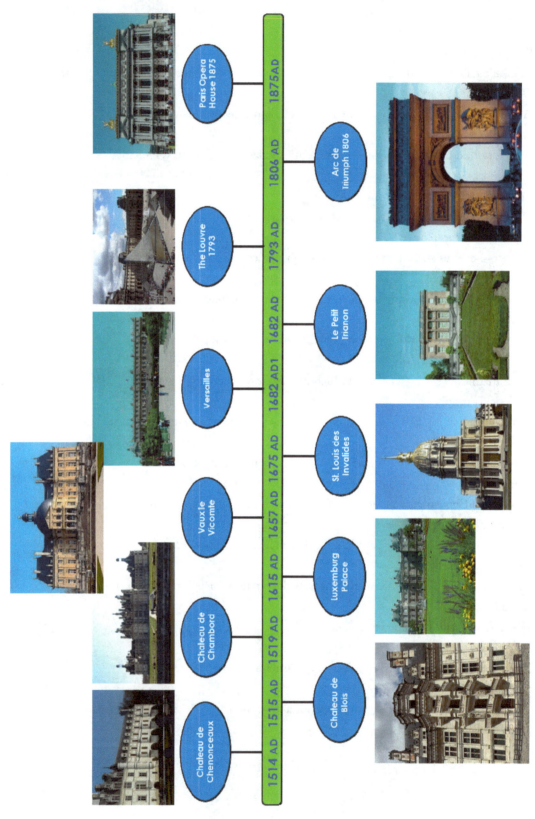

Chateau de Chenonceaux
Chateau de Chambord
Vaux le Vicomte
Versailles
The Louvre 1793
Paris Opera House 1875

Chateau de Blois
Luxemburg Palace
St. Louis des Invalides
Le Petit Trianon
Arc de Triumph 1806

1514 AD 1515 AD 1519 AD 1615 AD 1657 AD 1675 AD 1682 AD1 1682 AD 1793 AD 1806 AD 1875AD

Built on the ramparts of an old bridge and extended to span the River Cher, Chenonceaux remains one of the most well know Chateaus of the Loire Valley. Designed by architect Philibert de l'Orme, its riverine base uses powerful Romanesque arches while its Renaissance architecture is accented by slightly Gothic detail.

Late Renaissancel

Built as a hunting lodge for François I, Chambord is a distinct example of French Renaissance design. Its busy roof of towers, gables, and chimneys reside over an otherwise strict registry of ruled lines broken into a seven-part façade.

Its towers and moat are decorative and came long after times of turmoil that required such.

Though built over several iterations spanning between the Thirteenth to Seventeenth Centuries, it was Louis XII who affected its current architecture most, along with François I. It is one of the purest representations of French renaissance architecture, exemplified in surface and façade elements, and the iconic French-style roof.
The double helical stair is of a design attributed to Leonardo da Vinci.

(Below) Louis XII (shown on horse.

Late Renaissance

In 1610 Henry IV died and Marie de Medicis, regent for her son Louis XIII, acquired considerable power and elected to built a palace for herself but in the vein of her native Florentine Pitti Palace. She was said to have sent her architect to make measured drawings.

Later in 1642, she left the palace to her other son Gaston, who was considered by many to have her favor. Set in Paris' pristine Luxembourg Gardens, the palace has undergone several renovations over time but remains stately.

The Louvre is quintessentially French Renaissance and though built originally as a fortress for Philip II, today it stands as one of the largest if not most important museums in the world. Approximately 15,000 visitors each day get a glimpse of just some of the museum's collection of over 380,000 objects spread out over more than a half million square feet. (Opposite) Winged Victory (sculptor unknown), date to the Second Century BC and was likely originally stationed an a stone base that represented the prow of a ship.

Late Renaissance

Claude Perrault's East Front of the Louvre.

(Left) Roman version of The Three Graces (beauty, charm, and joy).

(Below right) Dating to the Second Century BC is Antioch's Venus de Milo. This Work has always received great admiration because even in her antiqued state with scratches and gauges, she is an example of simple and understated beauty. Likely, her left hand held an apple (of gold).

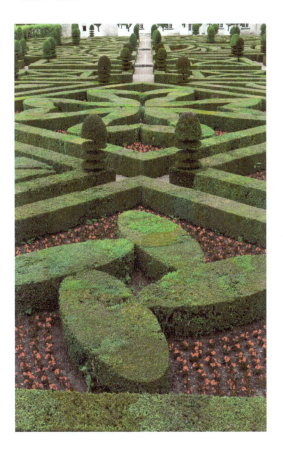

The Louis XIV Style was kicked off here when for the first time architecture (Le Vau), interior design (Le Brun), and landscape planning (le Notre), were performed as a collaboration. As mid-seventeenth-century French Renaissance takes a Baroque turn, all elements of this design are symmetrical. Additionally, traditional French Chateau depth or *corps de logis*, "main body," was one room but Le Vau's plan calls for a double-room depth. Constructed on a moated base, the façades were originally to be brick but as the seventeenth-century middle class copied the style, Le Vau decided to use stone.

Late Renaissance

A veteran's hospital, Les Invalides was the idea of Louis XIV who wanted the hospital built for aged or wounded soldiers. It is the burial site for Napoleon Bonaparte, among others.

After the Eiffel Tower, its gold decorated Baroque dome is the second most recognizable feature in the Parisian skyline. Architect Liberal Bruant was assigned the project and due to age and health, his efforts were augmented by Jules Hardouin-Mansard, who drew upon the design of St. Peter's for inspiration to raise the dome on an attic ring over the double-columned drum.

Named for the Parisian suburb where it is located, Versailles was originally a hunting lodge for Louis XIII and was the result of four important building campaigns. The first, called *Pleasures of the Enchanted Island*, saw expansions to accommodate more people. The second, after the Treaty of Aix –la-Chapelle, saw Le Vau collaborate once again with La Brun to construct the Grand Apartments. Jules Hardouin-Mansart constructed the north and south wings and the Hall of Mirrors after the Treaty of Nijmegen and lastly, Mansart designed and started the royal chapel following the War of the League of Augsburg.

Late Renaissance

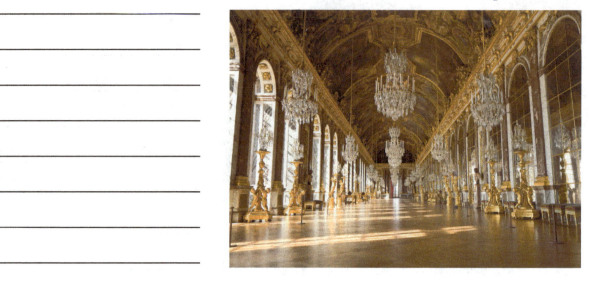

An example of French Renaissance steeped in the Baroque, Le Vau revisits classical elements; a deeply-tooled base of Romanesque arches, expressive horizontal entablatures supporting columns, and subtle pavilions pulled out slightly to fragment the façade. Baroque notions are cemented in both the interiors and the landscape gardens.

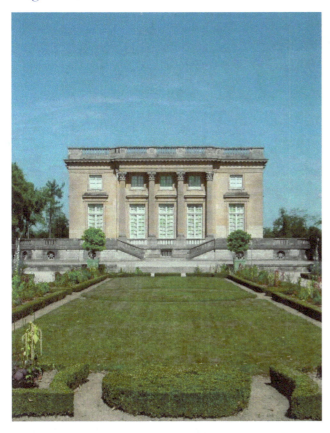

(Right) Le Petit Trianon, built by Louis XV was for his long-time mistress, was later the inspiration for Marble House at Newport, RI for Vanderbilt.
(Below) Le Grande Trianon, built by Louis XIV as a retreat in the gardens at Versailles.

Late Renaissance

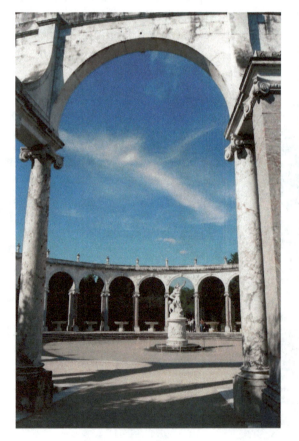

(Above) Built for Marie Antoinette and located near Le Petit Trianon is a small hamlet that served as her retreat called Hameau de la Reine. Used as an escape from her royal responsibilities, she would dress in peasant clothing and mill about, playing the role of a commoner. This led to the intense resentment that subjects held toward the monarchy.

(Right) The vast gardens of Versailles are formed around a central axial water feature called the Grande Canal where nearby you will find a mock Colosseum, shown right. The structure was used for garden performances, displays, and theatrical events.

1840 AD	
1767 AD	Royal Crescent
1749 AD	Palace of Westminster
1723 AD	Chiswick House
1675 AD	Strawberry Hill
1630 AD	Willton House
1619 AD	St. Paul's Cathedral
1615 AD	Royal Banquet
1596 AD	Queen's House
1580 AD	Hardwick Hall
1568 AD	Longleat Manor
	Wollaton Hall

Considered one of England's finest examples of Elizabethan architecture, Longleat illustrates Renaissance departures unique to English architecture. Deriving its name from *leat*, a water channel, the manor's façade is segmented into a seven-part rhythm but highlighted by much larger fenestration (window openings) than traditional structures of the Italian and French Renaissance styles. Another English contribution is the emphasized flat cornice, decorated by balustrades and perforated petit gables.

Another exemplary Elizabethan English structure, Wollaton, shares many of the same design elements as those seen at Longleat but with an introduction of Gothic, French, and even Dutch influences. Built of stone from Lincolnshire, it is widely thought that its owner, Sir Francis Willoughby, bartered coal from his mines for the stone. Italian master masons likely built the structure, evidenced by gondola mooring rings carved into the lower exterior base, likely used as a decoration but a function they were familiar with.

——————————————

——————————————

——————————————

——————————————

——————————————

——————————————

Built for Bess of Hardwick, this is yet another Smythson example of Elizabethan English Renaissance architecture. As glass was an expensive luxury, Smythson expressed Bess' wealth through the unusual proportion of "void to solid" or, fenestration. The numerous and requisite chimneys were also located internally to free-up exterior wall surface for more windows.

Jones carved his place on the architecture scene with this early commission for Ann of Denmark, Queen to England's King James I.

Influenced by his travels through Italy, Jones incorporated classic Palladian design elements in this early and first example of English architecture that reflects Classicism.

Today, it serves as a part of England's National Maritime Museum.

The surviving structure of Henry VIII's Palace of Whitehall, the Banqueting House, is a clear reference to Italian Renaissance style, Jones' continuation of neoclassical design during the Jacobean period. A deep-tooled rusticated base supports a register of alternating triangular and elliptical pedimented windows separated by Ionic pilasters. The upper register shows Corinthian pilasters supporting a cornice capped by balustrades, the frieze of which is decorated by draped swags.

The south front of the staterooms wing of Wilton was designed by Jones and is built in strict Palladian style but of local stone. Three porches of the lower level suggest pavilions while the piano nobile is accentuated by a central double-height Venetian window revealing the Pembroke coat of arms. The importance of the piano nobile is emphasized by the smaller windows aligned above, capped by a balustrade that is book-ended by the iconic Palladian "pavilions," that form a sort of tower. Its elegance is based on its simplicity, a classic Palladian architectural trait reinforced even in the grounds buildings (above).

Late Renaissance

Rising out of the Great Fire of London in 1666, St. Paul's stands as the only domed church in London and serves as the icon that represents the great City.

Having gone through several design iterations, Wren was tasked to build a church that replaced the liturgy of Old St. Paul's while recreating a landmark. Built on compromising soils consisting of clay, Wren expanded the usual crypt and enhanced the piers below to provide a wider distribution of downward forces.

The dome is Wren's design, unique to St. Paul's and like St. Peter's consists of an inner and outer dome but with a brick conical form between them that supports the weight of the lantern. The outer dome is built of wood timbers supporting a lead shell while the inner dome and cone are brick and reinforced by tensile chains to prevent outward thrusts.

St. Paul's was completed in Wren's lifetime, an achievement sometimes not common for this period.

English spirit was put to the test during the "Blitz" of WW II, when great efforts went into protecting St. Paul's, an obvious target. Christopher Wren, Horatio Nelson, and Edwin Lutyens are among those buried in St. Paul's.

Late Renaissance

(Above) The essence of Baroque ideals can be found in El Transparante, the altarpiece in the tabernacle of the Todedo Cathedral. The imagery of "The light of God" is accomplished through the use of skylights in both the roof and the wall behind the altar, allowing an abundance of light to illuminate the tabernacle.

(Right) An important specimen of Spanish Baroque ideals, the undulating turned-out cornice of the tabernacle frames the altarpiece and appears to be in dynamic motion.

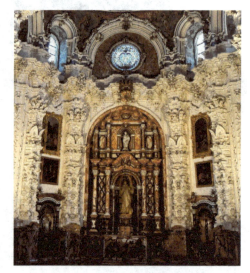

The slides: Europe to 1850
Granada Charter House, Granada Spain
1732 AD

Meaning "Basilica of the Fourteen Helpers," Vierzehnheiligen in Bavaria is known for its Baroque high altar with its dramatic turned out cornice and colorful columns that frame the painting showing the Assumption of Mary.

Meaning "St. Charles's Church," Karleskirche is Vienna'a finest example of Baroque architecture, defined by its eclectic ensemble of a Greek temple portico flanked by columns resembling Trajan's, all between roman arches, and a dome place on an extended drum.

The slides: Europe to 1850
Karleskirche, Vienna, Austria
1715 AD

Late Renaissance

Completing the triad of iconic monuments on the Paris skyline (Eiffel Tower, Les Invalids, and the Arc), it anchors the west end of the Champs-Elysees.

Standing 164 feet tall, the Arc was modeled after Rome's Arch of Titus and honors soldiers from the French Revolution and Napoleonic Wars.

A trivial fact attests to its scale—in 1919 a biplane flew through its arched opening.

Sculptures and reliefs ornament the Arc's surfaces and represent France's stories of political past.

Also known as the *Palais Garnier* after its architect Charles Garnier, this Beaux-Arts master-piece's façade serves as a history storybook. Poetry, music, dance, and drama are represented by statues between the lower register Romanesque arches; busts of great composers of the time are found in portals flanked by pavilions representing architecture, industry, painting, and sculpture. Finally, golden statues representing harmony and poetry frame the dome which is crowned by Apollo. The interior is Beaux-Arts opulence at its best.

Late Renaissance

———————————————

———————————————

———————————————

———————————————

———————————————

———————————————

———————————————

(Right) Spitalfields, an unusually plain rectangular nave, is fronted by its west tower — Tuscan columns raised on plinths support the arch and main body while the spire reflects a more Gothic form.

(Below) Inspired by Palladio's Villa Rotunda, Chiswick itself was viewed by Jefferson (an admitted disciple of Palladio) while on his way to France, himself modeling Monticello after the designs of both Villa Rotunda and Chiswick.

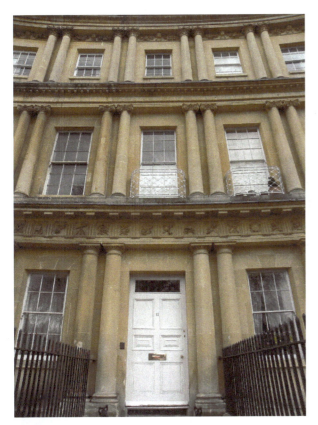

An example of Georgian architecture, The Crescent was an innovative approach at urban residential living consisting of thirty dwellings behind the sweeping façade of stacked orders. Here, a purchaser bought a length of the façade and used their own architect to complete the dwelling behind. The township of Bath is a Roman settlement, the buildings unified by its cream-colored stone.

Late Renaissance

(Above right) A unique example of Gothic Revival, expressions of pointed arches are combined with English roof parapet battlement. Its Gothic detailing carries over to the structure's interior.

(Right) Built by George IV while titled by the Prince of Wales, the Pavilion draws upon both Indian and Islamic forms while the interior decoration shows Chinese influence.

Providing the chambers for the House of Commons and House of Lords (the two Houses of Parliament), the "new" palace as it is referred to today is the result of fires, bombings , and other reconstructions.

Built in the Perpendicular Style of Gothic Revival, selection of a suitable stone quarry with waterway transport capabilities was crucial to the construction of such an expansive structure. The soft limestone selected however, began to decay due to pollution in the nineteenth century (coal burning a major source), and had to be mostly replaced.

The Palace's Victoria and Elizabeth Towers are icons of London today, the latter of which houses the clock of Westminster and tolls the Westminster Chimes of four bells, the largest of which is nicknamed, "Big Ben."

Italian Renaissance

Culture:
- Time of rebirth culturally with focus on humanistic studies, the sciences and art;
- The common people's middle class emerges;
- Wealthy merchants, bankers, and guilds finance cultural programs of art and architecture in Italy's city-states;
- Knowledge, power and wealth wrested from the Church;
- Michelangelo carves the Pieta, David and paints the Sistine.

Architecture:
- Renewed interest in Classical architecture;
- Academic and abstract approach to architecture;
- Civic focus on common buildings (not just the Church);
- Typical Renaissance expressions include:
- Surface rustication and elevation refinement
- Horizontal banding and strong cornice lines
- Three-story expression of much larger buildings
- The Italian "villa" is born;
- Common church façade motif includes Greek temple over the triumphal arch;
- Florence is the epicenter of early Renaissance development;
- Greatest period for art (painting, sculpture and architecture).

Detail:
- Brunelleschi invents the perspective drawing technique, uses the Roman triumphal arch as a design motif and designs a dome-within-a-dome;
- The printing press is invented (knowledge spreads);
- The preferred stone was Pietra Serena;
- Baroque (dynamic) period emerges as ellipses, trapezoids and other more complex shapes help redefine 3-dimensional space.

Late Renaissance

Culture:
- Energy of Italian Renaissance is contagious and spreads quickly;
- Basic Renaissance design principles copied while other regions try to apply individuality;
- French Kings impressed with Italian villas and construct their interpretations throughout the south of France in Loire Valley;
- English monarchs and land barons spread their ideas through the English countryside.

Architecture:
- French monarchs construct large chateaus using Renaissance principles to regulate and organize design lines;
- English monarchs construct large manors doing the same but at first resist expressing any Italian or French influence;
- Renaissance spreads, creating a poly-descriptive architectural vocabulary for architects to draw from;
- Trompe l'oeil "to trick the eye", is a technique developed to paint columns to look like marble I the absence of the skill-craft;
- Francois Mansart creates the "Mansart" roof during the expansion of the Louvre - becomes popular French form style;
- Inigo Jones and other English architects working from Palladio's Four Books of Architecture and Alberti's treatice.

Detail:
- France's chateaus organized about the multi-part façade where the center and flanking masses are pushed or pulled from the façade baseline;
- England's manors organized using less-pronounced movement and a bulkier massing;
- World Renaissance influenced mostly by Italian works.

Growth in a New World

- The first priority of Colonists was survival.
- Stability saw developments in style and close ties with England remained early due to lack of ability to manufacture building products.
- Virginia wealth is seen through masonry architecture, white paint (had titanium), and stylistic designs.
- Farming (tobacco) and its exportation is the power-base (fines and debts were paid in tobacco).
- Glass is shipped from overseas, along with many other manufactured products.
- Buildings were said to be burned down for their nails (a law was passed to prohibit that).
- Architecture is unrefined and reactionary. Following the Revolution, "Revival" architecture was instigated by Jefferson in an effort to implement architecture which symbolized America's democratic philosophies and spirit.
- Early American towns and villages were organic fabrics of water access, roads, and cart-ways and were characterized as farmlands, seaport villages, and mill towns.
- Ongoing developments influenced these towns and the way they were connected and continues to do so today, including shipping, rail transportation, steam, the textile industry, etc.

The Architecture

- Post-Revolution architecture sees sequential stylistic trends occur over the next 100 years. These styles emulate European expressions but are practiced with accuracy due to publications like Asher Benjamin's, *The American Builder's Companion*.
- Styles were a combination of an attempt to reflect European designs, use local materials, and respond to local conditions.
- Thomas Jefferson, president, scientist, botanist, statesman, and architect, would have a profound impact on municipal and monumental architecture in America.
- Benjamin Latrobe, a British emigrant and Charles Bullfinch of Boston are credited as being among the first to treat architecture as their professional practice and not as a "gentleman's art."
- Richard Morris Hunt and Henry Hobson (H.H.) Richardson are the first two American architects to graduate from France's *Ecole des Beaux Arts*, "school of fine arts." They returned from France and embarked upon important careers.
- The "Shingle Style" emanates from the Northeast as soft, shingled expressions reflecting the massing and lines of European works by masters including C.F.A. Voysey and Edwin Lutyens.
- Chicago's great fire helps usher in the "high rise."
- New York's ability to attract corporate headquarters to the City begins a skyscraper race.

Early American Colonial

1. Georgian Style:
 - The prerevolution style was popular not only in America but throughout the U.K. and beyond. Its namesake was due to its growth under the reign of England's King George III and its features included; a well-proportioned rectangular form of two stories, low hip roof, symmetrical outer chimneys, centered portico or classically-pronounced center entry, two windows symmetrically flanking the entry, and pilasters or quoins defining the front corners.

2. Federal Style:
 - Similar in many ways to the Georgian, the Federal was mostly a political name that reflected federalists attitudes during and after the Revolution. Made popular by U.K. architects, the Adam brothers, it was generally a well-proportioned rectangular or square form of two stories and two rooms deep, similar façade elements but with more decorative window treatments and swags, a low hip roof or gabled roof — sometimes dressed behind a balustrade, symmetrical chimneys two windows (never paired) flanking the entry. The entry portico was usually the most decorated part with varying designs of fan-light windows centered above.

3. Greek and Roman Revival:
 - Instigated by Thomas Jefferson after his service in France after the Revolution and during his two-term presidencies, these revivals came on the heels of American shipping to the Mediterranean and archeological finds defining Greece as the earliest democracy. Classical columns, entablatures, pediments, and arcuations adorned the front of buildings both private and public, expressing republican ideals and monumentality.

4. Italianate:
 - Impressed by Italian villas, sea captains and crew brought back this style expressed by high-ceilinged square floor plans, thin-tall windows usually paired, delicately detailed porches, low-pitched roofs with bracketed wide overhangs often capped by a window-lit cupola.

5. Second Empire:
 - This style was named for the reign of Napoleon III in France and consists of both symmetrical and asymmetrical façades balanced by a tower feature but with the signature steep mansard roof, the lower-steep slope of which was pierced by dormers.

▶ Colonial style names are more political in origin than descriptive. Greater wealth in the South early on was reflected in the architecture through employ of skilled masons and craftsmen, and use of durable materials

▶ Important early American architects include Asher Benjamin, Charles Bullfinch, Richard Morris Hunt, Thomas Jefferson, and H.H. Richardson (among others), and Freemasonry often played a role in building design and construction.

COLONIAL

1. Adam Thoroughgood House 1636
 at Virginia
2. St. Luke's Church 1632 – 1675
 at Smithfield, VA
3. Old Ship Meeting House 1681
 at Hingham, MA
4. "Wren Building" College of William and Mary 1695 – 1702
 at Williamsburg, VA
5. Stratford Thomas Lee House 1725 – 1730
 at Westmoreland, VA
6. Redwood Library 1748 – 1750
 at Newport, RI Peter Harrison

FEDERAL

7. John Brown House 1786
 at Providence, RI Joseph Brown
8. Massachusetts State House 1795 – 1798
 at Boston, MA Charles Bulfinch

ROMAN REVIVAL

9. Virginia State Capitol 1765 – 1789
 at Richmond, VA Thomas Jefferson
10. Monticello 1772
 at Charlottesville, VA " Jefferson"
11. University of Virginia 1817 – 1826
 at Charlottesville, VA " Jefferson"
12. St. Mary's Cathedral (Baltimore) 1804 – 1821
 at Baltimore, MD Benjamin Latrobe
13. Capitol Building 1792
 at Washington, DC Thorton, Latrobe, Bulfinch, Walter
14. Plan of Washington, DC 1791
 at Washington, DC Pierre Charles L'Enfant

GREEK REVIVAL

15. Second National Bank 1818 – 1824
 at Philadelphia, PA William Strickland

GOTHIC REVIVAL

16. Trinity Church		1839 – 1846
at New York, NY	Richard Upjohn	
17. St. Patrick's Cathedral		1858 – 1879
at New York, NY	James Renwick	

ECLECTIC

18. Memorial Hall, Harvard		1870 – 1878
at Cambridge, MA	Ware & Van Brunt	
19. Chateau Sur Mer		1873 – 1876
at Newport, RI	Richard Morris Hunt	
20. Tribune Building		1876
at New York, NY	"Hunt"	
21. Griswold House		1862
at Newport, RI	"Hunt"	
22. Marble House		1892
at Newport, RI	"Hunt"	
23. Trinity Church		1873 – 1877
at Boston, MA	Henry Hobson Richardson	
24. Sever Hall, Harvard		1878 – 1880
at Cambridge, MA	H.H. Richardson	
25. Crane Memorial Library		1880 – 1883
at Quincy, MA	H.H. Richardson	
26. Marshall Field Warehouse		1855 – 1887
at Chicago, IL	H.H. Richardson	
27. Provident Trust Building		1879
at Philadelphia, PA	Frank Furness	
28. Academy of Fine Arts		1872 – 1876
at Philadelphia, PA	"Furness"	

SHINGLE STYLE

29. Watts-Sherman House		1874 - 1875
at Newport, RI	H.H. Richardson	
30. The Newport Casino		1879 - 1881
at Newport, RI	McKim, Mead and White	
31. Isaac Bell House		1882 – 1883
at Newport, RI	McKim, Mead and White	

Early American Colonial

1. Adam Thoroughgood House:
– Indentured servant who works his way up, architecture reflects country English elements
2. St. Luke's Church:
– Gothic elements including quoined corners and masonry
3. Old Ship Meeting House:
– Building use typical of era — used for meeting, community, church, etc.
4. Wren's William and Mary:
– Renaissance lines, pioneering of American cupola (a necessity for ventilation)
5. Stratford Thomas Lee House:
– Revival entry and Renaissance elements
6. Redwood Library:
– Greek revival, quoined corners, built out of redwood but tooled joints made to look like masonry
7. Mass. State House:
– Bullfinch's design looks to Europe, the original dome was wood and is capped with a pine cone
8. Monticello:
– Jefferson models after Chiswick House but with corrections to refine that design
9. Monticello Plan:
– Grounds planning and structures modeled after Roman spaces
10. University of Virginia:
– Jefferson modeled the Rotunda (library) after Rome's Pantheon; it anchors symmetrical wings of academic buildings, each expressing different architectural order and forming the great "Lawn"
11. Virginia State House:
– Jefferson's suggestive use of Greco-Roman municipal architecture
12. Baltimore Cathedral:
– Latrobe draws two schemes, the Roman one chosen
13. Washington Capitol Building:
– Expresses grand monumentality and underwent several phases, being built, burnt, rebuilt, and renovated
14. Capitol Column:
– Column capitols with corn cob, to be purely American
15. Washington Capitol Dome:
– Built and then expanded with iron frames, its original dome has the frescoes of Brumidi
16. Plan of Washington:
– Similar to Paris, L'Enfant surveys site, places prominent buildings on nodes
17. Plan of Paris:
– Comparison to Washington demonstrating a city of links and nodes
18. Second National Bank:
– Earliest copy of Parthenon, program called for Greek-marble architecture

19. Memorial Hall, Harvard:
- High Victorian Gothic in its use of elements

20. Chateau sur Mer:
- American example of chateau, mansard roof

21. Griswold House:
- Tudor elements express a structure externally, a Dutch influence

22. Traverse Block:
- Shingle style

23. Marble House:
- Hunt models after the Petit Trianon and travels to Europe to select its marble

24. Trinity Church:
- American church expressed by Richardson in new style

25. Crane memorial Library:
- Classic Richardson, use of brown stone Romanesque arches, detailing and eyebrow roof vent

26. Watts-Sherman House:
- Eclectic half timber, Queen Ann lines

27. Marshall Field Warehouse:
- Richardson's mastering of Renaissance elements, referencing Palazzo Medici-Ricardi

28. Provident Trust Building:
- Furness expressing eclecticism in masonry, note detailing

29. Academy of Fine Arts:
- Eclectic expressions using rustication, scale, Gothic, and French elements

30. Trinity Church:
- By Richard Upjohn, use of Gothic Revival elements

31. Calvary Episcopal Church:
- A smaller local example of Upjohn's ecclesiastical work adhering to Gothic Revival

32. St. Patrick's Cathedral:
- James Renwick advancing the Gothic Revival

33. Kingscote:
- Example of "carpenter's Gothic"

34. Downing's Cottages:
- Sketch studies of Design V — bracketed mode

Early American Colonial Styles Timeline

Mid 18th c. Late 18th c. Early 19th c. Early 19th c. Mid 19th c. Mid-late 19th c. Late 19th c. Late 19th c. Late 19th c.

The Georgian

The Greek Revival

Italianate

Gothic Revival

Neo-classical

The Federal

The Roman Revival

Second Empire

Shingle Style

Early American Colonial Timeline

Mass. State House — 1817 AD
John Brown House — 1795 AD
Redwood Library — 1786 AD
Wren Bldg. William & Mary College — 1748 AD
Adam Thoroughgood House — 1725 AD

Univ. of Virginia — 1791 AD
U.S. Capitol Building — 1772 AD
Monticello — 1695 AD
Strafford Thomas Lee House — 1681 AD
Old Ship Meeting House — 1636 AD
St. Luke's Church — 1632 AD

Marble House, Newport — 1892 AD

Isaac Bell house, Newport — 1885 AD

Marshall Field Warehouse — 1882 AD

Severhall, Harvard — 1880 AD

Crane memorial Library — 1878 AD

Watts Sherman House, Newport — 1874 AD

Trinity Church, Boston — 1873 AD

Memorial Hall, Harvard — 1870 AD

St. Patrick's New York — 1858 AD

Trinity Church New York — 1839 AD

Second National Bank — 1818 AD

Early American Colonial

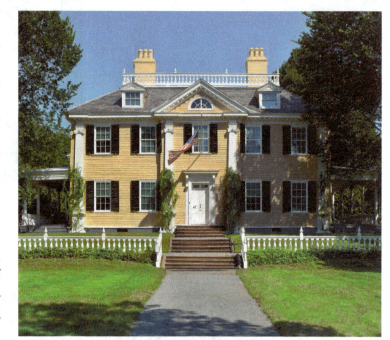

(Right) A classic example of Georgian architecture, the Long-fellow House in Cambridge, MA embodies all of the elements.

(Below) A view of the Mystic Seaport Museum looking northwest across the Mystic River in historic Mystic, Connecticut. Historically a seaport village originally settled in the seventeenth century, Mystic is home to one of the America's best preserved collections of Early American Colonial architecture.

The slides: Colonial Styles
Seaport Village
Mystic, Connecticut

(Left) Influenced by A.J. Downing's book *Cottage Residences*, this Mystic, CT home preserves the simplicity and essence of Downing's ideas.
(Below) A view looking west across the Mystic river shows the idyllic river-scape of this village, highlighted by its preservation of Period Colonial homes that while differing in style, stitch together a historic fabric frequented by tourists anxious to stroll its streets and view the architecture.

The slides: Colonial Styles
Seaport Village
Mystic, Connecticut

Early American Colonial

—————————————

—————————————

—————————————

—————————————

—————————————

—————————————

—————————————

Iterations of the Federal style, these Stonington, CT homes reveal the diverse pallet drawn upon by their designers. As a seaport village, shipping merchants often returned home from ports visited, with new ideas and an expanded architectural vocabulary of form and details. Skilled carpenters and shipwrights executed these designs with unparalleled crafts-

Popularized by Jefferson and admired abroad as trade expanded into the Mediterranean, the Greek Revival style compliments the Colonial fishing-village streets of Stonington, facing passersby with their exquisite fan windows emphasizing their pedimented gables.

Pilastered corners, bolt entablatures and pediment rakes,

Early American Colonial

(Above) Mystic's iconic "church on the hill", show's the Village's use of the Roman Revival style.

(Left) Stonington Borough's St. Mary's Church stands as testament to the simple power an arch can lend to architecture of faith. Its clean Revival façade uses an elegant oversized arch to welcome and "protect" parishioners.

The slides: Colonial

Colonial Revival

276

(Left) The delicate lines of the Gothic Revival style provide ornament to Mystic's Streetscape. (Below) Defined by thin-tall windows, a broad bracketed overhang, and delicately detailed porch, the Italianate style dots Mystic's streets that are higher in elevation thus rendering the cupola functional for viewing incoming ships.

The slides: Colonial Styles
Italianate
1851, Mystic, CT

Early American Colonial

The Second Empire style makes a stately impression in the village of Mystic. Its mansard roof defines the simple mass below and is ruled by lines of order but accented with elegant detailing.

The slides: Colonial
Second Empire
Mid—Late 19th Century (Mystic, CT)

278

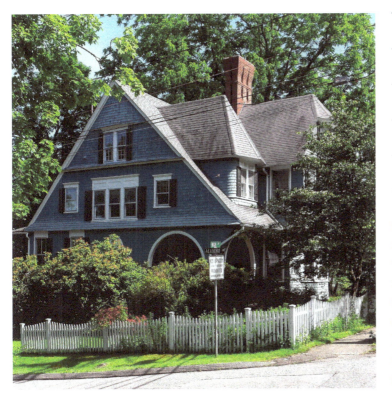

(Left) Another Mystic home reflects the eclectic Shingle Style, which allowed expressive design flexibility and was made popular in the architecture of Newport, RI. (Below) Bank Square anchors Mystic's W. Main Street west of the bascule bridge, fronted on the north by this neoclassical bank.

The slides: Colonial
Neo-classical
Late 19th Century (Mystic, CT)

Early American Colonial

(Above) This brick farm house, one of Virginia's oldest, was home to Adam Thoroughgood, an indentured servant. Its simplicity emphasizes function over style.

(Right) The oldest remaining brick church of the thirteen colonies, it was a post-Protestant reformation template for the colonies, expressing basic Gothic elements.

The slides: Colonial
St. Luke's Church, VA
1632 AD

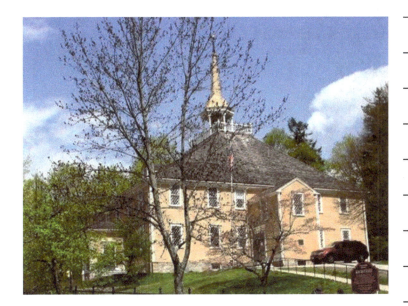

(Above) Built as a Puritan meetinghouse, Old Ship is the oldest continuously used ecclesiastical building in the United States. Evidence of its shipwright builders, are the nautically influenced hammerbeam trusses supporting the roof.

(Right) The Wren Building at the College of William and Mary is the oldest collegiate building in the United States. Alumnus Thomas Jefferson drafted plans for expansion of the structure into a quadrangle but the revolution interrupted the effort.

The slides: Colonial
Wren Building, William and Mary, VA
1695 AD

Early American Colonial

(Right) The Georgian design of the Lee house forms a "H" and was an early example of wealth expressing style in Virginia.

(Below) Based on a plate in the book *Andrea Palladio's Architecture* by Hoppus (1735), the Redwood Library is said to be the first public classical building in the United States. Deep-tooled joints and paint mixed with sand give the appearance that the building is made of stone.

(Left) On Providence's College Hill, the Brown House is a stately example of the Federal style with its symmetry, central pavilion, and balustrade capped roof.

(Below) Bullfinch draws upon the style of two London structures (Somerset House and Pantheon), along with some Renaissance ruling to place his majestic structure on Boston's Beacon Hill. The medallions in the spandrel of the arches reflect Brunelleschi's Founding Hospital. Paul Revere's copper company covered the original wood dome to stop leaks.

The slides: Federal
Massachusetts State House
1795 AD

Early American Colonial

(Above) Seeing Greco-Roman architecture as a reflection of America's new republic, Jefferson modeled Virginia's State Capitol after the Roman Mason Carree in Nimes, France. (Below) Similarly, Monticello derives its form from Jefferson's liking of Palladio's Villa Rotunda and Burlington's Chiswick House. Distinctly Jefferson, Monticello is a web of Jefferson touches, inventions, experiments, and decorative ideas learned abroad.

The slides: Roman Revival
Monticello, VA
1772 by Jefferson

One of Jefferson's lasting triumphs was the founding of the University of Virginia for which he was most proud. With other colleges founded about a chapel, UVA was the first nonsectarian college in the U.S. and the first to offer elective courses of study including the sciences. Jefferson layout out the master plan, designed the structures, organized the curriculums, and even appointed the faculty. The Rotunda Library modeled after Rome's Pantheon (above), is central to leaning and therefore central to the plan, where academic wings about the Rotunda form a "U," embracing The Lawn and forming what Jefferson called the "Academic Village."

Early American Colonial

Pierre Charles L'Enfant laid out the plan for Washington, DC in 1791, modeling it after Paris — a city of nodes and links resulting in powerful vistas. To accomplish this, L'Enfant designed a grid of streets that run cardinally north-south, east-west. Avenues intersect diagonally (named after the States of the Union).

A highlight of the plan is the National Mall, from which the Capitol Building is viewed (below). It ranks among the most powerful vistas in the world.

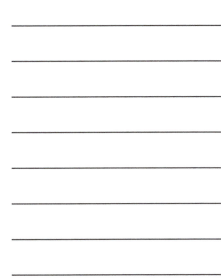

Though a design competition was held for the Capitol Building, the plans were rejected and it was a late submittal by a physician, Dr. William Thornton, that caught Jefferson's eye. The Capitol has been expanded and modified several times, first by Latrobe, then Bullfinch, and again by Walter. Most impressive is the dome, expanded to its current day design due to the capabilities of cast iron. The inner dome displays frescoes by Constantino Brumidi called *The Apothesis of Washington*, showing Washington surrounded by thirteen maidens and Greek and Roman gods and goddesses playing out important chapters in America.

Early American Colonial

———————————

———————————

———————————

———————————

———————————

———————————

(Right) Strickland, a pupil of Latrobe, shared his admiration of Greek revival architecture. (Below) Upjohn, an important ecclesiastical architect, put his stamp on Gothic Revival at Trinity in New York City.

The slides: Gothic Revival
Trinity Church, NY
Begun 1839 by Richard Upjohn

288

The Slides: Gothic Revival
St. Patrick's Cathedral
Begun AD 1858 by James Renwick

St. Patrick's, a Gothic Revival landmark in New York City, was designed by James Renwick. Though not formally trained as an architect, Renwick's knowledge-base could be credited to his father who was a professor of engineering at Columbia, and his two brothers who were also engineers. A brick structure clad with marble from Maine, artists from Chartes, France were involved in the production of the stained glass, and the altar was made by Tiffany & Co.

Early American Colonial

The Eclectic style of architecture allows design freedom but must also be constrained by proper scale, proportion, massing, and regulation. As seen at Memorial Hall and the Isaac Bell House above and below respectively, proper control of this freedom leads to architecture that appears pleasing, natural, and harmonious.

The slides: Eclectic (Shingle Style)
Isaac Bell House
1882 by McKim, Mead & White

Newport, RI was the focus of late nineteenth-century expression of wealth as families including the Astor's and Vanderbilt's constructed their "cottages" on Rhode Island's scenic coastline. Richard Morris Hunt, a graduate of France's *Ecole de Beaux-Arts*, was the architect of the Vanderbilts but shows his design diversity and command of Classicism in his works. Hunt drew upon his French training and modeled Marble House (below) on Le Petit Trianon.

The slides: Eclectic
Marble House, Newport, RI
1892 by Richard Morris Hunt

Early American Colonial

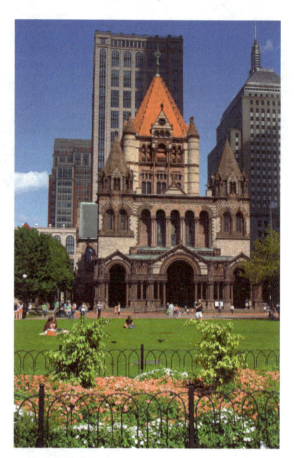

Also a product of the *Ecole de Beaux-Arts*, Richardson turned to the Romanesque style at Trinity. His trademark brownstone-pink granite combination and Romanesque features became widely known as "Richardsonian Romanesque."

Reflecting Byzantine architecture, Trinity's design is based on the Greek Cross and relies on the beauty inherent in its structure, over ornamentation on the interior.

Though much of Richardson's work exhibits his trademark Romanesque arch, brownstone base, and roof eyebrows, the works seen here illustrate his ability to be nimble with design — mastering form and creating ensembles of façade details both bold (half timber) and discrete (fine brickwork).

Richardson's work was original, unique, and would serve to inspire architects for generations to come.

The slides: Eclectic (Shingle Style)
Watts-Sherman House, Newport, RI
Begun 1874 by H.H. Richardson

Early American Colonial

(Above) Considered as an archetype of Richardson's work, Crane memorial embodies his trademark elements all in a single building. There may not be many late nineteenth-century towns in America without a building that draws from the vocabulary of this design, including the brownstone-pink granite combination, powerfully expressed Romanesque arch, rich brownstone casing and roof eyebrows.

(Below) When confronted with building a large-scale building in Chicago, when the surrounding context remained low to the ground level due to the Great Fire, Richardson turned to a masterpiece that pioneered this contextual problem — Palazzo Medici-Ricardi. Using rusticated stone gradually refining, he placed story—registers within registers divided by horizontal bands that articulate a subtle low, middle, and top. Its demolition was one of the most regrettable acts in the city's storied history.

Source: _Library of Congress_

Frank Furness is known as the quintessential eclecticist. An apprentice of Hunt, he also was a product of the *Ecole de Beaux-Arts*. Later the mentor of Louis Sullivan, his work of brick, brownstone, and subtle patterns of coursing and molded bricks were applied to whimsical building like the gate structures of the Philadelphia Zoo, and would be copied everywhere.

Impacts of the Industrial Age

- The Iron and Glass Period could be described as the confluence of scientific and technological advances being employed to create forms that express a fresh style that is very different from traditional Renaissance design.
- Cast iron had been primarily by engineers and generally hidden by architects.
- Henry Bessemer patented his process for economically producing steel from pig iron, a method involving the removal of impurities from the iron by oxidation, then skimming off impurities like silicon, manganese, and carbon, in the form of "slag."
- Later, the addition of various metals in the alloy allowed engineers to manipulate the behavior of the steel for ductility, corrosion resistance, hardness, etc.
- The Style affirms the Industrial Revolution. New forms accept new materials more easily than established forms.
- An artistic revolt against the quality of design of machine produced goods (for example at the Centennial Exposition of 1851 in London and Industrial Revolution) instigates the Arts and Crafts and Art Nouveau movements.
- Reductions in both labor and costs price steel equal to iron, turning many manufacturers to steel, expanding its use into bridges, buildings, rail, and ships.

The Architecture

- The use of cast iron, steel, and glass transcends all built forms, including bridges, buildings, and even parts of infrastructure.
- Europe and other parts of the world see greater transportation connectivity due to iron bridges, now able to be produced economically and with greater capabilities (spans and strength).
- Cast iron allows structural members to be designed and produced off-site and shipped to location for faster assembly.
- Iron frame and glass creates a distinct style that reflects the social attitudes during the Period.
- The technology lends itself to the rebuilding of Chicago after the great fire. The steel frame, consisting of columns supporting girders, that support beams and joists, leads to modulated design that is flexible, adjustable, and able to be expressed differently in each building.
- While buildings of the Period were still able to express Classically rooted designs of stone on the exterior, architects were now able to flood the interior with a lightness of space defined by abundant natural light. This was especially important to buildings of size, like libraries, train stations, and exhibition halls, the likes of which we came to know the Iron and Glass period.

1. Compression force:
 – Simply put, opposing forces "pushing" inward toward each other in a "crushing" manner.
2. Shear force:
 – Opposing coplanar forces pushing inward toward each other in a shearing manner.
3. Tensile force:
 – Opposing forces "pulling" away from each other in a "tearing" manner.
4. Torsion force:
 – Rotating forces applied outward of the axial line in a 'turning" or twisting manner.
5. Columns:
 – The vertical structural member that supports a girder, beam, or other member.
6. Girder:
 – A main horizontal member attached to the column, usually supports cross beams.
7. Spandrel:
 – Usually the girder member on the outer face of the building.
8. Beam:
 – An intermediate member attached to a girder (used to help distribute the loads).
9. Mullion:
 – A semistructural separator between windows.

▶ With Renaissance styles waning, the time was ripe for new materials and new expressions.

▶ Social attitude combined with the Industrial age to instigate the Iron and Glass period and its various reactions.

▶ Scientific and technological advancements were displayed during various World Expositions in London, Paris, and Chicago.

▶ The Arts and Crafts and Art Nouveau periods emerged as reactionary to the Industrial Age.

IRON and GLASS

1. Bridge over Severn		1777 – 1779
at Coalbrookdale, England	Pritchard and Darby	
2. Pont des Arts		1803
at Paris, France	DeCessart and Dillan	
3. Clifton Suspension Bridge		1836
at Bristol, England	I.K. Brunel	
4. Royal Pavilion		1818 – 1821
at Brighton, England	John Nash	
5. Bibliotheque St. Genevieve		1843 – 1850
at Paris, France	Henri LaBrouste	
6. Biblioteque National		1862 – 1868
at Paris, France	Henri LaBrouste	
7. Crystal Palace		1851
at London, England	Sir Joseph Paxton	
8. Eiffel Tower		1889
at Paris, France	Gustave Eiffel	
9. Grand Palais		1897
at Paris, France	Deglane, Louvet, Thomas and Girault	
10. Boston Public Library		1895
at Boston	McKim, Mead and White	
11. Penn Station		1910
at New York	McKim, Mead and White	
12. Rhode Island State House		1904
at Providence	McKim, Mead and White	

ARTS and CRAFTS

13. Red House		1859 – 1860
at Kent, England	Philip Webb	
14. Perrycroft		1895
at Malvern Hills, England	C.F.A. Voysey	
15. Broad Leys		1898 – 1899
at Windermere	C.F.A. Voysey	

1. Bridge over Severn:
– Example of how steel is implemented in civil engineering and impacting to transportation

2. Pont des Arts:
– Support pylons well designed to buttress against river current and complimented by lightness of iron

3. Clifton Suspension Bridge:
– Further expression of how concepts in steel revolutionize industry

4. Royal Pavilion:
– See Late Renaissance Chapter

5. Bibliotheque Ste. Genevieve:
– Cast iron columns define space, proportion shows off structural strength

6. Crystal Palace:
– Designed by Joseph Paxton (a botanist) and built in four months for the world exhibition of 1851, the Palace was an example of implementing the manufacturing processes; it measured 1851' x 450' and consisted of 3300 iron columns, 34 miles of gutter tubing, and 2224 girders

7. Gallery des Machines:
– An artful expression of the use of steel, the Gothic motif simplified in pointed arch form, knowledge of engineering expressed practically in its connections

8. Eiffel Tower:
– Rejected at first but the high point of French world exhibition of 1889, it becomes France's example of engineering and manufacturing coordination and now serves as the icon for Paris

9. Grand Palais:
– Located on the Champs-Elysees and built for the Universal Exposition of 1900, its an icon in the Paris streetscape of the iron and Glass Period

10. Red House:
– Philip Webb, example of eclecticism in Europe and an Art Nouveau reaction to industry

11. Perrycroft:
– C.F.A. Voysey, great example of European residential eclecticism and command of complex form

12. Broadley's
– C.F.A. Voysey design, mastery of roof form and mass ensemble

13. Boston Public Library:
– Romanesque in city beautiful landscape

14. Penn Station:
– American example of iron and glass

15. RI State House:
– McKim, Mead and White show mastery in classicism

Iron and Glass Timeline

- 1777 AD — Royal Pavilion
- 1786 AD — Bridge Over Servern
- 1803 AD — Clifton Suspension Bridge / Pont des Arts
- 1836 AD — Biblioteque Ste. Genevieve
- 1843 AD — Crystal Palace
- 1851 AD — Eiffel Tower
- 1889 AD — Beaux Arts in America
- 1890 AD — Boston Public Library
- 1895 AD — Grande Palais
- 1897 AD — R. I. State House
- 1904 AD

(Above) With the town of Coalbrookdale's industry at a growth breakpoint due to Darby's smelting of iron ore with coke, a direct route over the Severn Gorge was needed as a way to transport goods. Pritchard and Darby's iron bridge would span both a physical gap as well as a metaphorical one that soon made Europe a small place. (Right) Though identically replaced in modern times due to World War II damage, this bridge was the first metal bridge in Paris and served to provide the same results as the Iron Bridge Over Severn.

The slides: Iron and Glass
Pont des Arts, Paris
1803 by DeCessart & Dillon

Iron and Glass

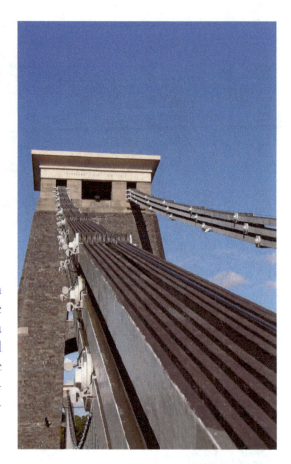

Spanning the Avon Gorge, Clifton provided an innovative and unprecedented method for bridge spanning. "Stringing" wrought iron chains in a catenary fashion over stone pylons, Brunel dropped vertical tensile rods to support the bridge deck. Rollers in the top of the pylons account for movement of the chain as loads translate over the bridge.

The use of iron found its way from civil engineering projects to architecture. Used as a structural frame and infilled with glass or other light weight "skins," it began to redefine architectural space, enclosure, and quality. The Bibliotheque St. Genevieve signaled the dawning of a new way to retain traditional exterior architectural expressions while embracing the capabilities of iron to provide light, airy interior space.

Iron and Glass

The popular World Expositions of the late nineteenth century required vast volumes of space for display and iron and glass provided a means to accomplish this with function, economy, and effectiveness.

(Above) Joseph Paxton's Crystal Palace proved to be an extraordinary structure and was built in record time, using state of the art manufacturing processes.

(Below) Paris' Grand Palais provides ornamented Beau-Arts façades of stone topped with innovative iron-and-steel-framed vaults of glass.

The slides: Iron and Glass
Grand Palais, Paris
1897 for the Universal Exposition of 1900

Built for the 1889 World's Fair, Eiffel's idea for the Tower was partially financed requiring him to provide half of the total. However, he received royalties for use of its image and commercial activity for twenty years.

Designs for the Eiffel Tower were not solely Eiffel's. Engineers (Koechlin and Souvestre) working for his company originated the concept. Initially of no interest to Eiffel, a modified concept attracted him and he purchased the rights to the design.

Once approved, the Tower's design received an avalanche of criticism from every corner; artists, writers, engineers, and even architects.

For a rather conceptually simple structure, construction was complex as it was built close to the Seine River. After six months of foundation work, iron began to rise and soon the diagonal legs were fitted with a "creeping" crane that moved along with construction. With the legs joined at the first platform, construction progressed rapidly. Lifts were built into the design as a way to safely transport visitors of the Fair to the top deck. Today, the Tower sees almost 20,000 visitors each day!

Iron and Glass

(Left) Views from the Tower's top looking toward Trocadero (top) and the Champ de Mars (bottom) respectively. (Below) From the base looking up, one can view the iron complexities and ornamentation that show that the sum of the parts, make the whole.

306

Fronting Boston's Copley Square and owing its façade arrangement to Bibliotheque St. Genevieve, the Library represents Romanesque features that highlight a Renaissance façade. McKim and White had both apprenticed for H.H. Richardson. Masters of Beaux-Arts designs and influenced by the City Beautiful Movement emanating out of Chicago after 1893, the firm put its stamp on monumental architecture up and down the eastern seaboard around the turn of the twentieth century.

307

Iron and Glass

Built from Georgia white marble and having the fourth largest self-supporting dome in the world, the State House was one of Rhode Island's first public buildings with electricity. This neoclassical structure's dome is topped with a lantern upon which stands the "Independent Man," referencing the ideals that led Roger Williams to establish Rhode Island and Providence Plantations.

After the Fire

- On October 8, 1871 after an abnormally dry summer, the great fire of Chicago broke out in the barn behind the home of Patrick and Catherine O'Leary.
- With the City seeking to immediately rebuild, it enacts codes calling for fireproof materials.
- Turning toward brick, stone, and other means of masonry building, Masons are called on to lead construction teams in a safe and methodical manner.
- In the midst of reconstruction efforts and busy times resulting in building shortcuts, the Cooke and Company bank collapse coupled with another smaller fire, halts the citywide rebuilding efforts and signals a large-scale economic depression.
- Seeking a way to create buildings made of a fireproof frame covered with a fireproof material, terra-cotta tiles make the scene as an economical but effective envelope material.
- With electric lighting available now, construction projects continued into the evening hours, allowing for a compressed building schedule.

The Architecture

- Various technologies lend themselves to the rebuilding of Chicago after the great fire. The steel frame, consisting of columns supporting girders, that support beams and joists, leads to modulated design that is flexible, adjustable, and able to be expressed differently in each building.
- With new building design opportunities available, Chicago's businesses called on the architectural community to solve spatial problems as they related to the urban footprint, the commercial and office environments, and spatial span, and height. They answered with the use of the steel frame and high-rise buildings that would later become skyscrapers.
- Combining the new superstructure with streamlined designs with unprecedented window openings and high-rise views, became known as the "Chicago School."
- William Le Baron Jenney's Home Insurance Building on LaSalle Street in 1884 became the first to incorporate the Chicago School vocabulary and he was soon followed by Chicago architects Daniel Burnham, John Root, Louis Sullivan, and Dankmar Adler, as the style rapidly redefined the city and brought Chicago back to prominence.
- The Home Insurance Building (considered by some to be the first skyscraper), was constructed of an orthogonal-grid steel frame that left large apertures for what became known as the mullioned "Chicago window." Office partitions were located and built independent of the frame and the interior was flooded with natural light from the windows.

Chicago School

1. Chicago School:
 - The title by which the "school" of architects practicing in Chicago in the late Twentieth Century became known. In buildings, it references the style of high-rise design developed in late Twentieth Century Chicago incorporating the steel frame and mullioned windows.
2. Chicago Window:
 - A stationary window flanked by hung-sash windows, allowing abundant light and ventilation.
3. Beaux Art:
 - Architecture that reflects the neoclassical training of architects specifically at France's Ecole des Beaux Arts, graduates of which include R.M. Hunt, H.H. Richardson, and Louis Sullivan.
4. Terracotta:
 - Meaning "baked earth," is a clay-based ceramic and was used as a partition-wall material with brick and was molded into decorative tiles for use on the exterior of buildings.

▶ The great Chicago fire of 1871 was the catalyst for developments in steel frame construction.

▶ The steel frame and demands of commercial clients led to the high rise and the architectural vocabulary organic to its construction.

▶ As buildings grew higher, architects treated the overall structure with the "parts of a column," having a base, shaft, and capitol.

▶ The Chicago School transitions to another reawakening of Classical design but applied through the new materials offered to their designers.

CHICAGO SCHOOL

1. Leiter Building		1889
at Chicago, IL	William Le Baron Jenney	
2. Monadnock Building		1884 – 1885
at Chicago, IL	(North) Burnham and Root, (South) Holibird and Roche	
3. Reliance Building		1890 – 1895
at Chicago, IL	Burnham and Root	
4. Chicago Auditorium		1887 – 1889
at Chicago, IL	Adler and Sullivan	
5. Masonic Temple		1892
at Chicago, IL	Daniel Burnham	
6. Court of Honor (World's Columbian Exposition)		1893
at Chicago, IL	Daniel Burnham (Director of Works)	
7. Guaranty Building		1894 – 1895
at Buffalo, NY	Adler and Sullivan	
8. Carson, Pirie, Scott Dept. Store		1899 – 1909
at Chicago, IL	Louis Sullivan	
9. Marquette Building		1895
at Chicago, IL	Holibird and Roche	
10. Rookery Building		1886
at Chicago, IL	Burnham and Root	
11. Fisher Building		1896
at Chicago, IL	D. Burnham and Seyfarth	

1. Leiter Building:
- At the time it was the largest retail store, 15 acres of floor area, 8 stories
2. Monadnock Building:
- The largest iron-framed exterior-wall load-bearing structure built, it expresses simple massing
3. Reliance Building:
- Land was worth nine times the appraised value of building
4. Chicago Auditorium:
- Sullivan's exquisite illustration of beauty and engineering acumen
5. Masonic Temple:
- Tallest building in world when constructed in 1892
6. Court of Honor, Chicago:
- Colombian Exhibition, starts "city beautiful" movement, classicism
7. Guarantee Building:
- Illustrates "Chicago" window — picture with double flank
8. Merchant's Bank Entry:
- Organic decoration in wrought iron — a love of Sullivan
9. Carson Pirie-Scott Building:
- Iron façade front example of classic Chicago wrought iron work, built on "the busiest street corner in the world," classic multi level department store
10. National Farmer's Bank:
- Sullivan shows mastery in use of brick, subtle detail and form design
11. Marquette Building:
- Steel frame with classic Chicago windows and brown terra-cotta cladding
12. Rookery Building:
- Root's trademark broad concrete-slab foundation reinforced with a mesh of iron rail and Richarsonian-inspired exterior detailing make the Rookery unique in the Chicago streetscape
13. Fisher Building:
- Standing today as one of Chicago's original 18-story structures, it remains the only one that had not been demolished

Chicago School

Known as Leiter II, this important Chicago landmark was designed by William L Baron Jenney, who is known as the "father of the American skyscraper."

Extending his implementation of the metal skeletal structure, Jenney was able to free up interior space as internal partitions were no longer load bearing. Additionally, with beams and girders bearing the loads, it allowed the exterior walls to be opened, allowing for larger windows, greater light, and better views.

The defining elements of Chicago School architecture are rooted in the skeletal frame and the articulations it produced (pilasters, mullions, spandrels, curtain walls, etc.).

One of Burnham and Roots' contributions to the Chicago School, Reliance too boasts a metal skeletal frame serving to provide the same advantages as the Leiter building. Taller plate glass and bayed windows add light while providing wider angles of viewing. The exterior is clad with terra-cotta and the structure rests on concrete caissons extending over 100 feet under its foundation.

Chicago School

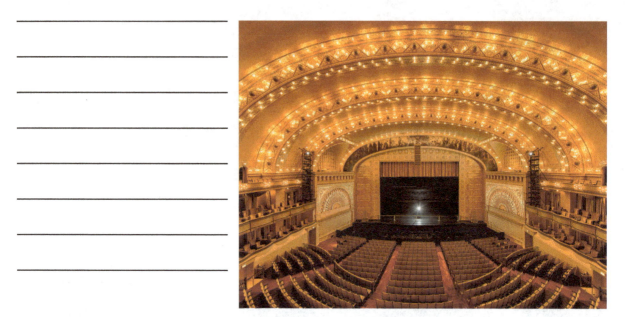

Drawing on Richardson's Marshal Field Warehouse and Italian Renaissance palazzo designs, Adler and Sullivan had to overcome structural constraints to support the building. Due to deep clay, they layered timbers and metal rails embedded in concrete to form a sort of "raft" to place the foundation on. Though effective, the structure has experienced considerable settlement after 100 years.

Sullivan's masterful handling of scale to draw on Italian palazzo designs was accomplished through rustication, story-through articulation of elements that are fragmented within, and graceful but powerful Romanesque arcuations.

Chicago School

(Right) Burnham's Masonic Temple, demolished in 1939, treated the building as a column with a distinct "base, shaft, and capitol." Commercial shops and offices filled the ground floor and middle sections while the Freemasons occupied the top.

(Below and right) Monadnock (North) by Burnham and Root, expressing its detail-less perforated mass of brick that lends to its portal wind bracing. It is the tallest iron-framed, load-bearing exterior-wall building. Its graceful sweep at the lower register visually responds to the building's imposing mass.

The slides: Chicago School
Monadnock Building (North)
1881 Burnham& Root

318

(Top, middle, and below) Chicago's building boom after the Great Fire culminated by hosting a world exposition. This would architecturally announce Chicago's return to prominence and also kick off the City Beautiful Movement, ushered in by neoclassical designs and grand master plans that redefined urban spaces.

(Bottom) Formerly the Palace of Fine Arts (by Charles Atwood) from the 1893 World's Columbian Exposition, this building is now the Museum of Science and Industry. The Court of Honor embodies the sentiment of Daniel Burnham who said, "make no small plans."

Chicago School

Another fine example of the Chicago School, this department store took advantage of its wide expanses of glass and pioneered sidewalk shopping of passersby. It is also know for Sullivan's trademark ironwork as shown in the photo above and seen from State Street and Madison.

Now called the Sullivan Center, the building's mullions and spandrels were initially designed to be clad in Georgia white marble but a quarry strike in 1898 drove Sullivan to decide on the use of terra-cotta panels. Still fearful of fire, Sullivan designed a 40-foot-tall water tower for the building's top to be used in case of fire.

The columns and spandrels of the Marquette's metal frame are clearly telegraphed by the fenestration. One of the purest examples of the Chicago School and the Chicago window, its articulation of vertical line and registers are followed by countless high rises built in cities throughout the country.

The building is also noted for its opulent lobby which is decorated by a mosaic frieze designed by Louis Comfort Tiffany and is embellished with Tiffany glass.

Chicago School

This Chicago School landmark derived its name from the "rook" bird, a black crow-like bird known for the look of "mischievousness," and referring to the alleged crookedness of politicians once affiliated with the Old City Hall building that previously stood on the site.

Roots trademark "grillage" foundation (a mesh of iron rails embedded in concrete) distribute broadly, the building loads from its innovative steel frame and exterior load-bearing walls. This infrastructural style is complimented by Byzantine, Moorish, and Romanesque features credited to the design of John Root, whose artistic edge was honed at Liverpool's Clare Mount School. He apprenticed for Renwick and was inspired by Richardson.

Built for paper industry mogul Lucius Fisher, the building stands today as Chicago School's last surviving 18-story building.

Occupied just nine months after ground breaking, its steel frame was erected in just one month. Its façade's surface is almost 75% glazed, giving it the feeling of transparency.

Using Fisher's name as parody, the building's details take on aquatic themes as crabs and dolphins become door handles and fish, frogs, and starfish decorate the glass and terra-cotta cladding.

Early American Colonial

Culture:
- Much of the wealth was in the South.
- When economically viable, the Colonists would try to copy European examples of architecture.
- The descriptive titles for colonial architecture are political in nature (not geographical) i.e. Georgian not related to the "South" but mostly constructed during the reign of King George III, etc.
- Colonial craftsmen constructed what they could mostly of wood, leading to unique stylistic expression.

Architecture:
- Most early Colonial architecture no longer exists due to materials used and harsh East Coast weathering.
- Georgian style mostly occurred prior to the Revolution.
- Federal style occurred during and shortly after the Revolution.
- Greek & Roman Revival periods (inspired by Jefferson) occurred after the Revolution and through Jefferson's two presidential terms (1800 - 1807).
- Italianate style occurred in the early nineteenth century as American trade with areas around the Mediterranean increased.
- Second Empire coincided with the reign of Napoleon III
- Gothic Revival & Carpenter Gothic coincide with increased interest in Gothic form and detail.
- Eclecticism develops as architects begin to blend styles
- Shingle Style (a purely American style) develops along the Northeast Coastline (specifically Newport, RI), though based on European forms.
- Neo-classical architecture (Newport Mansions, North Carolina, etc.), used to express wealth during and through the Industrial Age.

Detail:
- The Ventilating cupola is uniquely American.
- Some early settlements had to pass laws making it illegal to burn a neighbors buildings for their nails.
- Many of the early carpenters were actually shipwrights working on buildings outside of the maritime work months.

Iron and Glass & Chicago School

Culture:
- Advances in smelting and alloy manipulation by Henri Bessemer in France lead to advances in metallic architectural framework.
- Iron framework leads to expression of large expanses of glass, hence, the "Iron and Glass" age.
- Great Chicago fire of 1871 burns the City to the ground, making it a prime area for new construction that utilizes many of the new structural developments coming out of Europe.

Architecture:
- France opens the Ecole de Polytechnique (School of Engineering) and the "engineer" as a professional is born.
- Iron used as a structural element and leads to long spans, brightly lit spaces and a new expression.
- Iron used in bridge construction leads to spanning over otherwise impossible distances, leading to efficient transportation and communication networks and thus, making the civilized landscape smaller.
- Buildings can now express delicate interiors while maintaining elegant Renaissance design on the exterior (Biblioteque Ste. Genevieve).
- Metal framing leads to new exterior expressions, the mullion window and column and spandrel encasing for instance creates a style called "Chicago School".
- A counter reaction to the increase in architectural metal and "mechanized" production leads to the technology revolt that includes styles like the Arts & Crafts movement (a look back to organic forms derived from nature).

Detail:
- Ironwork expresses strength, design flexibility, and detail through artful connections and shapes.
- Engineers manipulate the forces of compression, tension, shear, moment and torsion, in calculating efficient metal members.
- Structures such as the Eiffel Tower and Crystal Palace exemplify the versatility of iron in construction.

Function, Expressionism, and the Abstract

- Modernism is the dominant movement in late nineteenth to early twentieth century architecture, which grew out of the technological innovations of nineteenth-century Industrial architecture, crystallized in the International Style of the 1920s and 1930s, and has since developed various regional trends, such as Brutalism.
- "Truth to materials" and "form follows function" are its two most representative dicta, although neither allows for the modernity of large areas of contemporary architecture, concerned with proportion, human scale, and attention to detail.
- The late twentieth century sees architectural postmodernism, a reaction to the movement developing alongside such modernist styles as high tech.
- The Modern Movement gained momentum after World War II when its theories, disseminated through the work of CIAM, were influential in the planning and rebuilding of European cities. The work of Le Corbusier is perhaps most representative of the underlying principles of the movement; other notable early modernists include Adolf Loos, Peter Behrens, Walter Gropius, and Mies van der Rohe.

The Architecture

- Structural concrete, steel, and large expanses of glass lend themselves to new and abstract spatial enclosures.
- Daring cantilevers offer differently defined spaces and allow architects more flexibility in planning and expression.
- This new form of enclosure promotes interstitial spaces; window-walls bringing the outside to the inside, the inside flowing outside to engage the landscape, and spaces "borrowing" qualities from adjacent ones due to open floor plans.
- Advances in concrete reinforcing allow architects more expression of form, than ever.
- Modernism could be considered the first stylistic "movement" to permeate all types of architecture; ecclesiastical, secular, commercial, residential, educational, etc.

Modernism

1. Brutalism:
 - A submovement of modernism of buildings expressing large mass, made of exposed concrete. It was popular in Europe mostly and found typically in the design of institutional architecture.
2. Cantilever:
 - A beam, plane, or even whole section of building projecting out freely from its supports.
3. Curtain Wall:
 - A glass wall system made of glass fixed in metal frames and mullions, usually spanning from floor to ceiling and from wall to wall hence, "curtain wall."
4. International Style:
 - Emerging in the early to mid-twentieth century, the style generally consists of rectilinear forms defined by rigid planes devoid of any ornamentation, abundance of light, open floor plans, and often highlighted by cantilevered planes.
5. Interstitial:
 - Referring to "the space between." In architecture, spaces conjoined (visually or through experience) but sometimes by an implied element that is not physical.

▶ The Modern Movement was greatly influenced by Walter Gropius and the Bauhaus.

▶ Modernism is without any Classical ornamentation and makes no historical reference.

▶ Le Corbusier, Eero Saarinen, and Louis Kahn are among those whose works are considered sculptural expression in the form of architecture.

▶ The Movement pioneered spaces defined by architectural expressions of spatial enclosure of planes and separation of structural elements from the building envelope.

MODERN MOVEMENT

1. Bauhaus 1919
 at Dessau, Germany Walter Gropius
2. Mies' Glass Skyscraper Study 1920
 at Werbund Exhibition Ludvig Mies van der Rohe
3. Barcelona Pavilion 1929
 at Barcelona, Spain Ludvig Mies van der Rohe
4. The Weissenhof 1927
 at Stuttgart, Germany Ludvig Mies van der Rohe
5. Villa Savoye 1928 – 1930
 at Poissy, France Le Corbusier
6. Notre Dame Du Haut 1951 – 1955
 at Ronchamp, France Le Corbusier
7. United Nations Building 1952
 at New York, NY Le Corbusier
8. Glass House 1949 – 1950
 at New Canaan, CT Philip Johnson
 Art Pavilions (Various Dates)
9. Salk Institute 1959 – 1965
 at La Jolla, CA Louis Kahn
10. Exeter Library 1965
 at Exeter New Hampshire Louis Kahn
11. Kimbell Art Museum 1972
 at Fort Worth, TX Louis Kahn
12. Kresge Auditorium 1955
 at Cambridge, MA Eero Saarinen
13. TWA Terminal (now USAir - Kennedy Airport) 1956 – 1962
 at New York, NY Eero Saarinen
14. Dulles International Airport 1958 – 1962
 at Chantilly, VA Eero Saarinen

1. Bauhaus School:
- Set up to expound on ideas of Werkbund, turning machines of industrial revolution into quality tools of good design

2. Barcelona Pavilion:
- Expresses use of planes to define space, glass represents absence of plane (view)

3. The Weissenhof:
- Rationalists expressions underlie the form

4. Villa Savoy:
- Elevated planes off the ground, curtain wall, and softening curved lines, parking under, addresses function of pragmatic living realistically

5. Notre Dame du Haut:
- Sculptural form in concrete, expression of modern "plastic" form (nun's habit) in concrete, thickness of walls and stained glass, heavy roof held by glass strip

6. United Nations Building:
- The building appears to be a glass box bound by its stone-end walls

7. Glass House:
- Johnson's theory of bringing outside in, transparent structure

8. Glass House Art Pavilions:
- Johnson applies no sense of relative scale, modern theories

9. TWA Terminal:
- Saarinen bangs client's request for plastic form representing flight

10. General Motors:
- Genius in Saarinen shown in use of "campus" planning on corporate scale

11. Dulles Int. Airport:
- Saarinen shown more of his understanding of form expressed

12. Exeter Library:
- Kahn's theory, simple form, use of light and dark, expressed structure

13. Salk Institute:
- Kahn defines space with structure and fills with glass and warm teak

14. Kimbell Art Museum:
- Again, Kahn defining space with structure and use of light

15. Carpenter Center:
- This is an artful yet functional use of concrete planes and glass to allow light but only indirectly

16. Farnsworth House:
- Mies elevates the horizontal plane and this iron and glass structure becomes iconic

17. Crown Hall at IIT:
- Same, elevates horizontal plane off ground, creates "universal space"

Modernism

Founded by Walter Gropius, the Bauhaus was a school of design and craft whose philosophy was the education of the "total" or "whole" designer. It would have a profound impact on not only the Modern movement but on architecture and design for years to come.

Bauhaus designs were known for:

- Advanced uses in concrete
- The void conquers the solid
- Abolition of walls as separators
- Utilization of the roof as space

Under pressure from Nazi propaganda, the school closed in the 1930s.

The Slides: Modernism
Bauhaus Archive, Berlin, Germany
Gropius Design Built in AD 1976

(Left top) Designed by Gropius in 1964, the Archive was finally built over a decade later to house important works from the Bauhaus including, art pieces, documents, literature, and other artifacts.

(Left bottom) Berlin during the period prior to WW II was pioneering large-scale urban housing. Schillerpark, in the Wedding district of Berlin, is an example of social housing and an effort to solve housing demands with dense unit inventory.

The slides: Modernism
Siedlung Schillerpark, Berlin, Germany
1924 by Bruno Taut

Modernism

Mies built the Pavilion for the 1929 International Exposition in Barcelona. Conceptually, the building creates spaces defined by floating rectilinear places. Supported on a platform of travertine, vertical glass and exotic stone planes are organized about a structural grid, floating under a powerful roof plane extending beyond its extents.
Only Georg Kolbe's sculpture (seen below) was on display during the Exposition, the building itself serving as an art piece.

Built as an urban housing project for the 1927 Werkbund exhibition, Weissenhof crystalized what became known as the International style.
The combinations of attached and detached dwelling units were designed by various architects and made partially of prefabricated elements, accounting for rapid fabrication.

Modernism

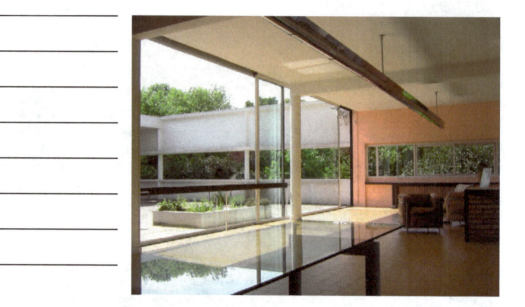

Villa Savoye is a wonderful example of Le Corbusier's command of spatial interstiality and the exercise of his own five tenets of modern design: 1) ground level structural supports; 2) a functional rooftop; 3) open floor planning; 4) wide fenestration; 5) façade design driven by internal function.

The house is a complexity of spatiality moving within the bounds of a rigid rectangular box, both literal and implied.

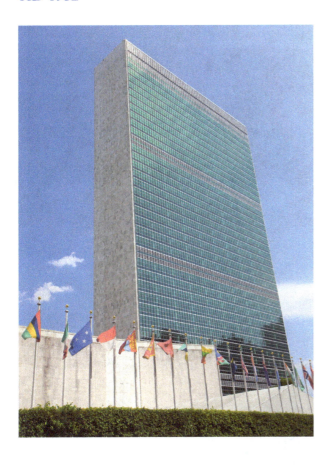

(Left) With its north and south walls of granite bookending the rectangle, the United Nations Building's east and west views reveal a delicate curtain wall of glass and floors that appear to "float" within the structure.

(Right) "Ronchamp," as it is known is a concrete masterpiece of sculptural form, mass, and the use of controlled light to create inspiration space both inside and out. Residing on a hill, the chapel appears natural, rather than as a dominant form.

The slides: Modernism
Notre Dame Du Haut
Ronchamp, France

Modernism

Said to be influenced by Mies' Farnsworth house, Johnson's Glass House is itself a treatise on modern minimalism, form, and geometry. A glass rectangular box bound within its steel frame, the only solid is the brick cylinder containing the bathroom and a fireplace.
When completed, the home was the subject of controversy both in the architecture world and also about town (New Canaan, CT). Johnson hosted friends and celebrities alike over the years at the home, used mostly on weekends as a retreat from New York City.

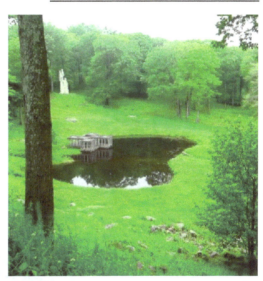

An avid art enthusiast and former curator of the Museum of Modern Art, Johnson's estate includes several art pavilions (top, right and below). (Above) Da Monsta, built as a visitor pavilion.

Modernism

(Opposite) The Salk Institute for Biological Studies is considered Kahn's masterpiece. Facing the Pacific Ocean, two buildings form a court whose floor is Roman travertine divided by a channel of flowing water. The buildings themselves are of concrete, the form construction not concealed. Made with volcanic ash, the concrete has a light rose hue and was rubbed to give it a velvety cool touch. Windows and shutters in teak frames contrast and compliment the exposed concrete.

(Below) The Kimbell Museum is considered by artists to be among the best environs to exhibit. Again, Kahn employs exposed concrete but borrows the simple form of military-shaped Quonset structures whose roofs are slit parallel to the vaulted top where baffles splay indirect light onto the curved concrete ceiling inside the exhibits.

Modernism

(Above right) One of the Modern period's most iconic sculptural architects, Saarinen built Kresge as one-eighth of a sphere, engaging the ground at only three points while glass curtain wall drapes the enclosure.

(Right) With its graceful lines suggesting "flight," Saarinen's airport terminal design placed him in high regard as an architect who solves pragmatic functional design problems with creative and inspiring solutions, unbound by industrial constraints.

The slides: Modernism
Dulles International Airport
1958 by Eero Saarinen

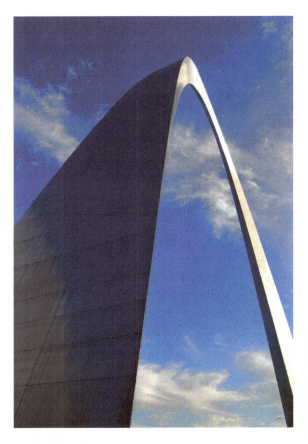

Standing as the tallest man-made U.S. monument, Saarinen proposed this design as a metaphorical "gateway" of westward expansion. Rising to 630 feet in height, the arch is a flattened catenary and is made of stainless steel. Once again he was unbound from industrial constraints and had to devise a method to support the legs of the arch as they were constructed and began to tilt ever-inward, accomplished by a scissors truss.

Organic Master of Modernism
- Born on the Catalonia coast of the Mediterranean in Spain, Gaudi's interest in nature, architecture, and their interrelationship, began while young and would profoundly effect his later work.
- He suffered various health concerns when young and adopted vegetarianism likely as a result.
- Though architecture school was interrupted by military service, he graduated in 1878.
- Gaudi caught the eye of Eusebi Guell at the 1878 Paris Worlds's Fair where he displayed a showcase he created for a glove manufacturer. His modern style impressed Guell, who would become his greatest benefactor.
- Having amassed one of the most unique portfolios of professional architecture, Gaudi stood out in a period of "sameness," was true to his beliefs yet continued to evolve his ideas throughout his career.
- Later in life, Gaudi would obsessively work on his most lasting project, the Sagrada Familia church. He slept on site and became so disheveled that while crossing a street in 1926, he was struck by a tram and pushed aside — the driver having mistaken him for a vagrant. He died of his injuries.

The Architecture
- Antonio Gaudi developed an original vocabulary of architecture unique to his work alone. With its roots found in the forms of nature, his architecture, though seemingly haphazard, was steeped in basic geometries that transformed into complex geometries, i.e., the hyperbolic parabola, hyperboloid, helicoid, and other shapes.
- In architecture school, Gaudi was impressed upon by photographs of art he studied including Egyptian, Indian, Japanese, Mayan, Moorish, and Persian works.
- Unique to Gaudi was a method referred to as "equilibrated," meaning structures that were self-supporting, requiring no additional internal or external elements that were not indigenous to, or inherent in, the structural system itself.
- His method for studying and analyzing structures included viewing the systems inversely — or upside-down using catenaries.
- Though the natural world imbues both the structure and detailing in his work, he became known as "God's architect." This was due to his devout Catholic faith and steadfast dedication to the Sagrada Familia church, a project that consumed the latter part of his life.

1. Basic Geometries (architectural):
 – Geometric forms built from basic lines, segments, squares, rectangles, triangles, circles, etc.
2. Complex Geometries (architectural):
 – Geometric forms built from permutation of basic geometries.
3. Equilibrated:
 – Gaudi's method for determining structure in design, meaning structures that are self-supporting, requiring no additional internal or external elements that were not indigenous to, or inherent in, the structural system itself.
4. Organic:
 – As related to architecture, meaning structures that derive their design and forms from objects or systems found in nature, i.e., pedals of a flower, a bees honeycomb, etc.

► Antoni Gaudi's work was original, especially when viewed in the context of the period he was practicing.

► Gaudi's work was rooted in the laws of nature and natural things, both geometrically and philosophically.

► Barcelona Spain is the home to most of Gaudi's work. His work is considered "modernista," belonging to the modern period.

► The Sagrada Familia church is the embodiment Gaudi's work. Construction on the church is estimated for completion in 2026, (100 years from the date of Gaudi's death).

WORKS

1. La Sagrada Familia	1882 – (ongoing)
at Barcelona, Spain	
2. Park Guell	1900 – 1914
at Barcelona, Spain	
3. Antoni Gaudi Home	1904
at Barcelona, Spain	
4. Casa Mila	1905 – 1907
at Barcelona, Spain	
5. Casa Batllo	1905 – 1907
at Barcelona, Spain	
6. Church of Colonia Guell	1908 – 1914
at (near) Barcelona, Spain	
7. Miscellaneous Works	Various Dates
at Barcelona, Spain	

1. La Sagrada Familia:
– Earning Gaudi the title "God's architect," he spent most of his life dedicated to the design and construction of this important work. It is estimated to be completed in 2026

2. La Sagrada Familia:
– The façades illustrate the Catholic faith through sculpture and form while the interior, unlike anything ever seen, is a breathtaking intended "walk through the forest"

3. Park Guell:
– A central visiting place in Barcelona, the Park was an ongoing commission for Gaudi, named for its benefactor's sake, Eusebi Guell

4. Park Guell:
– All elements of the Park exemplify Gaudi's affinity with nature, his inspiration for designs

5. Antoni Gaudi's Home:
– This somewhat modest casa is where Gaudi lived for more than 20 years

6. Casa Mila:
– Perhaps the best example of Gaudi's "equilibrated" method, the structure has no load-bearing walls and the stone façade of free from adjacent floor loads

7. Casa Batllo:
– This masterpiece of Gaudi's is sometimes called the "house of bones," due to its skeletal-like qualities

8. Church Colonia Guell:
– Sponsored by Eusebi Guell and built for the people just outside of Barcelona in a manufacturing community, the Church remains unfinished but is a visually descriptive example of Gaudi's use of hung weights and catenaries to analyze loads, inverted to inform the upright structure

9. Miscellaneous Works:
– Street Lamp showing the decorative nature of Gaudi's work (note the bat)
– Bronze doors of La Sagrada Familia, notice the cryptogram square (the numbers add up to 33 in all directions, the age of Christ at death)

Antoni Gaudi Timeline

Colonial Church Guell

Street Lamp Designs

(Street Lamps)

Casa Batllo

Casa Mila

Gaudi Residence

Park Guell Gatehouse

Park Guell

La Sagrada Familia

1908 AD

1906 AD

1906 AD

1905 AD

1905 AD

1905 AD

1900 AD

1900 AD

1900 AD

1882 AD

Gaudi's vision for La Sagrada Familia while unique and unparalleled, is rooted in his own faith. Carvings on the four main façades are intended to tell the story of the whole of the Catholic church. Playing out the scenes of the nativity, assumption, glory, and passion, he intended that they be used to teach.

Antoni Gaudi

La Sagrada Familia's interior was intended to look like a forest because that is where Gaudi felt man was closest to God. His columns rise up and branch out, just as trees do naturally to help distribute loads. As the columns get closer, the altar where they bear the most weight, the stone gets stronger, culminating in red porphyry from Iran which is known for its impressive strength.

Construction is ongoing and is estimated to be completed in 2026, 100 years from the death of Gaudi, known as "God's architect."

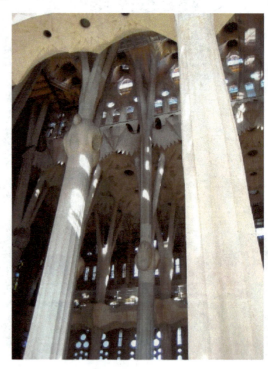

The Slides: Gaudi
Park Guell
AD 1900–1914

Antoni Gaudi

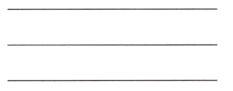

Gaudi takes design cues from nature (called bio mimicry), everywhere he can. Forms are generated naturally based on material selection and functionality. Stones provide base, tiles form scales.
The park serves as a peaceful retreat from the city and provides visitors with a connection back to nature.

Antoni Gaudi

Seen above, the park promenade is generally classical but in Gaudi's interpretation. The Doric columns seem modeled after those at the Temple of Poseidon and though appearing vertical, are without plumb.

The park gate houses provides an enchanted entry. Appearing without order, their envelopes respond to internal function and respond to organic design rules explored by Gaudi.

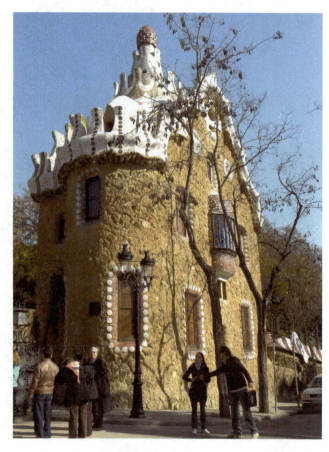

Gaudi's House-Museum served as his residence for roughly twenty years. Built as a sort of model home for Eusebi Guell's plan to build a garden city, the project never commenced and Gaudi assumed residency.

Today, it houses a collection of Gaudi artifacts including art, documents, furniture, and other objects designed by the great architect.

Antoni Gaudi

Appearing haphazardly designed, the undulating façade of Casa Mila follows Gaudi's strict dicta for architecture and structure in every way.

The stone façade is self-supporting (not load-bearing) and functions freely from the internal design. Curved iron beams allowed Gaudi freedom to place fenestration wherever desired.

A freeform internal court allows light to the interior of the nine-story structure.

The roof and another integral part of the building's systems, providing skylights, fans, vents, and even rooftop access.

One of Gaudi's several masterpieces, Casa Batllo (known as the "house of bones"), is one of his most unusual achievements in a career of many.

(Above) the roof, appearing like a dragon or serpent with its undulating spine, is actually littered with functional vents and chimneys designed to prevent backdraft.

(Left) The lower register of limestone, appearing like pelvic bones and knee joints, is detailed with craft-like joinery and multicolored stained glass. The middle register is mottled with blue and green glass in stucco, giving the illusion of shimmering water.

Antoni Gaudi

————————————

————————————

————————————

————————————

————————————

(Left) the lower level register seen from within, revealing the beautiful art glass. The exterior form translates to the interior, another staple in Gaudi's work.

Strength in the façade is achieved by the intersection of complex shapes that although seemingly unplanned, form a systemic solution for such a free-form design.

Conceived by Guell as a church for the population of a Barcelona suburb where he had manufacturing businesses, it remains unfinished.

To derive its design, Gaudi suspended weights from strings and catenaries to analyze forces thus allowing them to form a natural deformation. He would then record the result in a photograph and build the inversion which would perform statically.

(Above) Barcelona's street lamps are among the additional works credited to Gaudi. Entangled in symbolisms, they provide the streets with guardian mythical creatures.

(Below) The bronze doors of La Sagrada Familia's Glory façade by Subirachs are an exercise in typography of relief letters (spelling out the Lords Prayer in 49 languages). Note the small cryptogram with numbers — when added in any direction, they result in the number 33, the age of Christ at death.

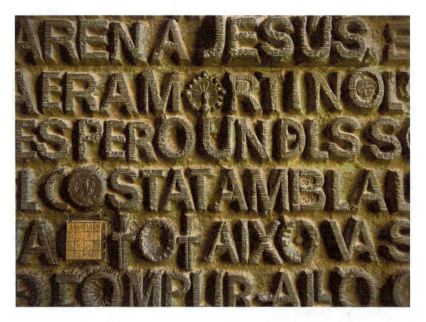

An American Original
- Frank Lloyd Wright (FLW) was born in 1867 in Wisconsin.
- FLW's father was a music teacher and itinerant minister; his mother a school teacher (she used Froebel Gifts to teach).
- FLW designed 1141 structures, over 400 were built.
- Wright did not finish high school (as he had to provide for his mother and sisters).
- In 1882 he started college at 15, in 1887 he moved to Chicago and becomes apprentice for Joseph Lyman Silsbee.
- In 1887, FLW left Silsbee for work with Louis Sullivan, eventually becoming Sullivan's chief assistant.
- In 1889, Catherine Lee Tobin married FLW thus giving him "social polish." They settled in fashionable Oak Park and had 6 children.
- In 1889, FLW built his own Oak Park house at 951 Chicago Ave.
- FLW resigned from Adler and Sullivan after Sullivan learned Wright was designing homes on his own.
- FLW and Catherine's first born was Frank Lloyd Wright, Jr. (1890–1978), an architect.
- FLW's granddaughter was actress Ann Baxter (starred in "The Ten Commandments").
- By 1900, FLW was into his Prairie Style of design.
- In 1902, he designs the Dana House in Springfield, IL.
- In 1914, Mamah Cheney, her two sons, and five other employees at Taliesin are brutally murdered.

The Architecture
- In his early years, Wright worked for the dean of the University of Wisconsin's engineering department while helping make ends meet for his family.
- He wanted most to be an architect and left Madison, WI for Chicago where he apprenticed for Joseph Silsbee before becoming Louis Sullivan's chief assistant.
- Having built his own home and seeking to augment his income, he began preparing designs for a fee on his own time but was released from Sullivan's office once this was discovered.
- In private practice, Wright developed his Prairie Style of architecture early on, consisting of horizontal lines sympathetic to the prairie landscape, usually punctuated with daring cantilevers — all radiating out in a "pinwheel" fashion about a central fireplace.
- Nonresidential commissions soon came to Wright, allowing him to explore many original styles, all rooted in his affinity for organic form and response to function.

1. Art Glass:
 – Much of Wright's work is imbued with colorful art glass. Allowing light in while masking sometimes close proximity to neighboring structures, the art glass was unique to each design and was usually rooted in abstract organic designs.

2. Pinwheel:
 – In reference to Wright's work, in plan, his designs radiated outward about a central space or fireplace thus the term "pinwheel."

3. Prairie Style:
 – Wright's unique style consisting of horizontal lines sympathetic to the prairie landscape, usually punctuated with daring cantilevers — all radiating out in a "pinwheel" fashion about a central fireplace.

4. Usonian:
 – Wright's later vision to unify the planning of cities with the architecture of buildings, considering social demands for functioning communities and responding sustainably to issues surrounding landscape, energy, spatial needs, and affordability.

▶ Frank Lloyd Wright is considered the greatest American architect.

▶ Wright is known for his Prairie and Usonian styles.

▶ Wright was a master of arranging spaces that considered all planes of enclosure while using ornamentation rooted in nature.

▶ Wright's work insists upon harmony with natural surroundings, that forms organically generate, and that designs be distinct for each site.

FRANK LLOYD WRIGHT

1. Walter Gale House		Late Nineteenth Century
at Oak Park, IL		
2. Wright's House		1897
at Oak Park, IL	Frank Lloyd Wright	
3. Dana-Thomas House		1902
at Springfield, IL	FLW	
4. Heurtley House		1902
at Oak Park, IL	FLW	
5. Unity Temple		1906
at Oak Park, IL	FLW	
6. Robie House		1906
at Chicago, IL	FLW	
7. Coonley Playhouse		1908
at Riverside, IL	FLW	
8. Taliesin East		1911–1925
at Spring Green, WI	FLW	
9. Imperial Hotel		1915
at Japan	FLW	
10. Hollyhock House		1917–1920
at Hollywood, CA	FLW	
11. German Warehouse		1921
at Richland Center, WI	FLW	
12. Moore-Dugal House		1922
at Oak Park, IL	FLW	
13. Freeman House		1923
at Los Angeles, CA	FLW	
14. Ennis House		1923
at Los Angeles, CA	FLW	
15. Falling Water		1936–1937
at Bear Run, PA	FLW	
16. Johnson Wax Building		1936–1949
at Racine, WN	FLW	
17. Taliesin West		1938–1959
at Scottsdale, AZ	FLW	
18. Price Tower		1952
at Bartlesville, OK	FLW	
19. Annunciated Greek Orthodox Church		1956
at Wauwatosa, WI		
20. Guggenheim Museum		1956
at NYC, NY	FLW	
21. Marin County Civic Center		1960 (Posthumously)
at San Rafael, CA	FLW	

1. Wright House:
– Designed as home/studio once he left Sullivan, avant garde design for times

2. Dana-Thomas House:
– Early Prairie Style, raised living room, large overhangs, many original works

3. Larkin Building:
– Revolutionary concepts in office space, personnel space (demolished)

4. Unity Temple:
– Cubism theme, Wright raises the sanctuary floor "above the common street"

5. Robie House:
– Sweeping horizontal lines, dramatic overhangs and stretches of art-glass windows and open floor plan make it the quintessential Prairie Style house

6. Coonley Playhouse:
– Considered Wright's best windows "kinder-symphony"

7. Taliesin East:
– Wright's house-studio built on the "brow" of his childhood lands

8. Imperial Hotel:
– Withstood the earthquake of 1923 in Japan only to be torn down in 1968

9. Hollyhock House:
– Wright explores primitive archi-forms in concrete, reacts to climate

10. Storer House:
– Same as above

11. Freeman House:
– More development of Wright's "textile block" expressions

12. Ennis House:
– Ennis and Wright shared a love of Mayan art, transcends design

13. Falling Water:
– Artful juxtaposition of vertical "natural" and horizontal "man-made" elements

14. Wingspread:
– Sculptural interpretation by Wright

15. Johnson Wax Tower:
– Curving corners and glazing shows the horizontal platforms (floors)

16. Johnson Interior:
– "lillypad" columns had to be proven by Wright in the field prior to construction

17. Guggenheim Museum:
– Sculptural quality of building argued for decades now, end of Wright's career

Frank Lloyd Wright Timeline

Frank Lloyd Wright

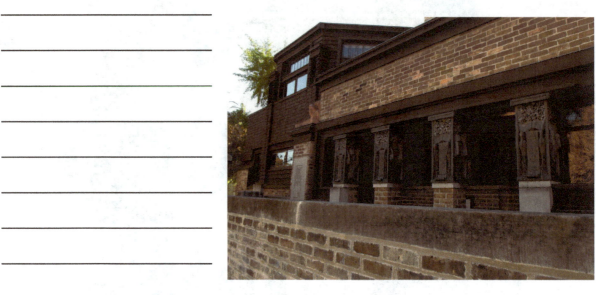

Wright's first house in Oak Park was initially a modest structure almost characterized by Queen Ann lines of design (steep gables and regular geometries). Typical of Wright and in other houses yet to come, his studio was in-suite with the home.

The young Wright was typically low on money, he accounted for this in his biography stating that it was due to his taste for fine clothing, cars, and fine objects. That said, Wright's first home was well appointed. It also revealed early on, qualities of his designs that would stay with him; emphasized geometries, art glass, spatial command, and an affinity for anchoring his designs so securely to a site that they "appear to have grown out of the land."

Wright's "Prairie Style" began to emerge early in his career, a style unique to his designs only and one that he would develop and refine over time.

Evidenced by the Heurtley house shown below, draw-out horizontal lines emphasized in surface coursing and deep-daring cantilevers mimic the prairie lines of the Chicago area's Mid-West landscape.

Also in evidence early on, is his ties to Sullivan and therefore Richardson as illustrated by the monumentally scaled arch.

Frank Lloyd Wright

(Above) Known as the Walter Gale House, this was one of Wright's designs executed outside the employ of Sullivan for which he was released. He performed this on his own time in order to satisfy his expensive taste.

(Right) Just a block from his own house, Wright caved to the wishes of his client and adhered to designing in the Tudor style. Wright did not consider the house original as it adhered to a historical style.

Due to a house fire in 1922, Wright later was able to "correct" the design during its reconstruction, adding elements more in keeping with his style.

The slides: Wright
Moore-Dugal House, Oak Park, IL
1895 (Renovated 1922)

Considered the masterpiece of Wright's Prairie style (a style whose name was given by architectural critic and not Wright himself), the Robie House embodies all of the style's tenets; open floor plan radiating (pinwheeling) outward from a block of central fireplaces, emphasis on low horizontal prairie lines, art glass, integration with the landscape, drawn out cantilevered overhangs, and Wright's signature custom furniture designs.

Also common in Wright's designs is attention to the ceiling plane, often trayed and highlighted with decorative beams.

Frank Lloyd Wright

One of the first and most certainly important modern buildings in the world, Unity Temple expressed Wright's growth as a designer. The Temple forms two masses joined by a low loggia, a design technique common to some of Wright's work called bipartite. This was done to separate the community space from the Temple space adequately.

The Temple's columns with their foliate design are likened to give the exterior almost Mayan elements. Made of a single material, reinforced concrete, the interior explodes with light and color, owing its ambiance to the coffered art glass ceiling.

(Above) The remaining portion of Wright's Imperial Hotel, a project that pioneered innovations, was laid out in plan to mimic the Hotel's insignia (combined "H" shape with a bisecting "I"). The foundation was floated on a broad platform to distribute loads and allow independence of the structure in the case of seismic forces. The reflecting pool provided a water source for firefighting. Imbued with Mayan design elements, the hotel was the only building in its proximity to remain undamaged in the great earthquake of 1923.

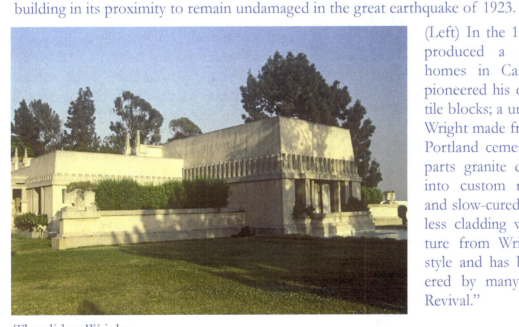

(Left) In the 1920s, Wright produced a number of homes in California that pioneered his concrete textile blocks; a unique precast Wright made from one-part Portland cement and four-parts granite dusk pressed into custom metal molds and slow-cured. This jointless cladding was a departure from Wright's Prairie style and has been considered by many as "Mayan Revival."

The slides: Wright
Hollyhock House
Begun 1917

Frank Lloyd Wright

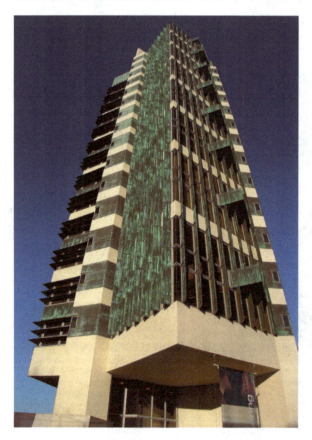

(Above) Located in Richland Center, the commodity warehouse designed for Albert German is made from red brick and concrete and extends Wright's Mayan Revival to the Mid-West.

(Left) Built for Harold Price as his company's corporate headquarters, this unique 19-story tower was considered by Wright to be as natural as a tree. Its core (trunk) of elevators are supported by a deep foundation (taproot) from which the floors cantilever out (branch). The outer walls are suspended from the floors and are foliated by patinated copper (leaves).

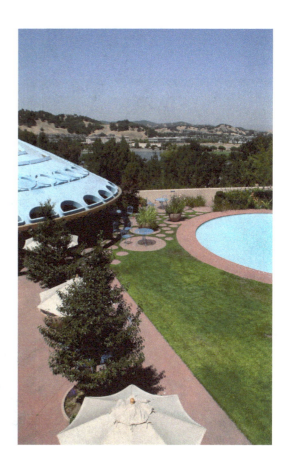

(Above) For centuries, the essence of the Greek church has been the Greek cross and the dome. Reflecting this Byzantine dictum, Wright captured the spirit of those two basic elements but in his usual abstract and purified manner.

(Right) Composing a campus of buildings, the Marin County Civic Center was Wright's last design and was completed after his death. His selection as architect was controversial and led to dissention among the political ranks — even holdouts of people key to the project. The most notable features include the dome with its arched cutouts and a spire that was intended to be an antennae.

The slides: Wright
Marin County Civic Center
1960

Frank Lloyd Wright

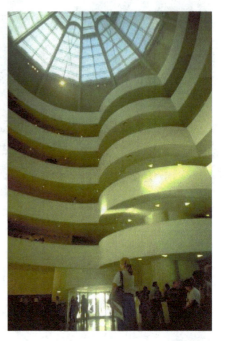

Located on New York's 5th Avenue, the Guggenheim was initially vilified by artists and critic who thought it competed with the very artwork it displayed. Providing a soft, graceful form in the otherwise rigid orthogonal environs of NYC, the structure is another one of Wright's bipartite buildings.

The Guggenheim's interior appears as natural and fluid as the spirals in a seashell. Displaying the collection of Guggenheim's nonobjective geometric paintings, Wright's concept called for the viewer to ascend via elevators to the top of the spiraling ramp, and effortlessly descend while enjoying the works on display. After its initial criticism, it is seen today as the genius solution Wright meant it to be.

Frank Lloyd Wright

Considered by many to be the most iconic and identifiable residence in the world, Falling Water is one of the best examples of Wright's organic architecture. Seemingly a part of the landscape, structure and nature are close and connected, as soaring cantilevers deliver floor planes out among the tree canopy.

(Top) Wright's unique "exploding box window" allows for controlled ventilation while suggesting the glass corner. Note how the desk cuts out to accommodate the window's operation.

(Left) Stones that remained unmoved form the hearth of the fireplace. The red kettle is for water to warm, upon placement back into its stone niche, its energy is absorbed by the stone and radiated back into the house as heat.

(Bottom) Cantilevers of reinforced concrete are punctuated by verticals of limestone, the composition remaining transparent through curtain walls of glass. Notice the descending stair, said to satisfy Mrs. Kaufman's request to cool her feet in the cold waters of the stream.

The Skyscraper Race

Quick Facts

New York and Corporate Expression
- Many mechanical and structural developments in the last quarter of the nineteenth century contributed to its evolution.
- With the perfection of the high-speed elevator after 1887, skyscrapers were able to attain any desired height.
- The earliest tall buildings were of solid masonry construction, with the thick walls of the lower stories usurping a disproportionate amount of floor space. In order to permit thinner walls through the entire height of the building, architects began to use cast iron in conjunction with masonry.
- This was followed by cage construction, in which the iron frame supported the floors and the masonry walls bore their own weight.
- The next step was the invention of a system in which the metal framework would support not only the floors but also the walls. This innovation appeared in the Home Insurance Building in Chicago, designed in 1883 by William Le Baron Jenney — the first building to employ steel skeleton construction and embody the general characteristics of a modern skyscraper.
- The subsequent erection in Chicago of a number of similar buildings made it the center of the early skyscraper architecture.
- In the 1890s the steel frame was formed into a completely riveted skeleton bearing all the structural loads, with the exterior or thin curtain walls serving merely as an enclosing screen.

The Architecture
- As corporations were attracted to New York City, skyscrapers raced upwards as height became synonymous with corporate success and power.
- As architects responded to demands of powerful clients, they endeavored to discover new expressions of verticality while adapting to materials and systems that would support their visions.
- Ground levels were dedicated to bustling commercial spaces, while upper floors were occupied by office tenants and eventually residential tenants also.
- The skyscraper race could be compared to the competition for height among villages building their respective cathedrals during the Gothic period.
- With New York setting the pace, major cities around the Country compete for architectural recognition.

1. Elevator:
 – Crucial to the viability of skyscrapers, the elevator provides safe, fast, and efficient vertical circulation between floors. Using steel cables and pulleys, elevators have a remarkable safety record since their inception, owing this to the safety brake invented by Elisha Otis in 1854.

2. Load bearing:
 – A structural planer line (beam, wall, etc.) that bears the component weight of assemblies above it, usually directed to that plane.

3. Skyscraper:
 – A building that surpasses approximately 330 vertical feet, inverts the environmental controls between the core and the exterior envelope, and applies greater concern to wind loads than seismic loads.

4. Zoning Regulations:
 – Using guidelines developed by Hugh Ferriss, New York adopted zoning ordinances in 1922.

▶ Skyscrapers are systems of building that consider the independent behavior of the structural frame, and the curtain wall envelope.

▶ Corporations seek expression of success and power through height and unique skyline identity.

▶ The twentieth century sees skyscraper frames transition from iron-riveted framed, to tubular rigid frames offering greater strength and efficiency.

▶ The ideals of symbolism and expression realized through skyscrapers likely led to New York City's twin World Trade Towers' becoming the targets of terrorist attacks on September 11, 2001.

SKYSCRAPER

1. Flatiron Building (Originally Fuller Building) 1902
 at New York, NY Daniel Burnham
2. Woolworth Building 1910 – 1913
 at New York, NY Cass Gilbert
3. Nebraska State Capitol 1916 – 1924
 at Lincoln, NE Bertram Goodhue
3. Chicago Tribune Competition 1922
 at Chicago, IL Gropius, Saarinen, Howells, and Hood
4. American Radiator 1924
 at New York, NY Raymond Hood
5. McGraw-Hill Building 1929 – 1930
 at New York, NY Raymond Hood
6. Chrysler Building 1930
 at New York, NY William Van Allen
7. Empire State Building 1931
 at New York, NY Schreve, Lamb, and Harmon
8. Daily News 1929 – 1930
 at New York, NY Raymond Hood
9. Rockefeller Center 1932 – 1939
 at New York, NY Reinhard and Hofmeister/Hood
10. Philadelphia Savings Society 1929 – 1932
 at Philadelphia, PA Howe and Lescaze
12. Lever House 1950 – 1952
 at New York, NY Skidmore-Owings and Merrill (SOM)
13. Seagram Building 1955 – 1958
 at New York, NY SOM
14. Marina City 1959
 at Chicago, IL Bertrand Goldberg
15. Lake Point Tower 1968
 at Chicago, IL John Heinrich
16. Transamerica Tower 1969
 at San Francisco, CA William Pereira
17. Sears Tower 1973
 at Chicago, IL SOM
18. City Corp Bank 1977
 at New York, NY Hugh Stubbins

1. Flatiron Building (Burnham):
– This Beaux Art landmark derives its name from a flatiron used to press clothes, the building's footprint resolves a difficult site constraint and pioneered the high-rise movement about to hit New York City

2. Woolworth Building (Gilbert):
– Temporarily the world's tallest building, passed by Chrysler

3. Nebraska State House (Goodhue):
– Innovative use of masonry and form, symbolism

4. Chicago Tribune (Hood):
– The design competition is won by Hood but runner-up Eliel Saarinen

5. American Radiator (Hood):
– Upper "courts" ensure identity from any view toward building

6. Daily News (Hood):
– Vertical stripes of windows and brown brick spandrels

7. Rockefeller Center (Hood):
– Fourteen buildings form an intimate urban space

8. Empire State Building (Schreve, Lamb, and Harmon):
– John Jakob Raskob asked when looking at a pencil on end "how high can you make it so it won't fall down"; a symbol that rose out of the Depression, completed $8M under the estimated $50M budget

9. Philly Savings Society (Howe and Lascaze):
– The first attempt to apply "International Style" to skyscraper

10. Chrysler Building (Van Alen):
– Art Deco spire built inside fire shaft and pushed into place 1048-feet first building to top the Eiffel Tower

11. Lever House (SOM):
– International Style influence, column-supported single-story supports tower, the structure takes on whole different look at night, cites "clean business look," separation of skin and structure

12. Marina City (Goldberg):
– Disciple of Mies, designed as a vertical city for the middle class

13. Lake Point Tower (Heinrich):
– Student of Mies at IIT employ undulating curtain wall

14. Transamerica Tower (Pereira):
– William Pereira: Rebirth of corporate logo, use of pyramid functional

15. Sears Tower (1973):
– SOM: Redefines Chicago's pioneering of the skyscraper, multifunctional uses

16. CitiCorp Tower (Hugh Stubbins with William LeMessurier):
– Creative use of structural system, a 400-ton concrete tuning block counter weight, site plan innovation over St. Peter's Lutheran Church

Skyscraper Timeline

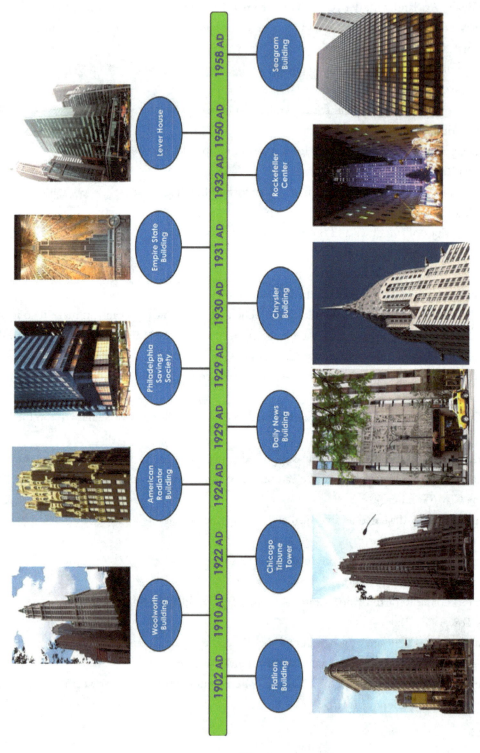

1958 AD — Seagram Building

1950 AD

1932 AD — Rockefeller Center

Lever House

1931 AD — Empire State Building

1930 AD — Chrysler Building

1929 AD — Philadelphia Savings Society

1929 AD — Daily News Building

1924 AD — American Radiator Building

1922 AD — Chicago Tribune Tower

1910 AD — Woolworth Building

1902 AD — Flatiron Building

(Above) Resolving the acute angle of the intersection of NYC's Fifth Avenue, Broadway, and East 22nd Street, the Flatiron (named for a clothes iron) pioneered skyscrapers in New York, articulated by its varying horizontal treatments.
(Left) Woolworth derives its form as a response to zoning constraints that called for buildings to "wedding cake," or reduce sequentially while rising. Cass Gilbert's 57-story design had the first high-speed elevator and is articulated in Gothic limestone.

The slides: Skyscrapers
Woolworth Building, NY
1910

The Skyscraper Race

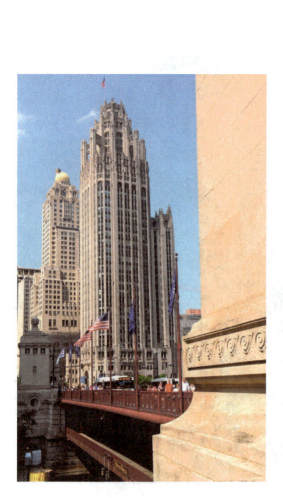

(Above) Designed by Goodhue, an apprentice for Renwick, Nebraska's was the first statehouse to depart from the neoclassical architecture of the Nation's Capitol in Washington, DC.

(Right) The competition for the Chicago Tribune Tower was won by Raymond Hood whose Gothic buttresses support the structure's lantern. Eliel Saarinen, father of Eero Saarinen, placed second in the competition and is said to have emigrated his family from Finland to the Unite States with prize money awarded.

The slides: Skyscrapers
Chicago Tribune Building
1922

The slides: Skyscrapers
Daily News Building, NY
AD 1929

(Right) Hood's design for the American Radiator Building used black brick to represent coal and gold crenellation to represent fire. The vertical lines were also intentionally expressed to suggest greater height.

(Below) The globe in the Daily News' lobby symbolizes the company's position that it was the first "global" news organization. Upon ribbon-cutting and for a short time after, the globe spun in the wrong direction but was corrected. It rotates once every ten minutes and marks direction and distances to points around the world.

The Skyscraper Race

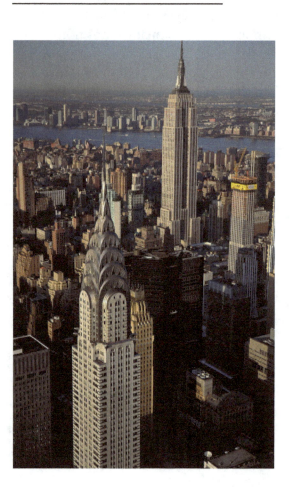

(Above) Considered the first International Style skyscraper, the Philadelphia Savings Society (now a hotel) is a juxtaposition of rectilinear forms defined in Art Deco detailing.

(Right) The Chrysler and Empire State buildings in the foreground and background respectively, punctuate the impressive skyline of New York City, connected by its rivers and bridges thus forming one of the world's most unique urban fabrics. As large as it is, there is still a sense of human scale that define its Boroughs and villages.

As floors rose, constructed at a rate of four floors per week, the Chrysler building raced against the Bank of Manhattan to be the world's tallest structure. In spite of the aggressive schedule, no workers died during construction.

The Bank of Manhattan was the same size until an antennae was put on, then Chrysler hoisted a 185-feet spire in four sections to the top in 90 minutes the next day (making it the first building to surpass 1,000 feet in height.

The building was paid for personally by Chrysler (not his company), so his family could inherit it.

Dissention during construction ensued and Chrysler did not pay Van Alen his full fee.

The Skyscraper Race

Still one of the worlds most iconic and recognizable skyline features, the 102-story Empire State building derives its name for the town where its limestone was quarried, Empire Mills. It was the tallest building in the world for 36 years (five workers died during construction). At its top was planned a dock for dirigibles (airships).

Having its own postal zip code (10118), each Fathers Day, a card is sent to the Reynolds Building (in NC), as the architects modeled its plans from their design of its top.

Financed by Rockefeller after the 1929 Stock Market crash, Rockefeller Center redefined urban space as it continued to evolve with increased traffic and larger buildings. A campus of urban buildings, its piazza, Rockefeller Plaza along with Radio City Music Hall (home to the Rockettes), are among the City's most popular sites to experience. Ascending to the top of "The Rock" provides unparalleled views of the City and Central Park.

The Skyscraper Race

(Above) The Manhattan Suspension Bridge, completed in 1909, was the third to span the East River, adding to the City's romantic cityscape.

(Right) Designed by SOM's Gordon Bunshaft, Lever House was the City's second glass curtain wall skyscraper and builds upon the seminal edicts of Mies.

The bottom register engages the city sidewalk while its mass conceals a public courtyard. The glass box tower seemingly disappears from the street level.

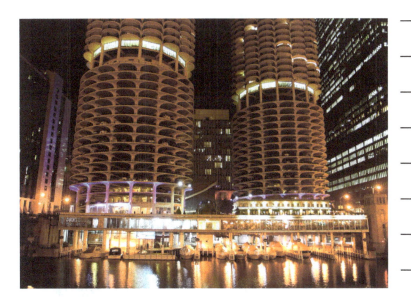

Located on the Chicago River, Marina City stands as an innovative mixed-use residential and commercial complex. Integrating multimodal transportation (auto and water craft), the towers provide for slips, auto parking, common laundry service, and apartments with scenic views of Chicago.

The concept for the project was the result of planners trying to interrupt an exodus of mostly middle-class residents from the city center (referred to in historical terms of a city's pathology as "white flight").

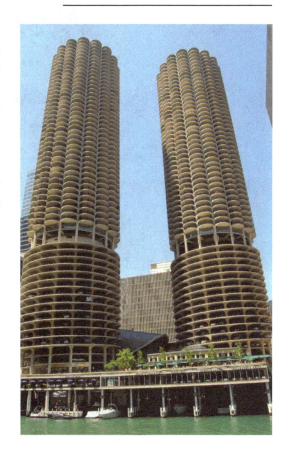

The Skyscraper Race

(Above) Inspired by an unbuilt glass skyscraper Mies had conceived, Lake Point is a 70-floor residential skyscraper standing on the shores of Lake Michigan. Like Wright's Price Tower, it was built with a structural core that bears the vertical loads.

(Right) The second icon of San Francisco's skyline (the Golden Gate Bridge being first), the Transamerica tower's form is a creative response to zoning constraints. A tall pyramid, the wings allowed the elevator and stair to be externalized thus freeing up the core.

The slides: Skyscrapers
Transamerica, San Francisco, CA
AD 1972

For 25 years, the Sears Tower was the tallest building in the world once it surpassed the twin World Trade Towers in 1973.

Its plan is based on nine squares (3x3), each becoming an extruded tube of varying story height bundled to form the skyscraper. The bundled tube theory was said to have been conceptualized by the building's structural engineer Fazlur Khan.

Today, a popular glass skydeck cantilevered at the 103rd floor allows visitors to experience suspension 1353 feet above the street.

The Skyscraper Race

(Below) For six years from 1998, the Petronas Towers were the tallest buildings in the world. Designed by Cesar Pelli, steel and glass frames deriving their form from Islamic art providing the concept for the structure as well as its structural capacity. Two different construction firms were hired to complete the project on time.

(Above) Sharing space with St. Peter's Lutheran Church stands CitiCorp Tower on four columns. An example of triumph over failure, engineer William LeMessurier designed a tuned mass damper of concrete to stop the building from swaying in high winds, a failure discovered by a Princeton engineering student. Value engineering (cost reductions) had caused the joints to be bolted rather than moment welds. Welded plates were added along with the tuned mass damper to successfully stabilize the tower.

Classicism Meets Modernism

– In the last half-century, several events have had profound impacts on the world of architecture. They include the space program and its exploration of strong, light-weight materials and use of color, rock-and-roll and its impact on mainstream culture and art, and the advent of the computer age, which has allowed for more efficient engineering, three-dimensional modeling, changes in manufacturing process-es, and many, many other elements.

– The postwar period (meaning even after the Vietnam conflict), saw fluctuations of economy and spikes in various construction markets that, along with many changes in corporate culture and economic cli-mates, have led to vast changes in architectural pedagogy. The following slides illustrate these new ide-als and the culture which has promoted them.

– Architect Robert Venturi's book *Complexity and Contradiction in Architecture* (1966), provided architects a treatise that allowed reflection of the whole of history while considering context and vernacular issues.

– Pedagogy in the training of professional architects was going through changes as well as schools of architecture added academic researchers and historians to their faculty.

The Architecture

– Postmodernism of the late twentieth century provides a critical look art architecture, art, history, litera-ture, and philosophy.

– As related to architecture, Postmodernism ushers in a revival of abstract Classical forms and surface ornamentation.

– While Ludwig Mies van der Rohe coined the phrase "less is more," postmodern architect Robert Ven-turi rebutted with "less is bore." This represented a clear rejection of the failed utopic communities promised by modernists including Gropius, Corbusier, and van der Rohe.

– Postmodern architects categorize into "whites" and "grays"; the whites holding onto the purity and abstraction of the modern edict, and the grays seeking the reunion of historical reference, style, and detail.

– Deconstruction—the intended fragmentation of building components, becomes briefly enjoyed by the art and architecture realms at the turn of the twenty-first century.

Postmodernism

1. Contextualism:
 – As related to architecture, it refers to design sensitivity to a building's immediate environs.
2. Symbolism:
 – In the context of Postmodernism, can be described as minimal architecture conveying the essence of a main idea, sometimes even in a bold way while remaining simplistic.
3. Trompe L'oeil:
 – Artistic and architectural devices used to "trick the eye," or create an illusion.
4. Vernacular:
 – A more macro consideration of context, whereby consideration is given to culture, history, and even social and philosophical issues.

▶ The Postmodern period revives the sense of classicism — not just form but its interrelationship with cultural ideals.

▶ Designs take on bold, sometimes whimsical scale while double coding function and purpose.

▶ The descriptive nature of the Postmodernists arrives at the confluence of the computer age and new developments in materials.

▶ Rather than replacing modernism (the way many successive eras replace their predecessor), Postmodernism offers an alternative that is equally ethereal.

POSTMODERNISM

1. Piazza d'Italia		1978
at New Orleans, LA	Charles Moore	
2. JFK Library		1979
at Boston, MA	I.M. Pei	
3. Dallas City Hall		1979
at Dallas, TX	I.M. Pei	
4. East Wing National Gallery		1979
at Washington, DC	I.M. Pei	
5. John Hancock Tower	I.M. Pei	1979
at Boston, MA		
6. Portland Building		1982
at Portland, OR	Michael Graves	
7. Dolphin Hotel		1987
at Disney World, FL	Michael Graves	
8. Louvre Court Entrance		1988
at Paris, FR	I.M. Pei	
9. Seattle Art Museum		1991
at Seattle, WA	Robert Venturi and Denise Scott Brown	
10. Provincial Capitol		1999
at Toulous, FR	Robert Venturi	
11. Rock and Roll Hall of Fame		1995
at Cleveland, OH	I.M. Pei	
12. Kansai Airport Terminal		1994
at Osaka, Japan	Renzo Piano	
13. Dancing House		1996
at Prague, CK	Frank Gehry	
14. Getty Center		1977
at Los Angeles, CA	Richard Meier	

Postmodernism

1. Piazza d'Italia:
- Moore reintroduces Classicism to the Postmodern vocabulary, emphasizing base, column, and entablature.

2. JFK Library:
- One of Pei's most coveted accomplishments, the structure imbues youth and strength at the same time, reflecting attributed of John F. Kennedy.

3. Dallas City Hall:
- Pei pays homage to Le Corbusier with his use of concrete and deep set fenestration, reflecting Chandigarh.

4. East Wing, National Gallery:
- Bold form gives way to delicate spaces in another Pei masterpiece.

5. John Hancock Tower:
- Designed by Henry Cobb of Pei's office, the Hancock tower is a glass monolith in the vein of Mies and stands as the tallest building in New England.

6. Portland Building:
- One of Grave's bold postmodern expressions of over emphasized Classical elements.

7. Dolphin Hotel:
- Another bold, larger than life, Grave's postmodern structure designed to bring out the whimsey of Disney.

8. Louvre Court Entrance:
- Daring and not at all enjoyed by the French initially, its the perfect solution and a perfect form (pyramid) juxtaposed against such elegant French architecture.

9. Seattle Museum of Art:
- One of the most interpretive and successful designs by Venturi and Scott-Brown.

10. Provincial Capitol, Toulous:
- A masterful ensemble of courts, public space and architecture play out in this design.

11. Rock and Roll Hall of Fame:
- Pei sought to mimic rock and roll's continued tradition to express old and new.

12. Kansai Airport Terminal:
- A disciple of Kahn, Piano uses structure and light while organizing the airport operations around interstitiality.

13. Dancing House:
- The playful deconstructionism of Gehry is evident in this tongue in cheek play on the dancers Fred Astaire and Ginger Rodgers.

14. Getty Center:
- A masterful command of space, assembling structure to define the negative spaces between.

Post Modernism Timeline

2000 AD	1996 AD	1995 AD	1988 AD	1987 AD	1986 AD	1980 AD	1979 AD	1979 AD	1978 AD

"Dancing House"

Louvre Court Pyramid Enhance

Humana Building

East Wing National Gallery

JFK Library

Experience Music Project

Rock and Roll Hall of Fame

Dolphin Hotel

AT&T Building

Dallas City Hall

Piazza d'Italia

Postmodernism

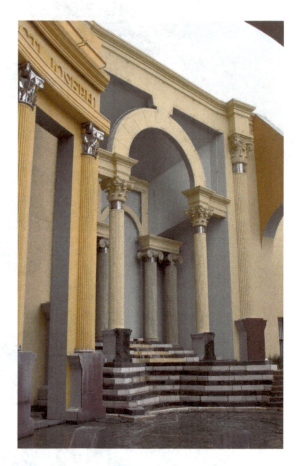

Built as homage to New Orleans' under-recognized Italian-American community, Post-modern architect and former Yale School of Architecture Dean Charles Moore conceived the clean, abstract, yet Classically-rooted Piazza d'Italia. Stainless steel column capitols support enthusiastic entablatures in this witty exchange of Roman temple form. The square came under much criticism and was less than popular as an urban public space.

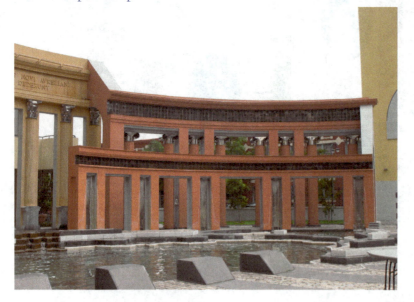

The Slides: Postmodernism
JFK Library, Boston, MA
AD 1979

Considered one of Pei's most successful designs among many, the Kennedy's desire to use Pei was driven by his tenacity to approach design solutions from exhaustive angles. Like the young Kennedy, the building of concrete and glass responds to budget constraints yet expresses promise.

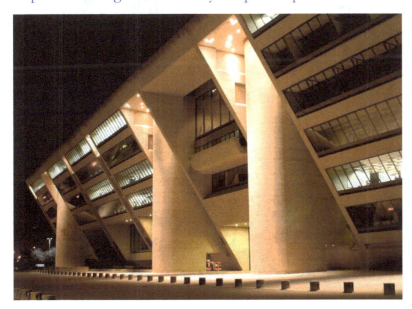

The City of Dallas was cast into a shadow of negativity after the assassination of JFK and the new City Hall sought to reinvent the City's image.

Pei uses modern expressions while breaking away from the building committee's intended Beaux-Arts style. The building's concrete form if nothing, pays tribute to Le Corbusier's government buildings at Chandigarh, the Indian capitol.

The slides: Postmodernism
Dallas City Hall, Dallas, TX
AD 1979

Postmodernism

(Above) Reflecting the site's triangular shape, Pei's sculptural posttensioned concrete design for the East Wing capitalizes on constraints presented by the site's irregularity.

(Right) Inheriting a prominent site next to Richardson's Trinity Church, Pei's response to build Boston's first glass skyscraper was to use mirrored glass thus giving Boston back a view of itself. Pei was distraught when failures in the curtain wall caused glass to "pop out," later revealed to be a manufacturing defect.

The slides: Postmodernism
John Hancock Tower, Boston, MA
AD 1979

(Above) Kicking off a period of witty Postmodern forms, Grave's Humana building over-sizes Classical features. In deference to the City's older buildings downtown to the north, an open loggia fronts the sidewalk.

(Below) Together with its sister resort Swan, the Dolphin once again reveals the enthusiastic side of Graves, whose over-sized features play directly into the Disney World experience. Bold color and monumental scale plainly depict the classic pediment.

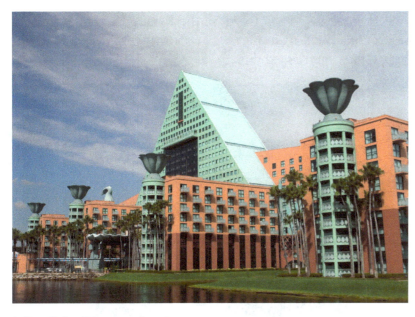

The slides: Postmodernism
Dolphin Hotel, Disney World, FL
AD 1987

Postmodernism

As a part of President François Mitterrand's plan to renovate the Louvre, Pei was commissioned to design a new Court entrance. Forcing the entrance below ground, Pei chose to use a steel and glass pyramid to allow light into the new lobby, as a pyramid is a decreasing mass and would provide the most transparency and not block or compete with the original French renaissance structures.

Though initially disdained by the French, they grew to adore the Pyramid of the Louvre as a new Parisian landmark. During construction, subterranean rooms were discovered with over 25,000 artifacts, now a part of the Louvre's exhibits.

The Slides: Postmodernism
Seattle Art Museum, WA
AD 1991

(Above) Led by Robert Venturi, one of Postmodernism's theorists, Venturi, Scott Brown and Associates masterfully crafted like the art it displays, the Seattle Art Museum, an icon of Postmodernism made of limestone and decorated with terra-cotta accents.

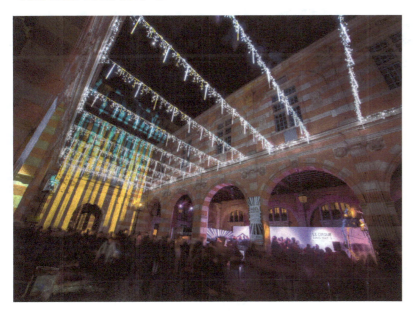

(Left) Somewhat shoehorned into the small-scale residential and commercial district of Toulous, the Provincial Center's solution included two parallel narrow buildings that form a sort of "main street."
The project's rhythm and scale though not copied, compliments the City's existing fabric.

The slides: Postmodernism
Provincial Capitol, Toulous, FR
1999

Postmodernism

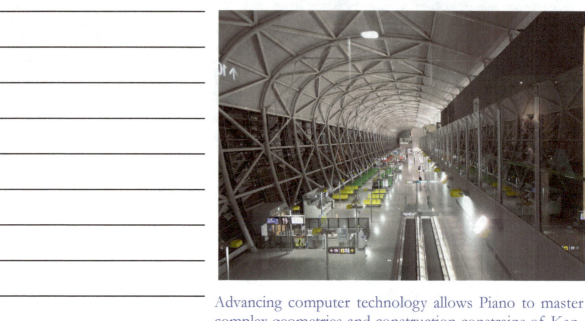

Advancing computer technology allows Piano to master complex geometries and construction constrains of Kansai's terminal, openly visible to boarding gates through the transparent architectural curtain wall.

In describing the Rock and Roll Hall of Fame in Cleveland, Pei once noted that he intended to use architectural elements that were "bold and new," and echoed the energy of rock and roll.

The Slides: Postmodernism
Dancing House, Prague, CK
AD 1996

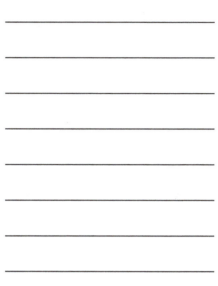

(Above) Playfully dancing in Prague's streetscape, "Fred and Ginger" as the building is affectionately referred, is an example of Gehry's witty use of deconstructive form.

(Left) The artful addition to the Getty campus of buildings overlooking LA, Meier first had to consider seismic issues when developing his design solutions to house the collection's drawings, illuminated manuscripts, paintings, and other pre-twentieth century works.

The slides: Postmodernism
Getty Center, Los Angeles, CA
AD 1997

World Trends Today

- The turn of the twenty-first century has brought both unprecedented challenges and opportunities to the world of architecture.
- Terrorist attacks, specifically the ones that brought down the World Trade Towers in NYC have brought features such as safety and structure to light while playing a part in one of the greatest economic downturns in recent history. The former has caused architects to consider ingress security, impact resistance, and other safety elements while the latter has played a role in renewed efforts for designs that are sustainable, require less energy consumption, and create healthier spaces.
- Coupled with the above are the statistical occurrences of catastrophic weather events. New codes and regulations have been enacted to protect people and their possessions from these natural hazards.
- Effects of the economic downturn are evidenced by shockwaves sent through the banking industry. Money has become more difficult to borrow and as a result of relying heavily on credit, consumers dial back their habits, procuring what they need versus what they want. This is also reflected in the housing market which sees new starts down, downsizing of the living unit, and flight back to the urban environment as green, sustainable, and walkable communities flourish.

The Architecture

- While necessity is said to be the mother of invention, there perhaps has never been a time of such design flexibility; polycarbonate materials are lightweight and strong, titanium has architectural applications from infrastructural to nanotechnologies, and computing power and wireless capabilities have combined to allow design freedoms never before realized.
- With an eye toward sustainability and advanced window technologies, large apertures of glass have become popular as a means to admit natural daylighting.
- The desire to move away from fossil fuels has renewed interest in energy fields that include geothermal, solar, and wind.
- Cohabitation of the Planet with all other species and a renewed sense of environmental stewardship now drives planning projects both large and small.

1. Alternative Energy:
 - Energy systems that provide environmental control (heating and cooling), lighting, or other amenities that require energy consumption formerly satisfied primarily by fossil fuels but now include: geothermal systems; hydroelectric energy; solar photovoltaic energy; wind turbine energy.
2. Smart Growth:
 - Urban planning and public circulation theories that concentrate growth around city centers to avoid urban sprawl, advocating compact transit-oriented, walkable, bike-friendly land use incorporating mixed-use development, community-reinforcing networks, neighborhood schools, and a range of housing choices.
3. Sustainable Design:
 - Building "that meets the needs of contemporary society without denying future generations of the ability to meet their needs."
4. Walkable Communities:
 - Urban and semiurban communities that provide mixed uses and essential everyday services within a five-to ten-minute walk, i.e., banking service, markets, postal service, cafes, etc.

► Buildings and communities are now designed more sustainably.

► Residential living space requirements have been downsized.

► Socially, communities are thinking more systemically than ever before.

► The necessity and desire to build more sustainably leads to fresh architectural expressions that satisfy both human function and spirit within the built environment.

CURRENT TRENDS

1. Gate of Europe (formerly KIO Towers) 1996
 at Madrid, Spain Philip Johnson and John Burgee
2. Reighstag Building 1999
 at Berlin, Germany Norman Foster
3. Potsdamer Platz 2000
 at Berlin, Germany Renzo Piano
4. Petco Park 2004
 at San Diego, CA Renzo Piano
5. Seattle Library 2004
 at Seattle, WA Rem Koolhaas
6. Museum of Islamic Art 2008
 at Doha, Qatar I.M. Pei and Partners
7. California Academy of Sciences 2008
 at San Francisco, CA Renzo Piano
8. Modern Wing-Art Institute of Chicago 2009
 at Chicago, IL Renzo Piano
9. Millau Viaduct 2004
 at Millau, France Norman Foster with Michel Virlogeux
10. Swiss Tower 2004
 at London, England Norman Foster
11. London Aquatics Center 2011
 at London, England Zaha Hadid
12. Bilbao Museum 1997
 at Bilbao, Spain Frank Gehry
13. Oslo Opera House 2008
 at Oslo, Norway Snohetta
14. The Senedd 2006
 at Cardiff, Wales Richard Rogers
15. Supertree Grove (Gardens on the Bay) 2012
 at Marina Bay, Singapore Grant Associates

1. Gate of Europe:
– Two monoliths tilted inward 15 degrees, they form a traditional "gate arch" to Europe

2. Reichstag Building:
– Meaning "parliament," the building was renovated with Foster's glass dome after Germany's unification

3. Potsdamer Platz:
– The revival of this important square near Brandenburg Gate, symbolizes the end of the Cold War

4. Petco Park:
– Exemplifies current trends to unify event stadiums with mixed uses and a "main street" feel

5. Seattle Library:
– The façade engages the public sidewalk as platforms appear to hover behind a steel net

6. Museum of Islamic Art:
– Ancient Islamic architecture drives the form and detail of this sensitive Museum by Pei

7. California Academy of Sciences:
– Founded in 1853, Piano's design replaces the original building damaged by earthquake

8. Modern Wing-Art Institute of Chicago:
– Deemed a "green" building, computer-generated operable roof blades (referred to as "magic carpets") allow controlled amounts of natural light into the exhibits

9. Millau Viaduct:
– The 12th highest bridge deck in the world, its cable-stayed construction is artful and was completed using new technologies that permitted rapid new placements of concrete in the piers

10. Swiss Tower:
– Known locally as the "Gherkin," it is one of the most identifiable shapes of London's skyline and was designed not to compete with the dome of St. Paul's Cathedral (by codes)

11. London Aquatics Center:
– A daring sculptural building for the 2012 Olympics, Hadid uses a sustainable approach, relying on precast concrete and an aluminum roof

12. Bilboa Museum:
– One of the best examples of Gehry's command of space and volume using complex shapes, creating an architectural "experience"

13. Oslo Opera House:
– Norway's emphasis on their cultural events sees this building join their maritime aspects with their lust for the performing arts

14. The Senedd:
– An inspirational space using sustainable glass and other materials to offset carbon footprint

15. Supertree Grove:
– Singapore's effort to transition to a "city in the garden," the "grove" of trees biomimic actual trees as they harness energy through photovoltaics to produce energy for lighting

The Age of Information

(Above) *Puerta de Europa*, "Gate of Europe," forms a metaphorical gate entrance in the vein of a Roman arch, into Madrid's Plaza de Castilla. The twin office monoliths conceptualized by Johnson and Burgee, incline inward at 15 degrees to suggest their symbolic archway.
(Below) The Reichstag (meaning parliament), once synonymous with the Cold War, was modified to receive Foster's glass dome with a spiraling ramp delivering viewers to the top. Symbolizing that people are above the government, the dome, representing Germany's reunification, contains mirrors that direct an abundance of light into the interior space.

The slides: Trends and Issues Today
Reichstag Building, Berlin, Germany
AD 1999

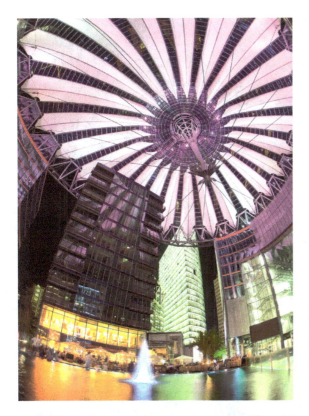

(Left) The new, fresh, and energetic work of Piano at Berlin's Potsdamer Platz also reflects Germany's reunification and the promise it brings, as it reconnected parts of Berlin with areas previously separated by the Berlin Wall.

(Left) Pei draws upon his own knowledge of cultural symbolisms in creating this museum that sensitively reflects Islamic culture through geometries, form, and details.

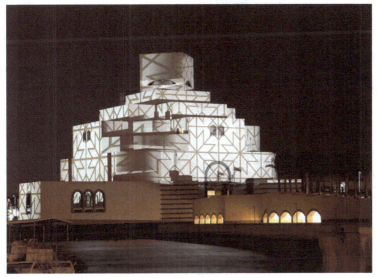

The slides: Trends and Issues Today
Museum of Islamic Art, Doha, Qatar
AD 2008

The Age of Information

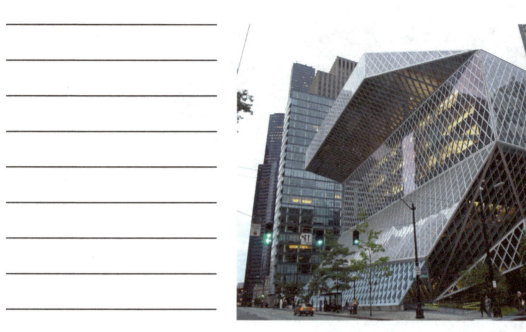

(Above) Responding to a difficult site that translates almost thirty vertical feet across its depth, Koolhaas employs a "push and pull" approach to conform the structure to both the site and the zoning regulations, making both an opportunity rather than a constraint. Floors appear like linear platforms concealed behind a steel and glass net.

(Right) Seated prominently on San Diego's Bay, Petco's Predock design engages the urban waterfront, enhancing the "main street" feel near the Gas Light District and contributing to the City's civic engagement.

The slides: Trends and Issues Today
Petco Park, San Diego, CA
AD 2004

410

(Above) A product of the sustainable design movement, Piano's design reflects the ecological mission of the Academy and boasts its status as a certified platinum LEED building for its water conservation, solar panels, green roof, and use of natural daylighting.

The slides: Trends and Issues Today
Modern Wing-Art Institute of Chicago
AD 2009

(Left) Innovative, "green," and a product of its time, the Art Institute of Chicago reflects its mission through Piano's systems-centric design that includes computer-generated operable roof blades (referred to as "magic carpets"), that allow controlled amounts of natural light into the exhibits.

The Age of Information

(Above) Making it the 12th highest bridge deck in the world, the Millau Viaduct's cable-stayed construction is artful and was completed using new technologies that permitted rapid new placements of concrete in the piers.

(Left) Affectionately known as the "Gherkin," it is one of the most identifiable shapes of London's skyline and was designed so as not to compete with the dome of St. Paul's Cathedral (by codes). Though appearing to be complex, its structure is a fabric of interconnecting triangles, allowing for rigidity and flexibility of the form at the same time.

The slides: Trends and Issues Today
Swiss Tower, London, England
AD 2004

The Slides: Trends and Issues Today
London Aquatics Center
AD 2011

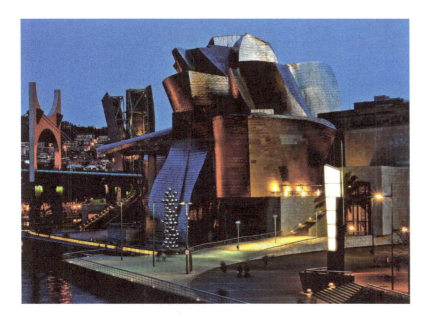

The slides: Trends and Issues Today
Bilbao Museum, Bilbao, Spain
AD 1997

(Above) Hadid's design was to capture the essence of fluid geometries in motion. The roof appears to be swelling up like a wave, defining the spatial volume within while contributing to the architecture of the riverfront landscape.

(Left) Perhaps one of the most iconic designs of Gehry's many, Bilbao's Guggenheim appears from all angles like a metallic explosion (intended to capture light), that indicates the City's progression from Gothic to contemporary style. The Museum is viewed favorably by academics, architects, critics, and the public at large, a rare occurrence.

The Age of Information

Snohetta's design amplifies Norway's Northern European emphasis on cultural art events as the Opera House joins Oslo's maritime aspects with the significance it places on community and the performing arts. Significant to the design is a powerful roof slope that plays on human nature to climb and beckons one to ascend to the top and enjoy Oslo's scenic vistas. Inside, the white granite and marble of the building is softened by rich oak wood and curves that ease the rigid lines of the exterior's form.

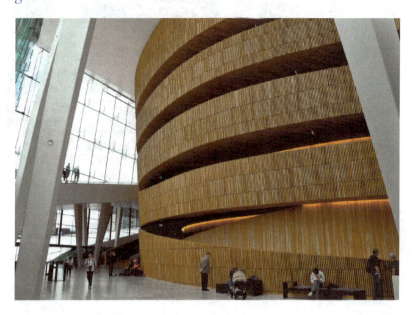

414

The Slides: Trends and Issues Today
The Senedd Debating Chambers, Wales
AD 2006

The slides: Trends and Issues Today
Supertree Grove, Singapore
AD 2012

(Above) With an eye toward conservation of the planet's resources underlying architecture in the early part of the twenty-first century, sustainable design has started to develop a "look" as buildings use common vocabulary to create form from materials that result in performance that attains desired outcomes, as evidence by the Senedd Debating Headquarters.

(Left) Supertree Grove is a part of Singapore's efforts to transform the City into a "city in the gardens" versus the old adage of building a garden in the city. The Grove's "trees" collect solar energy via photovoltaics to produce light, the same way a tree photosynthesizes solar energy into carbohydrate energy. If we are to live as contributing members of the planet, we must mimic the organisms around us better.

Gaudi & Wright

Culture:
- Growing up on the coast of Spain, Gaudi had a unique affinity for nature and how natural systems worked.
- Gaudi developed a unique portfolio which stood out during a period of "bland sameness".
- Wright grew up in a modest middle class mid-west family and had to provide for his mother and sisters early.
- In an emerging age of industrialism, Wright reflected his mid-west prairie surroundings in his unique styles of design.

Architecture:
- Gaudi graduated from Barcelona's Provincial School of Architecture in 1878.
- Veering from the Victorian architecture of his period, Gaudi developed his own vocabulary of design elements unique to his work alone.
- A unique methods of developing design form called "*equilibration*" (suspending lines & weights and inverting them) was developed by Gaudi.
- Gaudi was known as, "God's architect".
- Wright worked for the Dean of the Univ. of Wiscosin's engineering dept. but never graduated college.
- He left for Chicago where he apprenticed for Joseph Silsbee and later became Louis Sullivan's chief assistant.
- Following a disagreeable split with Sullivan, Wright opened his practice where he developed his *Unisonian* and *Prairie* styles of design.
- Both architects found their designs rooted in nature.
- Both architects were viewed as oddities early-on yet were producing some of the most unique architecture.

Detail:
- Gaudi's masterpiece La Sagrada Familia is the World's longest ongoing construction project and will result in the highest church ever built.
- Gaudi also designed lamp posts, furniture and more.
- Wright executed over 1,100 designs many of which continue to be finished posthumously.
- Wright was considered a master of spatial arrangement, considering all planes of enclosure.
- Wright insisted that architecture be in harmony with natural surroundings.

Modernism, Skyscrapers & Post Modernism

Culture:
- Modernism emerged as the dominant movement of the late 19th - early 2oth centuries growing out of techno-logical innovations and crystallizing in the abstract.
- "*Form follows function*" was the leading dicta.
- The skyscraper race emanating out of NYC was in reality, a race for corporate expression of self and prestige.
- The post-war period saw innovations in materials, fast fluctuations in economies, and profound changes in the training of architects, resulting in an abstract classical resurgence referred to as Post Modernism.

Architecture:
- Structural steel, sculptural forming of concrete, and large expanses of glass define the predominant forms of Modernism.
- Modernism presented new and fresh forms of spatial enclosure and is considered the first stylistic movement to permeate all building types and uses of architecture.
- Emerging out of the great Chicago fire was a developing structural style that led to skyscrapers, generally a steel "*matrix*" frame bearing all the building loads and allowing for exterior curtain walls.
- NYC set the pace of the skyscraper race, attracting corporations wishing to express "success and power" through design.
- As students and professors provided a critical look at architecture, Postmodernists rejected the utopic views of the modernists.
- Postmodernism brought about new expressions of clas-sicism while reintroducing playful designs of surface ornamentation.

Detail:
- Walter Gropius and the Bauhaus greatly influenced the Modern movement.
- Modernism makes no classical references while celebrating interstitial spatial enclosure.
- Skyscraper development was brought about through mechanical, elevator, and zoning innovations.
- Postmodernism promoted contextualism symbolized cultural ideas.
- Unlike past era progressions, Postmodernism isn't seen as Modernism's replacement but simply as an alternative.

Epilogue

Truly great architecture does not have to be monumental, grandiose, or from within a self-appointed establishment that seeks to be the designators of such. A building that humbly inspires the human spirit, solves real spatial problems functionally, is "buildable," and of design, materials, and reflections of the culture that built it, is truly great architecture and — often *does* include buildings that *are* monumental.

We often highlight the visionary patrons who have sponsored great works old and new, along with the *architectus* "master builder" who conceived and brought those works to fruition.

Lost in the credit and forgotten in our rush to only experience the final product, or in many cases its ruins, is the individual whose aching muscles, split and bruised-fingered hands, and worries of the day are hidden from us by the seduction of the greater part of the story.

Michelangelo said, "The greater danger for most of us lies not in setting our aim too high and falling short; but in setting our aim too low, and achieving our mark." While that may be true for artisan, it seems not to have been allowable for the craftsmen who toiled in often challenging, if not unsafe conditions, to permit us the adoration of their unrecognized efforts.

Creating a building is an indescribable feeling, especially when it "works" for what it was intended for and satisfies in all aspects the client who caused it to be built. Teaching is an indescribable feeling also, especially when the indifferent student has that epiphanous moment that causes them excitement for what you are teaching and an unstoppable eagerness to learn more.

Whether practicing the role as architect or professor teaching in the classroom and leading learners to experience the world's landmark structures and spaces; never forgotten, always respected, and forever inspirational to me, is that constructor who may never know that at least I, think of them — their tired bodies, daily stresses, and families waiting for them at day's end. I view the stone-carved gargoyle just feet from me atop Chartres; study and run my hand over the exquisite carving at the door's portal entry into the Florence Cathedral; and place my hand on something as simple as the handle to an old cistern lid in Venice but all the while think of you.

<div align="center">

MARK ANDREW COMEAU
Architect
Professor
Eternal Learner

</div>

Photo Credits

General

A majority of the photographs used in this book were taken on location by the author, Mark A. Comeau. Over the years, an increasing number of locations do not permit photography of their sites, buildings, interiors or content and where images by others exist that depict the author's illustrative intent, they are used with permission and credited as follows. Photos on pages not cited for credit are therefore the author's own Work.

The Egyptian Kingdom | Mycenae and the Aegean | Ancient Greece | The Roman Empire

Byzantine | Gothic

Photo Credits

Instinia/Shutterstock.com (Durham Cathedral Cloister) — Page 143
Universitaria/Shutterstock.com (Durham Cathedral Exterior) — Page 143
Alastair Wallace/Shutterstock.com (Durham Cathedral Exterior) — Page 143
Pack-Shot/Shutterstock.com (Nave of St. Etienne) — Page 144
Bertl123/Shutterstock.com (St. Etienne Exterior) — Page 144
Gattopazzo/Shutterstock.com (Drawing of Flying Buttress) — Page 148
Sigurcamp/Shutterstock.com (Nave of St. Denis) — Page 152
Pandapaw/Shutterstock.com (Reims Cathedral Exterior) — Page 156
Meiqianbao/Shutterstock.com (Reims Cathedral Interior) — Page 156
Pecold/Shutterstock.com (Amiens Cathedral Exterior) — Page 157
Pecold/Shutterstock.com (Amiens Cathedral Sculpture) — Page 157
Pecold/Shutterstock.com (Nave of Amiens Cathedral) — Page 157
Ana del Castillo/Shutterstock.com (Beauvais Cathedral Exterior) — Page 158
Claudio Giovanni Colombo/Shutterstock.com (Beauvais Cathedral Vaulted Ceiling) — Page 158
Claudio Giovanni Colombo/Shutterstock.com (Beauvais Cathedral Flying Buttresses) — Page 158
ErickN/Shutterstock.com (Saint Chapelle Exterior) — Page 159
Circumnavigation/Shutterstock.com (Saint Chapelle Interior) — Page 159
Richard Melichar/Shutterstock.com (Aerial of Lincoln Cathedral) — Page 160
David Reilly/Shutterstock.com (Nave of Lincoln Cathedral) — Page 160
Morphart Creation/Shutterstock.com (Lincoln Cathedral Rose Window) — Page 160
Richard Melichar/Shutterstock.com (Salisbury Cathedral Exterior) — Page 161
David Smart/Shutterstock.com (Magna Carta) — Page 161
Photoseeker/Shutterstock.com (Nave of Salisbury Cathedral) — Page 161
Ian Woolcock/Shutterstock.com (Exeter Cathedral Exterior) — Page 162
SergioBoccardo/Shutterstock.com (Vaulted Nave of Exeter Cathedral) — Page 162
Ratikova/Shutterstock.com (Westminster Abbey Cloister) — Page 163
JuliusKielaitis/Shutterstock.com (Westminster Abbey Exterior) — Page 163
Gordon Bell/Shutterstock.com (Kings College Chapel Exterior) — Page 164
Radek Sturgolewski/Shutterstock.com (Nave of Kings College Chapel) — Page 164
Claudio Divizia/Shutterstock.com (Milan Cathedral Interior) — Page 166
Anton_Ivanov/Shutterstock.com (Milan Cathedral Pediment) — Page 166
Anton_Ivanov/Shutterstock.com (Milan Cathedral Pediment) — Page 166
Leonid Andronov/Shutterstock.com (Milan Cathedral Exterior-night) — Page 166
Kiev.Victor/Shutterstock.com (Rouen Cathedral Glass) — Page 167
And_Ant/Shutterstock.com (Nave of Rouen Cathedral) — Page 167
Katarzyna Mazurowska/Shutterstock.com (Rouen Cathedral Façade Sculptures) — Page 167

Photo Credits

Photo Credits

Photo Credits

Photo Credits

Photo Credits

The Skyscraper Race | Postmodernism | The Age of Information Continued

References, Sources, and Further Reading

The path to becoming a licensed architect includes rigorous education resulting in a professional degree, training through a documented internship under the direction of professional architects, and successful completion of board examinations that assess the licensure candidate's competence to professionally practice architecture and protect the health, safety and welfare of the general public.

Though architecture programs differ slightly, the teaching of architectural history spans over two to four different courses, depending on the institution, and is embedded across the curricular core. The practice of architecture is often reflective and as such architects are exposed to countless fragments of historic information from books, journals, magazines, museum visits, and even tours.

The text narratives that accompany the images in this book were derived from a strong background in architectural history, ongoing research, reading, lecture preparation, and most importantly almost two decades of leading travel studies around the world. The volumes cited in the Reference List and Further Readings are part of the ongoing accumulation of the author's personal library spanning over three decades of collection.

Sources

It would be nearly impossible to list all of the sources that have contributed to the author's body of knowledge as it relates to architectural history, cultures, and societies. The following were especially influential however, and are recognized for their tremendous efforts and contributions, both to the author and the many learners who have participated in travelstudies with EF Tours*.

Rebecca Barry, Resides in London, UK
Licensed Tour Guide
EF Tours

Paul Costa, Resides in Tuscany, Italy
Licensed Tour Guide, Historian of the Renaissance and Languages
Owner: Tuscan Tours (www.tuscantourguide.com)
(Formerly with EF Tours)

Giuseppe D'Angelo, Resides in Naples, Italy
Licensed Tour Guide
EF Tours
Owner: Leisure Italy (www.leisure-italy.com)

Guillaume Moalic, Resides in Paris, France
Licensed Tour Guide
EF Tours

Hala Shady, Resides in Cairo, Egypt
Licensed Tour Guide and Egyptologist
EF Tours

Enrico Shattenmann, Resides in Naples, Italy and Patmos, Greece
Licensed Tour Guide
EF Tours

Numerous Local Licensed Tour Guides, Various Locations
Subcontracted to EF Tours

* EF Tours (Education First), EF Cultural Travel, LTD.
 Boston ▪ Luzern

Reference List and Further Reading

General

Fletcher, Knt., Sir Banister. *A History of Architecture on the Comparative Method*. 15th ed. London: B. T. Batsford, 1950.

Watkin, David. *A History of Western Architecture*. 3rd ed. New York: Watson-Guptill Publications, 2000.

Pevsner, Nikolaus. *An Outline of European Architecture*. United Kingdom: Penguin Books, 1943.

Scully Jr., Vincent. *Architecture: The Natural and The Manmade*. New York: St. Martin's Press, 1991.

Hamlin, Talbot. *Architecture Through the Ages*. New York: G. P. Putnam's Sons, 1940.

Garner, Helen. *Art Through the Ages*. 5th ed. Revised by de la Croix, Horst, and Tansey, Richard, G. New York: Harcourt, Brace & World, Inc., 1970.

Janson, H.W., and Janson, Anthony F. *History of Art*. 5th ed. New York: Harry N. Abrams, Inc., 1991.

Giedion, Sigfried. *Space, Time and Architecture*. Cambridge: The Harvard University Press, 1942.

The Egyptian Kingdom | Mycenae and the Aegean | Ancient Greece | The Roman Empire

Tarsouli, Georgia. *Delphi*. Athens: M. Pechlivanidis & Co., 1956.

Schultz, Regine, and Seidel, Matthias, eds. *Egypt: The World of the Pharaohs*. Cologne: Könemann, 1998.

Scranton, Robert L. *Greek Architecture*. New York: George Braziller, Inc., 1962.

Maniadakis, K. *Kreta, Knossos-Phaistos*. Athens: Verlag M. Pechlivanidis & Co., 1965.

Brown, Frank. *Roman Architecture*. New York: George Braziller, Inc., 1962.

Miliadis, John. *The Acropolis*. Athens: M. Pechlivanidis & Co., 1956.

MacKendrick, Paul. *The Greek Stones Speak*. New York: St. Martin's Press, 1962.

Greenhalgh, Michael. *What is Classicism?*. New York: St. Martin's Press, 1990.

Byzantine | Gothic

Stoddard, Whitney S. *Art & Architecture in Medieval France*. New York: Harper & Row Publishers, 1972.

MacDonald, William. *Early Christian & Byzantine Architecture*. New York: George Braziller, Inc., 1962.

Saalman, Howard. *Medieval Architecture*. New York: George Braziller, Inc., 1962.

Kunstler, Gustav. *Romanesque Art in Europe*. New York: W. W. Norton & Company, Inc., 1968.

Reference List and Further Reading

Italian Renaissance | Renaissance Masters | Late Renaissance

Pozzoli, Milena E. *Castles of the Loire: Past and Present*. Vercelli: White Star S.r.l., 1996.

Wirtz, Ralph C. *Florence: Art & Architecture*. Cologne: Könemann Verlagsgesellschaft mbH, 2000.

Bradbury, Kirsten. *Michelangelo*. Singapore: Parragon Publishing, 2002.

Michelangelo and Raphael in the Vatican. Vatican City: Editions of the Vatican Museums, 2000.

Lowry, Bates. *Renaissance Architecture*. New York: George Braziller, Inc., 1979.

Early American Colonial | Iron and Glass | Chicago School

Blumenson, John J.-G. *Identifying American Architecture*. New York: W. W. Norton & Company, Inc., 1977.

Benjamin, Asher. *The American Builder's Companion*. 6th ed. R. P. & C. Williams, 1827. Reprint, New York: Dover Publications, Inc., 1969.

Adams, William Howard, ed. *The Eye of Thomas Jefferson*. Columbia: University of Missouri Press, 1976.

The Mystic Coast: Stonington to New London. Newton: PilotPress Publishers, Inc., and Twin lights Publishers, Inc., 2000.

Modernism | Antoni Gaudi | Frank Lloyd Wright

Storrer, William Allin. *Architecture of Frank Lloyd Wright*. Chicago: University of Chicago Press, 2007.

van Hensbergen, Gijs. *Gaudi: A Biography*. New York: HarperCollins Publishers, Inc., 2001.

Benevolo, Leonardo. *History or Modern Architecture: Volume 1*. Cambridge: The MIT Press, 1977.

Benevolo, Leonardo. *History or Modern Architecture: Volume 2*. Cambridge: The MIT Press, 1977.

Curtis Jr., William. *Modern Architecture*. New York: Prentice-Hall, Inc., 1983.

Scully Jr., Vincent. *Modern Architecture*. New York: George Braziller, Inc., 1961.

The Skyscraper Race | Postmodernism | The Age of Information

Bascomb, Neal. *Higher: A Historic Race to the Sky and the Making of a City*. New York: Doubleday, 2003.

Kemp, Jim. *American Vernacular*. New York: Viking Penguin, Inc., 1987.

Architectural Record. New York: McGraw Hill Construction, Monthly Issues 1990 to the Present.